WILD FLORIDA

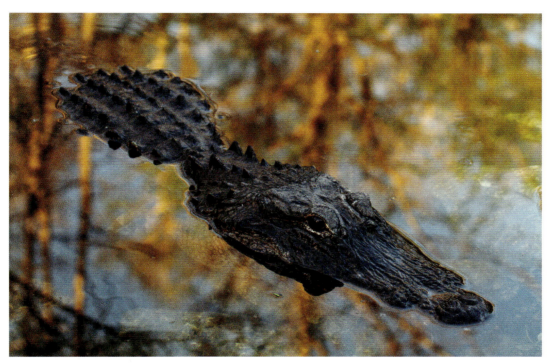

American Alligator (*Alligator mississippiensis*)

UNIVERSITY PRESS OF FLORIDA

Florida A&M University, Tallahassee
Florida Atlantic University, Boca Raton
Florida Gulf Coast University, Ft. Myers
Florida International University, Miami
Florida State University, Tallahassee
New College of Florida, Sarasota
University of Central Florida, Orlando
University of Florida, Gainesville
University of North Florida, Jacksonville
University of South Florida, Tampa
University of West Florida, Pensacola

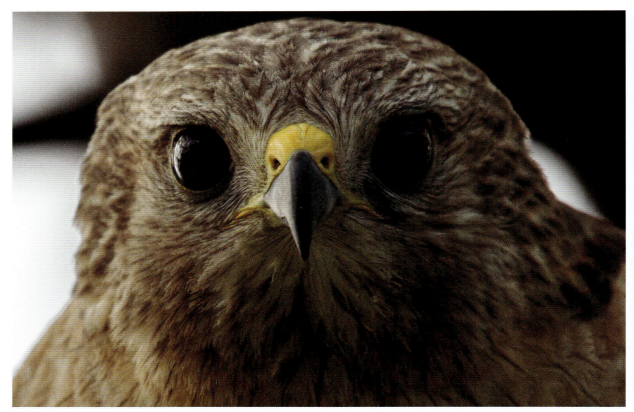

Red-shouldered Hawk (*Buteo lineatus*)

Wild Florida
An Animal Odyssey

Kirsten Hines

UNIVERSITY PRESS OF FLORIDA

Gainesville · Tallahassee · Tampa · Boca Raton
Pensacola · Orlando · Miami · Jacksonville · Ft. Myers · Sarasota

Copyright 2023 by Kirsten Hines
All rights reserved
Published in the United States of America.

28 27 26 25 24 23 6 5 4 3 2 1

Library of Congress Cataloging-in-Publication Data
Names: Hines, Kirsten, author.
Title: Wild Florida : an animal odyssey / Kirsten Hines.
Description: Gainesville : University Press of Florida, 2023. | Includes index. | Summary: "A captivating visual and narrative journey into the ecology of Florida's animals, this book features brilliant wildlife photography and intimate storytelling that introduces the variety of species within the state"— Provided by publisher.
Identifiers: LCCN 2023022684 | ISBN 9780813069814 (cloth)
Subjects: LCSH: Animals—Florida—Pictorial works. | Wildlife photography—Florida. | Photography of animals—Florida. | Nature photography—Florida. | BISAC: PHOTOGRAPHY / Subjects & Themes / Plants & Animals | NATURE / Animals / Wildlife
Classification: LCC QL169 .56 2023 | DDC 591.9759—dc23/eng/20230707
LC record available at https://lccn.loc.gov/2023022684

The University Press of Florida is the scholarly publishing agency for the State University System of Florida, comprising Florida A&M University, Florida Atlantic University, Florida Gulf Coast University, Florida International University, Florida State University, New College of Florida, University of Central Florida, University of Florida, University of North Florida, University of South Florida, and University of West Florida.

University Press of Florida
2046 NE Waldo Road
Suite 2100
Gainesville, FL 32609
http://upress.ufl.edu

In honor of Dr. William H. Buskirk and Dr. John B. Iverson, who first introduced me to Florida and its animals, and to Dr. James A. Kushlan who exponentially deepened my understanding and love of the Sunshine State, its animals, and its history, both natural and human.

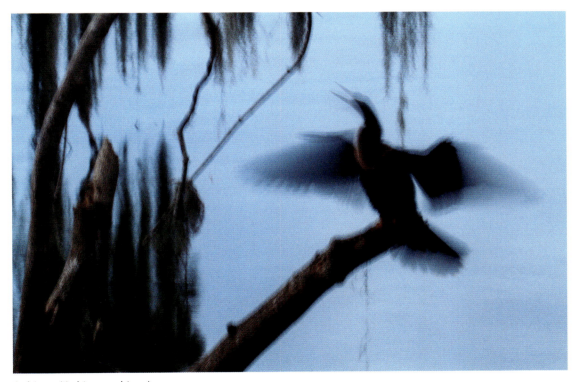

Anhinga (*Anhinga anhinga*)

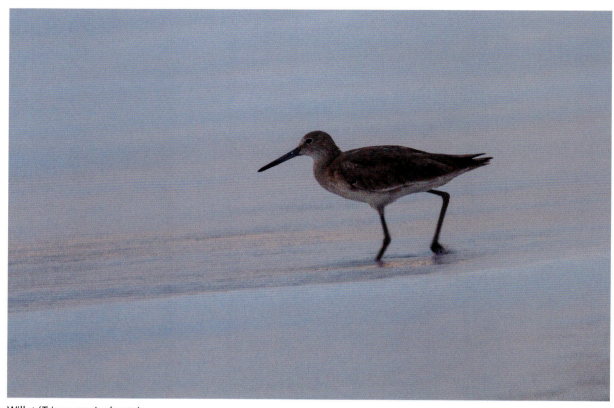
Willet (*Tringa semipalmata*)

Contents

Foreword ix

Preface xi

Approach xix

⁓

NATIVE 1

NONNATIVE 44

TROPICAL 77

TEMPERATE 108

BLENDED 146

RESERVES 184

COEXISTENCE 220

HELPING 252

REFLECTIONS 291

⁓

Acknowledgments 295

Index 299

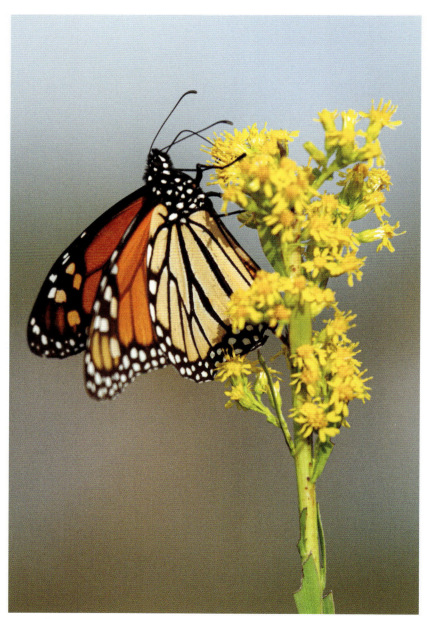

Monarch (*Danaus plexippus*)

Foreword

It is rare to find a dedicated biologist and conservationist who also happens to be a passionate and accomplished photographer. Kirsten Hines is among the best in each of those arenas. In this stunning book, her love of wildlife is reflected in her captivating storytelling where she uses beautiful images combined with engaging creative writing to connect the reader to what she holds so dear to her heart—Florida, and its amazing natural treasures.

From the seasonal climates associated with the temperate southeastern United States to the subtropical climates more commonly seen in the northern Caribbean, Florida is where one can explore a wide variety of unique environments. From the tiny tiger beetle to the enormous leatherback turtle, Kirsten introduces us to an incredible diversity of wildlife, some of which is found nowhere else on earth.

In addition to the wonderful variety of native wildlife, Kirsten also introduces us to the challenges presented by the large number of exotic species that have established themselves throughout the state. What I like to call the "Ellis Island" of exotic animals, Florida is home to more nonnative species of wildlife than any other state in the nation. From the icon of all invasive species, the Burmese python, to the plethora of invasive plants, she explains some of the threats these exotics present to Florida's native environments and how the changing of those environments is allowing for other nonnative species to expand their ranges and become "new natives." She describes in engaging ways how many of these exotics arrived here and what challenges they may present in the future.

Her personal stories of the frustrations encountered while trying to capture a photo of a bear to her colorful description of the body language battle between nonnative and native lizards brings a whimsical aspect to this book that makes it not only educational but entertaining. Kirsten brings you with her as she seeks out elusive subjects in Florida's most beautiful natural habitats. *Wild Florida* is a feast for the eyes and the mind as told by someone who understands that it is just as important to connect as it is to inform.

Throughout the years I have known her, Kirsten has dedicated herself to educating and inspiring others to care for our environment and the wildlife that inhabits it. Her skills as a photographer and as a writer make her uniquely qualified to serve as an ambassador for our natural world. I feel privileged to call her a friend and know that through her exceptional storytelling abilities, she is making a positive impact. This book is an excellent example of that effort.

Baba Dioum, a Senegalese conservationist, once said, "In the end, we will protect only what we love, we will love only what we understand, and we will understand only what we are taught." In *Wild Florida,* Kirsten Hines helps teach us about the wonders of Florida's wildlife in hopes that we will better understand it and in turn come to love and protect it for future generations. It is an enjoyable and enlightening journey!

Ron Magill

Ron Magill is a wildlife expert and photographer whose accolades include hosting and directing numerous wildlife documentaries, media appearances and interviews, being a Nikon Ambassador, and producing award-winning images that have appeared in publications and galleries around the world. He was a regular on the Spanish-language variety program *Sabado Gigante* for over two decades and hosts the television series *Mundo Salvaje con Ron Magill.* He has been the face of Zoo Miami for over forty years, serving as communications director and pushing his on-the-ground conservation agenda forward through the Ron Magill Conservation Endowment.

Preface

My first experience with Florida's animals was as a college kid packed into the back seat of a van filled with students on a zoology class field trip. It was spring break 1997 and we'd just driven straight through the night from Indiana. A few heads lifted groggily from pillows as we passed the Florida state welcome sign, but most remained buried beneath blankets. There was a stretch here and a yawn there as dawn broke, but the mood remained lethargic—until the brakes screeched.

Heads jerked to attention as our herpetology professor suddenly whooped, "It's a diamond-backed rattlesnake!"

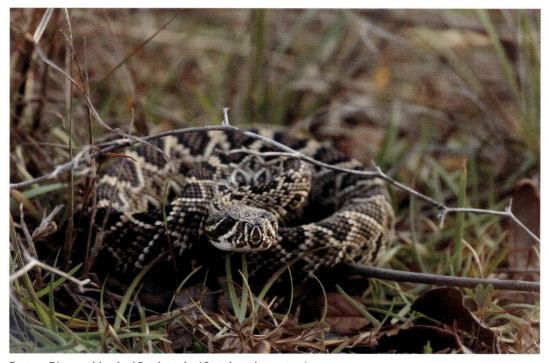

Eastern Diamond-backed Rattlesnake (*Crotalus adamanteus*)

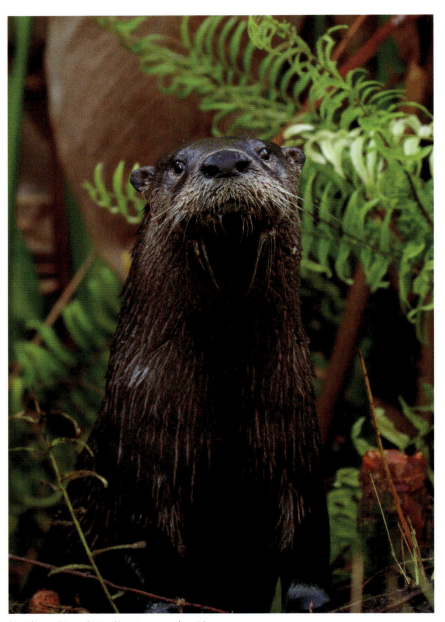

Northern River Otter (*Lontra canadensis*)

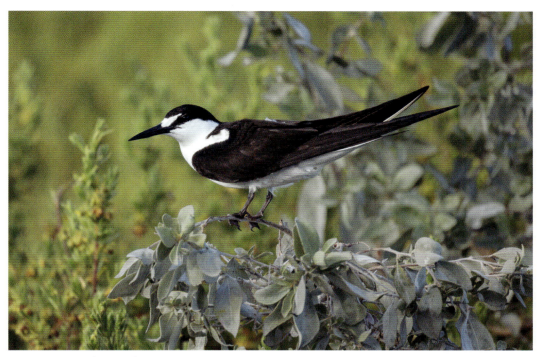

Sooty Tern (*Onychoprion fuscatus*)

Eyes widened and knuckles whitened as he reversed at high speed back up the highway, weaving around oncoming cars and abruptly halting on the shoulder. He swung open the door leaving the engine running as he raced to the middle of the lane and scooped up the writhing animal with a snake stick. He returned smiling, seemingly oblivious to both the annoyed drivers and the disconcerted rattling of the snake he'd just rescued from the road. Thus began my animal odyssey in the Sunshine State.

That trip influenced the course of my life. I decided that I too wanted to be a biologist, a herpetologist even. I moved to Florida, the state that had captivated me with its warm weather and animal adventures, though at the time my interest in Florida had more to do with its proximity to the "true" tropics. I'd grown up in the Philippines and those college winters in Indiana had set my sights solidly on the equator. I settled in Miami for graduate school studying poison dart frogs in Costa Rica and rock iguanas in the Bahamas. I had no real intention of staying in Florida, but I began assisting fellow graduate students with their Florida-based animal studies. I

Preface · xiii

conducted plant surveys for a local not-for-profit, taught environmental education at a seaside nature center, and began to appreciate the state's diverse ecology. The more time I spent in Florida's natural areas and the more I learned about its environment, animals, and plants, the more it captivated me and shifted my interest away from distant tropical lands and to the state that has become my home.

Florida and its animals are like no other. Its temperate north is similar to the rest of the southeastern United States, while its southernmost islands and coasts resemble those of the Caribbean. Animals found widely across North America such as raccoons, white-tailed deer, bobcats, and black bear live in Florida. But Florida is also the only place in the continental United States where tropical birds, such as Masked Boobies, Sooty Terns, White-crowned Pigeons, Snail Kites, and Magnificent Frigatebirds, nest. In Florida alone, American alligators at the southern edge of their distribution across the southeastern United States coexist with American crocodiles at the northernmost edge of their neotropical distribution. Florida's unique blend of native tropical and temperate species has intrigued naturalists, collectors, and adventurers since Europeans first encountered Florida in the 1500s. This fascinating blend

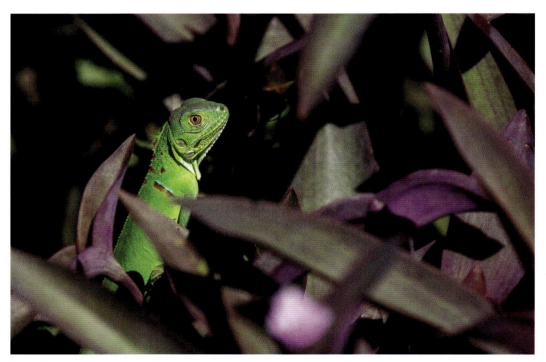

Green Iguana (*Iguana iguana*)

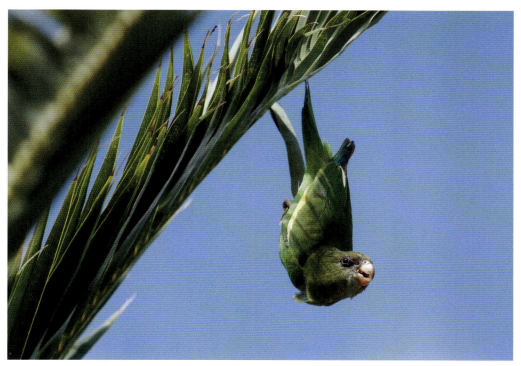

White-winged Parakeet (*Brotogeris versicolurus*)

is what drew me to Florida and continues to draw millions of people annually to the state's parks and nature reserves.

But people also come to see the numerous nonnative species that now call Florida home. I remember well my first few weeks of graduate school in Miami, walking across campus with a reptile identification guide in hand and discovering that most of the lizards I encountered were species introduced from elsewhere. There were brown and knight anoles from Cuba, Puerto Rican crested anoles, and Central American basilisk lizards. Reptile enthusiasts travel thousands of miles to Florida to bolster their life lists with such geographically disparate species as African agamid lizards, South American tegu lizards, and Asian tokay geckos on just one trip. Similarly, birders come to add Egyptian Geese, South American parakeets, and Asian bulbuls to their life lists. Florida is both a national and global leader when it comes to nonnative species. Red-eared slider turtles originally from the Mississippi Delta are now scattered in ponds across the state, Central American green iguanas line bodies of water in southern Florida's coastal communities, flocks of South American

Preface · xv

macaws shriek across Miami's skyline, and Asian Burmese pythons occur throughout the Everglades and continue slithering northward despite extreme management efforts. These species and more are here to stay and so have insinuated themselves into the list of animals to be seen in Florida, often more prominently than the native species.

While this is a somewhat depressing reality for environmentalists such as myself, the truth is that faunal change is inevitable. The assortment of animals living in Florida today is different from what it was at the time of European contact, a somewhat arbitrarily chosen measure that defines what we now consider to be native. At that time, when Indigenous People such as the Timucua, Apalachee, and Calusa lived off the land and waters, there were still Caribbean monk seals, a black subspecies of red wolf known as Florida wolves, and Dusky Seaside Sparrows, animals that have since been lost to extinction. But these were not the first animals to have been lost from Florida. Over 10,000 years prior, before the Everglades had even formed, Paleoindians hunted giant sloths, mastodons, dire wolves, and saber-toothed cats, animals I can scarcely imagine roaming the peninsula today.

Environmental change has long been a driver of faunal change, but what's worrisome today is how rapidly these changes are happening, mostly at human hands. Some animals have coped with these changes, finding urban parks and golf courses to be sufficiently similar to their natural habitats. Others, finding the altered landscape conducive to their needs, have increased in population and expanded their ranges. But for many animals, these changes have been devastating. Animals dependent on Florida's specialized habitats find their homes reduced to tiny patches. Add to fragmentation the pressures from human-introduced nonnative species, pollution, and in some cases hunting or collecting, and it's only because of human intervention that we haven't lost more of Florida's animal species.

Humans caused the near disappearance of alligators and crocodiles from Florida in the early twentieth century, but it was also humans who orchestrated the remarkable recovery of both these reptiles to their current healthy population numbers, proving that we can mitigate some of the human-caused changes. Biologists, resource managers, zoo personnel, and private citizens work together to control invasive species and protect native threatened species. Every piece of land, both private and public, from backyard gardens to national parks, provides vital habitats that support Florida's animals from the small Atala butterfly on a garden coontie to the wide-ranging Florida black bear roaming through a state forest.

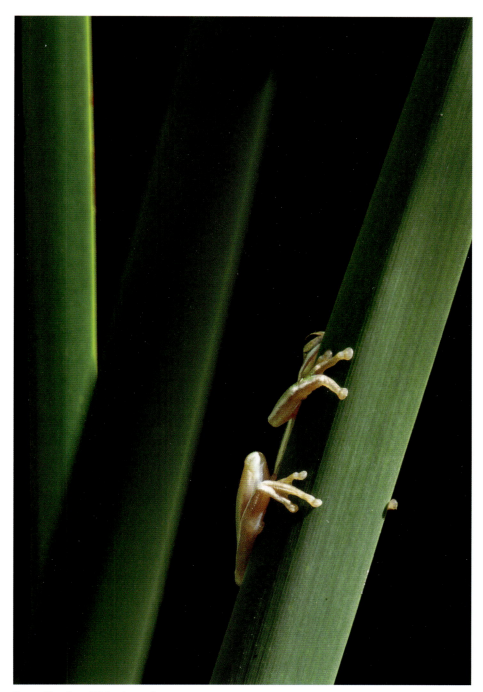

Green Treefrog (*Hyla cinerea*)

The number of animals that call Florida home is nothing short of astounding. This book is a celebration of that diversity, highlighting a representative selection of mammals, birds, reptiles, amphibians, and invertebrates from all around the state. It is my hope that the images and stories in this book will not only provide an intimate look at Florida's wildlife in the early twenty-first century but will also inspire Florida's residents and visitors to explore, appreciate, and act on behalf of the state's nonhuman residents.

Approach

As a biologist, my job was to find stories in numbers. Armed with tape measures, scales, nooses, nets, sound recorders, a frog treadmill once, and always data sheets, I set out into the woods to quantify a narrow piece of the world. But as I ran transects for plant surveys across Florida marsh, I'd find myself distracted by peeping hatchling Red-winged Blackbirds in their carefully woven nest. In the Costa Rican rain forest as I walked between strawberry poison frog acoustic survey points, I'd find myself wandering after a howler monkey troop or an unexpected vested anteater. In the Exuma Islands of the Bahamas as I sat poised with my pen to record the next iguana egg weight, I'd find myself preoccupied by a curly-tailed lizard scampering across the sand. I enjoyed nothing more than hanging off the end of an airboat at night to pluck pig frogs from atop shadowy Everglades waters or bellying beneath thatch palm thickets in the Bahamas, sneaking ever so slowly toward an Allen Cays rock iguana to slip a noose around its neck, catching these animals to be weighed, measured, and marked for research.

Nothing felt more alive to me than being deep in the woods, surrounded by nature in its full glory, but I struggled to focus on just one piece. And while I was always pleased to learn the story our numbers told, the process of tediously entering them into a statistical program was somewhat less inspiring. I felt constrained by the necessarily objective style of scientific writing that failed to convey my enthusiasm and would likely never be read beyond the realm of academia. So I backpacked around Australia after completing my master's degree in biology to seek a new path that would keep me immersed in nature and contribute to its preservation. It was an unscripted journey that eventually meandered across eleven countries and three continents over a three-year period, during which time I discovered a different means of storytelling—creative writing and photography.

I may have traded my iguana-catching noose for a camera, but my goal is still conservation, and I have most definitely not abandoned biology. I rely on knowing animal behavior to find my subjects, to understand when and how to approach them,

when to back off so as not to disturb, and when to have my camera at the ready for an upcoming action shot. I rely on all my years of experience sneaking up on animals for mark-recapture studies to help me now as I inch through the woods for a more intimate view or better camera angle. With few exceptions, my shots are taken handheld because tripods impede my lurking habits. I've also never gotten into remote cameras. While I admire their utility in capturing nocturnal and elusive species, I prefer to share moments in the wild with the animals, to better understand my subjects, and to experience the serendipitous moments that so often best capture an animal's character.

The stories and photographs in this book are the result of my thousands of hours of solo wandering or sitting silently, waiting, and watching for just the right moment to capture unposed wild animals in their natural environment. I've learned many lessons from these interactions I've been fortunate to have. For those animals too rare or imperiled to happen upon organically, I relied on the guidance and company of experts with appropriate permits and an intimate knowledge of the species to ensure animals weren't harmed in any way. I also delved deeply into the literature to ensure historic and scientific accuracy of my facts, choosing to follow standardized nomenclature where available. Bird names, for example, follow the internationally accepted Birds of the World database, which dictates capitalization of common names. All of these sources informed the biological and conservation insights I share in photo-illustrated essays. Longer thematic essays explore overarching concepts I've come to appreciate as I've explored Florida's diverse fauna and its conservation. Interspersed between are species-specific essays. Some of the stories and images are intimate portraits, some reveal behavior or biological insights, others are of a more emotionally interpretive artistic style, but all are intended to reveal something special about Florida and its incredible world of animals. My goal is to share my passion and understanding through words and images, to take my audience alongside me on an odyssey into Florida's natural areas.

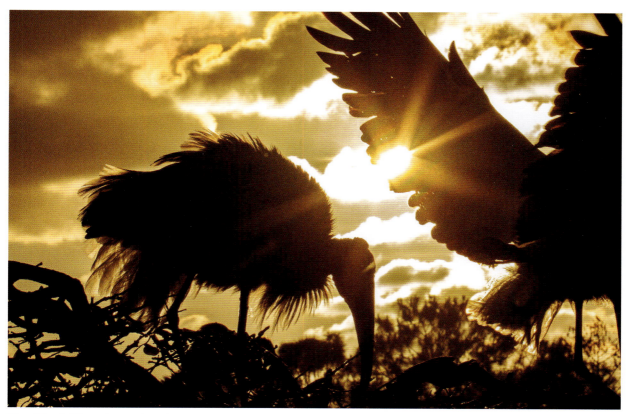

Wood Stork (*Mycteria americana*)

Native

A wave crashes onto the shore. I listen as pebbles tinkle across the sand, carried by foam returning to the sea. Darkness reigns except for reflections from the moon shimmering along cresting waves. I watch the dancing moonlight as it draws a line down the arcing water; but then a disruption. A dark dome emerges from the sea, its curves glisten as moonlight pools atop its smooth surface. It draws near, riding the water up the beach and resisting its tug back into the sea. The dome looms large, a commanding presence even as a shadow in the night. Flippers fling grains of sand into the air and a mother loggerhead sea turtle moves forward. She toils up the beach, persevering past the high tide line in her quest for a safe nesting spot.

This is an animal whose ancestors roamed the earth alongside dinosaurs a hundred million years before modern Florida formed. Sea turtles were among the first to leave tracks on Florida's natal sands, laying eggs that no doubt helped feed the peninsula's first Indigenous Peoples as did their susceptible mothers whose bones appear in middens, and whose carapaces were used in ritual context. With a little less reverence, early European mariners stacked sea turtles upside down in their ships for a long-term supply of fresh meat, a practice memorialized when Juan Ponce de Léon named the Tortugas after this provision in 1513, creating the second-oldest persistent place name in North America, older than all but La Florida itself. Pioneer settlers all along Florida's coast also harvested nesting sea turtles and their eggs for personal consumption. Early commercial fishing industries in Key West, Indian River Lagoon, Lake Worth, Cedar Key, and Crystal River revolved around green sea turtles, that is until they were harvested to economic extinction. All sea turtle species are now protected. The fact that I can sit and watch sea turtles nest on Florida beaches today is a testament to their population recovery. On the night I watched that Jurassic shadow emerge from the sea though, the point that struck me most was that these ancient animals predated the very beach I sat upon. Atlantic loggerheads evolved alongside the changing Florida landscape, a Florida native species for as long as there has been a Florida.

Sea turtles are not the only animals to have coevolved with Florida's lands. At the maximum of the last ice age when sea levels were lower, the peninsula wider, and climate drier, animals adapted to this more xeric environment ranged all the way from California and Mexico across the Gulf Coast states into Florida. Sea levels then rose and landscapes altered, erasing the biological connections between Florida and the arid environments of the North American southwest to separate populations of gopher tortoises, Burrowing Owls, Crested Caracaras, and scrub jays, which then adapted in isolation to Florida's ever evolving climate and habitats. The Florida Scrub-Jay diverged enough to be considered a distinct species—Florida's only endemic bird species. A type of widow spider also infiltrated the state during low sea levels but became stranded on upland dunes when waters rose, evolving into the red widow spider that now occurs only on scrub habitat along ancient sand ridges in central and eastern Florida. It feeds primarily on specialized scarab beetles that also persist in this particular habitat and occur nowhere else in the world.

Similarly, the bluffs, ravines, and seepage streams of the Panhandle and the rocklands of southeastern Florida and the Keys are other uniquely Florida habitats that

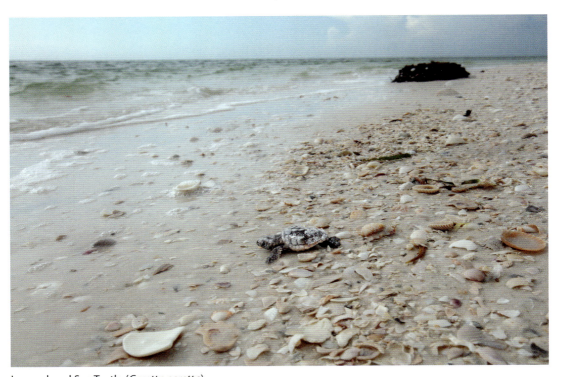

Loggerhead Sea Turtle (*Caretta caretta*)

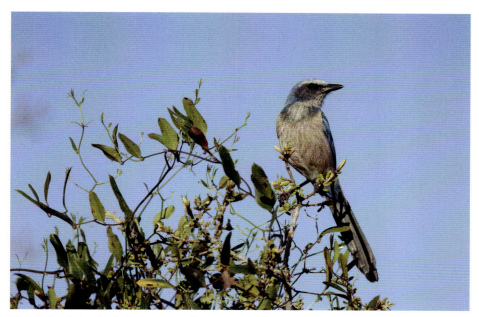
Florida Scrub-Jay (*Aphelocoma coerulescens*)

animals have evolved with. The Florida crowned snake, rim rock crowned snake, short-tailed kingsnake, Florida sand skink, Florida wormlizard, Florida scrub lizard, Florida bog frog, Florida bonneted bat, Florida mouse, and many insects and other invertebrates have all adapted so specifically in their isolation that Florida is now the only place they call home. These hundreds of endemic animals evolved alongside Florida's landscape over hundreds and thousands of years, creating a native fauna that ranks the state fourth in the nation for endemism.

Terrestrial animals, such as bears, panthers, deer, and toads, followed land routes from North America into Florida's peninsula, some of these also becoming isolated from their mainland counterparts to evolve into populations sufficiently distinctive to be considered subspecies—the Florida black bear, Florida panther, and Key deer, for example. Tropical species from the West Indies swam, flew, or were blown across the sea to establish populations in Florida of American crocodiles, Geiger tortoise beetles, Atala butterflies, land crabs, tree snails, and Roseate Spoonbills, to name a few. Some of these also specialized into distinctive subspecies such as the Florida manatee, and the endangered Miami blue and Schaus swallowtail butterflies, adding to Florida's inventory of native animals.

Native migratory animals have also molded their lives around Florida's lands over prolonged periods of history. Piping Plovers breed in the arctic summer but spend the winter on Florida beaches. Ruby-throated Hummingbirds, hoary bats, and green darner dragonflies are other examples of animals that spend the summer in temperate North America and retreat to Florida for the winter. Using a reverse strategy, Gray Kingbirds and Swallow-tailed Kites spend their winters in the Caribbean, Central and South America, arriving in Florida to nest through the summer. And there are hundreds of other animals, primarily birds and insects, that pause only briefly in Florida to rest and refuel on their seasonal journeys back and forth between temperate and tropical climes. These are patterns that evolved over millennia, contributing to Florida's diverse list of native species.

So, one might wonder, is the test of time what makes a species native? While that's often a large part of the equation, it's not the full answer. The idea behind the term *native* is to distinguish nature's blueprint unimpeded by human meddling. It's meant to discern those species that populated Florida on their own. The time of European contact is widely accepted as the measure in North America with species already present at that time considered native. But the environment continually changes, so complexities abound. A species of armadillo, for example, appears in Florida's fossil

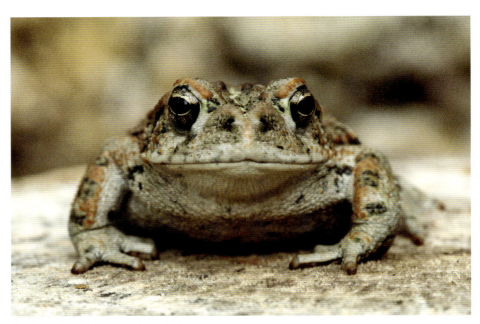

Southern Toad (*Anaxyrus terrestris*)

4 · *Wild Florida*

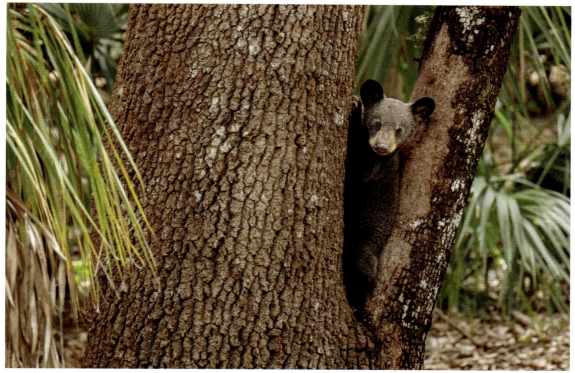

Florida Black Bear (*Ursus americanus floridanus*)

record but was extinct at the time of European contact. In the 1920s, an armadillo native to the southwestern United States but not previously documented in Florida was introduced by humans to the state, which should've classified it as a nonnative species. However, that particular armadillo also expanded its range independently, spreading both north and east to make it into Florida on its own, an accomplishment that deserves native status. In this case, the armadillo's place on Florida's list of native animals is further reinforced by genetic studies suggesting that this modern species of armadillo is in fact no different than the one that originally inhabited the peninsula.

With or without fossilized credentials though, the fact is that some animals make it to Florida on their own. Coyotes, Cattle Egrets, and Cave Swallows are other examples of animals that have independently expanded their ranges to include Florida, finding our modern landscape of suburbs, cow pastures, and bridges sufficient substitutes for the natural habitats they evolved with in their original homelands. These too are now Florida natives.

Florida also receives vagrant animals, occasional unscheduled visitors on generally short stays—a Buff-bellied Hummingbird that wandered beyond Louisiana or a Bahama Mockingbird that crossed the Florida Straits. Bananaquits, Western Spindalises, and Cuban Pewees are increasingly common West Indian visitors to the Florida Keys. These are birds that might one day establish breeding populations in Florida. Neotropic Cormorants from South America, for example, were once transient visitors but now regularly nest in southeastern Florida.

As human development and climate change continue to alter Florida's landscape, we can expect our native faunal community to change and perhaps adapt as they have over thousands of years. But drastic changes are happening so quickly that we need to pay particularly close attention to Florida's native species, especially those that evolved slowly over time to be precisely specialized to the state's unique environment. These are the animals that make Florida different, and they rely on the habitats that make Florida different—habitats that are all too rapidly changing through human

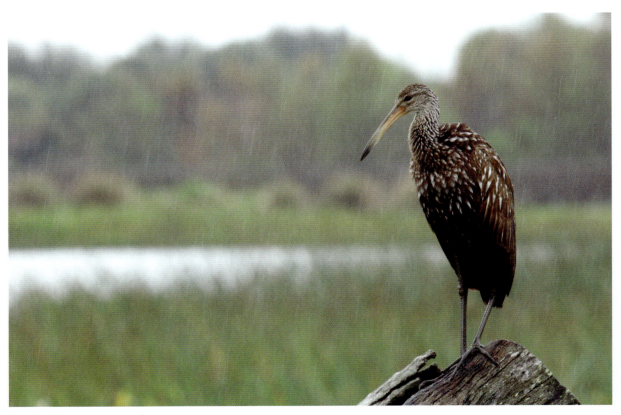

Limpkin (*Aramus guarauna*)

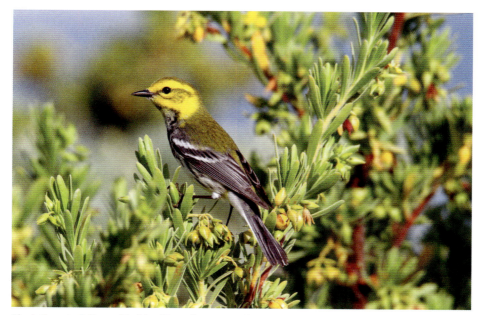
Black-throated Green Warbler (*Setophaga virens*)

influence. The fact that our lands are now conducive to new native animals, such as Cattle Egrets and red fox, is an indication of how much we've altered the landscape. So while Florida welcomes native newcomers, we as the enablers shouldn't neglect nature's pre-Columbian blueprint. In this time of global homogenization, should we not strive to maintain Florida's diverse blend of temperate and tropical, permanent and transient native animals? Florida's native species are what make Florida special.

Red Widow Spider (*Latrodectus bishopi*)

It's July, nowhere near the late winter timeframe my research has led me to believe is required for finding red widow spiders. There's also no fog, reportedly essential for turning invisible webs into dew-drenched silvery blankets that would guide me to spider-hosting palmettos. Still, the requisite sand pine scrub at the Seabranch Preserve State Park is beautifully maintained and perhaps the overcast sky can substitute for fog; what do I have to lose? I diligently scan not just the palmettos but every plant I pass along the trail. I notice a low scrub oak ensnared in a tangle of webs. I step closer, seeking structure within the threads. I find a funnel and draw my face closer, peering deep into the shadows where a perfectly round white woven sac hangs from a weft of leaves. A blur of red appears from behind the sac and I'm staring into the eight seemingly angry eyes of a mother red widow spider defending her egg sac. I jerk back, my adrenaline pumping as much from the fact that I've found this rare endemic spider as by the speed of her appearance. The fact that her venom is likely as noxious as that of the related black widow does race across my mind, but there are no records of a red widow spider biting a person and I suspect, like most spiders, it would be unlikely to do so without me grabbing it. Nonetheless, I move back to give her space.

Once I know what I'm looking for, I find mazes of webs across every other oak as well as the occasional palmetto. Some mothers tuck behind their egg sacs at my intrusion, others ignore my presence and stay in place, and others, like that first, charge, the full glory of their warning colors signaling their authority. I don't challenge that authority, and in exchange I'm permitted an intimate view into their lives. One mother pounces upon a freshly caught scrub palmetto scarab beetle, another Florida sand scrub endemic whose importance to the diet of the red widow spider is thought to limit the spider's distribution. Another mother tends her brood of already hatched young, standing guard as they spread like miniature rubies about the entrance to her lair. A pair of hikers pass me on the trail as the sun finally emerges from behind the clouds; they're completely oblivious to the arachnid gems sparkling in the bushes along the trail.

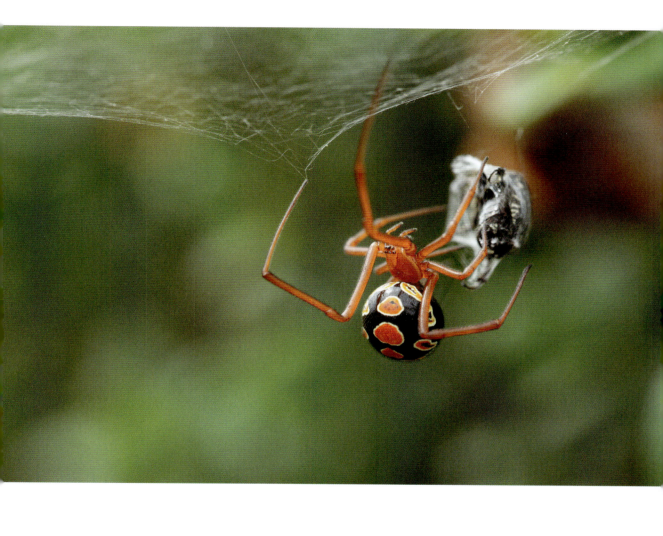

Black Vulture (*Coragyps atratus*)

Eerie shadows haunt a blanket of fog. Something flaps to my right, then to my left. I turn from one sound to the next, spinning in circles as the cacophony grows. Dark shapes shift in the branches above. I inch out of the forest along the boardwalk heading toward the Suwannee River. A shroud of clouds blurs the scene and the only thing I see is a row of vultures lining both sides of my walk, fading into the fog. I feel trapped in a modern rendition of Hitchcock's *The Birds*. I slowly step forward. The two closest vultures take to the sky. Another step, another two birds fly. The ominous raptors abandon their posts two at a time as I approach, but settle again once I pass. Emboldened, I continue. The remaining flock lifts, swirling briefly into the air, before returning to the rails.

I make my way down to the dock, entranced by the view. The pilings are living totem poles, ever-shifting masterpieces of poised, displaced, and repositioned vultures.

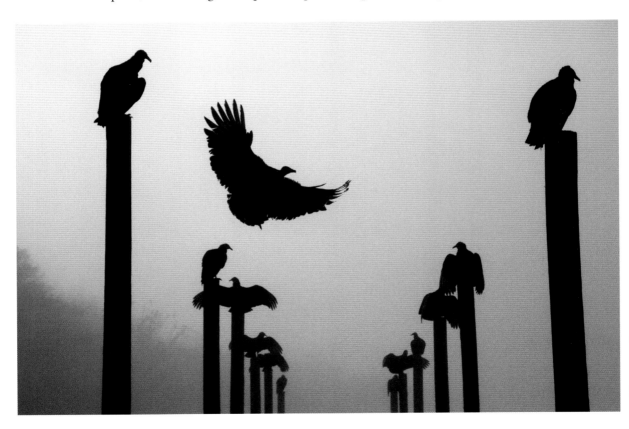

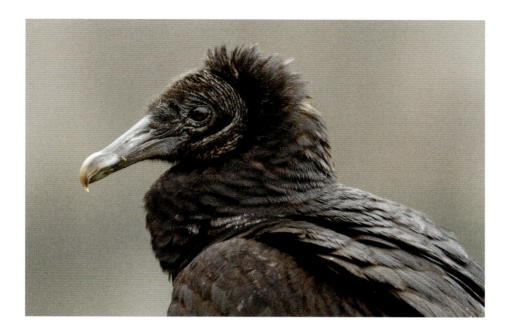

I sit on a nearby bench to watch, and a Black Vulture lands on a railing beside me. The bird sidles closer. It turns its head in my direction, and I feel as if it's looking me up and down. A second vulture joins the first, then a third and a fourth. Still more join and I find myself seated in a circle of birds.

One of the vultures drops to the floor in the center of the ring. It puffs out its feathers, takes a few small hops, then gazes up at the audience. A second vulture drops to the floor and the first charges. They nip, bat, and chase, then one returns to the rail and another bird drops into the arena. I don't understand the rules of engagement, but I'm reminded of Roman gladiators. The show continues until the sun peaks through the fog. As if responding to the same ray of sunshine, all the birds—the fighters, the audience, the totems, and the boardwalk liners—all spiral into the sky.

I'd always thought of vultures as solitary, but I realize I was wrong as I watch my companions go. It turns out Black Vultures often mate for life, spending all year with their partner and maintaining long-term bonds with other familial relations. Perhaps the jostling totems and gladiator displays were simply the bickering and hooligan play that might be expected at any reunion.

Native · 11

Eastern Newt (*Notophthalmus viridescens*)

Disco balls of floating vegetation on the water's surface hide a party below. The smooth skin and newly ruddered tails of metamorphosed adult eastern newts signify their readiness to tango. Costumes donned, the males begin the soiree. As if trained by belly dancers, the beat begins at their heads and shimmies down their bodies, undulating one section at a time until a grand swishing of the tail initiates another wave from the top. An interested female can stop the show, tapping the performer's tail to receive a spermatophore package for her eggs, but not all males are so lucky. If the so-called hula display does not suffice, the dance takes on a more frenetic tone. One dancer, maybe even two or three, will claim a single female, holding on tightly from above with his hind legs. He swishes her back and forth, fanning his scent to her with his tail while stroking her cheeks with his front legs. If she still does not cave, he dismounts, gyrates, then lays his sperm package before her in the hopes that she'll accept his goody bag. These aquatic parties occur in the same ponds, canals, streams, or swamps where the participating newts were born. What's interesting though is that there are two subspecies of eastern newt in Florida, and beyond these parties, their life histories differ. Newts across the northern edge of the state spend a couple years as terrestrial efts, orange teenagers that shift to an olive tone, like the one I photographed, when they reach adulthood. Peninsula newts from the rest of mainland Florida, however, lack this eft stage. Many spend their entire lives underwater, sometimes retaining their childhood gills into adulthood.

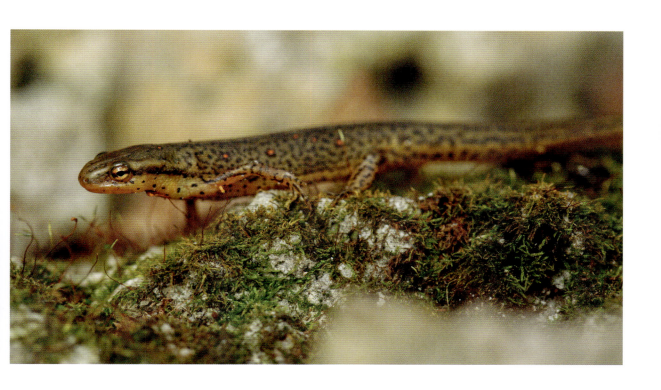

Florida Panther (*Puma concolor coryi*)

It starts with a shadow—glowing eyes and the faint outline of a large cat just beyond the reach of my headlights. A few days later something more tangible—a long tail twitching from taut muscles fully spotlit and close enough to touch if I weren't keeping up with traffic on Tamiami Trail. A mother and two kittens on an early morning stroll in the Fakahatchee Strand. A lone male on another day, and glimpses of solo cats on two others, both silently slipping into the forest before I fully register their presence. How can it be possible that I've seen seven wild Florida panthers in less than two years? This would've been incomprehensible a mere decade ago.

When I moved to Miami in 1998, a friend told me on my first visit to Everglades National Park that the panther crossing signs were mere tourist attractions. He was

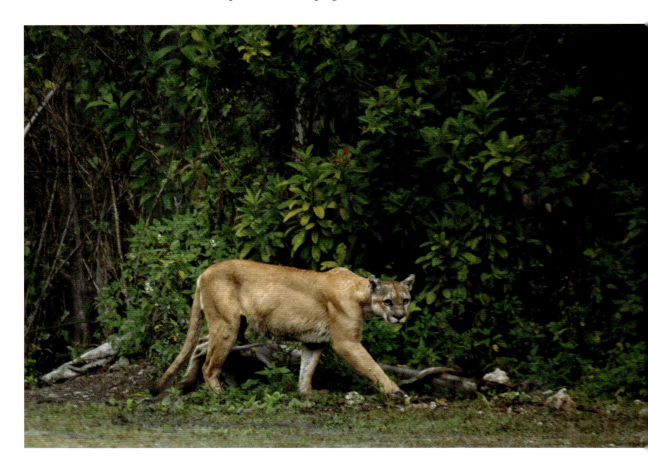

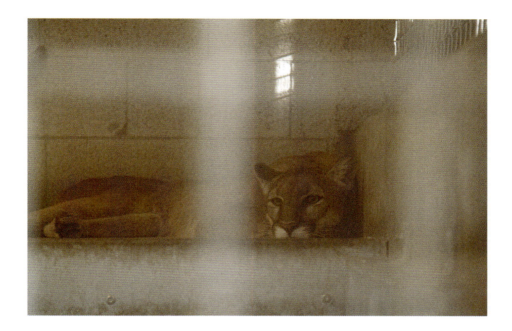

joking, but not about the ridiculousness of thinking one might actually see a wild panther at that time. Three years prior, less than fifty Florida panthers were estimated to remain in the wild. At the time of my friend's joke, there were likely still fewer than seventy and that included up to eight female Texas cougars that had been released into the Big Cypress Swamp in an attempt to resurrect the Florida panther from imminent extinction.

The introduction was controversial at the time, opposed even by some panther biologists who worried about maintaining the subspecies' genetic purity. Others worried that the gentle, timid character of Florida panthers would be drowned out by the Texas cougar's more aggressive nature. When I ask Deborah Jansen, the wildlife biologist at Big Cypress National Preserve who was involved from the beginning of the recovery effort, she smiles and shakes her head, "Only in that they were finally healthy enough to defend themselves again." Apparently the few remaining individuals, plagued with such genetic disorders as faulty hearts and undescended testicles, had become too weak to even resist capture. There's no doubt in Deborah's mind that Florida panthers would no longer exist in the wild had those Texas cougars not been brought into the genetic mix. But she's equally certain that the fight isn't over yet. As the population recovers, the panthers need more space.

Conservation lands were set aside for this purpose around the Big Cypress population core, but even these tracts are divided by highways, new developments continue to spring up between the reserves, and the panthers have already moved north of these original protected enclaves. It's not unheard of for homeowners in southwest Florida to find panthers sitting among the potted plants on their patios or napping in the shade of their trampolines, and sightings are increasingly common in Central Florida. I've seen panther tracks in Palm Beach County, and there have been reports of animals nearly as far north as St. Augustine. Are there enough large tracts of undeveloped land to support them as they expand northward? And what about all the highways? Vehicular accidents have been the leading cause of panther mortality over the last twenty years or so. The captive animal in the photograph on the previous page is Mahala, a panther orphaned as a baby by one of these highway accidents and as a result is now living her life at Zoo Miami.

People have gone to great effort to salvage Florida's state animal from the shadows, but more is needed to keep it in the light. Panthers are a species for which the Florida Wildlife Corridor, a project designed to connect the state's network of reserves into contiguous wildlife habitat, combined with highway safeguards such as fencing and underpasses, is essential. It is one of those species that will require human tolerance as it learns to accommodate to our world, and we learn to accept its majestic presence among us.

Florida Watersnake (*Nerodia fasciata pictiventris*)

The limbs of a bushy cypress appear alive from a distance. Brown ribbons coil and undulate as I approach the water's edge. Even standing before the writhing mass, it takes a moment to interpret the scene. A large female Florida watersnake, just coming into her spring breeding, intertwines within the smaller bodies of interested males. One head. Two heads. Three heads, four. I count as the suitors surface from the twists. One extracts itself, slithering down a branch to disappear in the foliage. Another follows, and yet another grows bold, traveling along the female's neck, wrapping his tail around her head as the last of his competitors admit defeat. Knowing the victorious male will spend the next hour or so wooing his dame, biting her neck to position her tail just so, I decide to take my leave and give them their privacy.

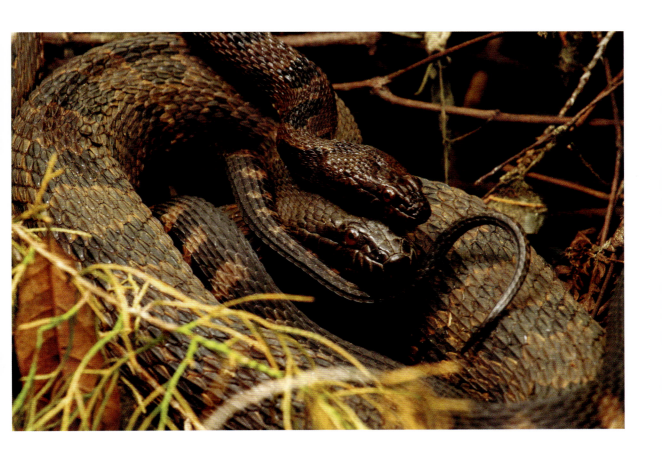

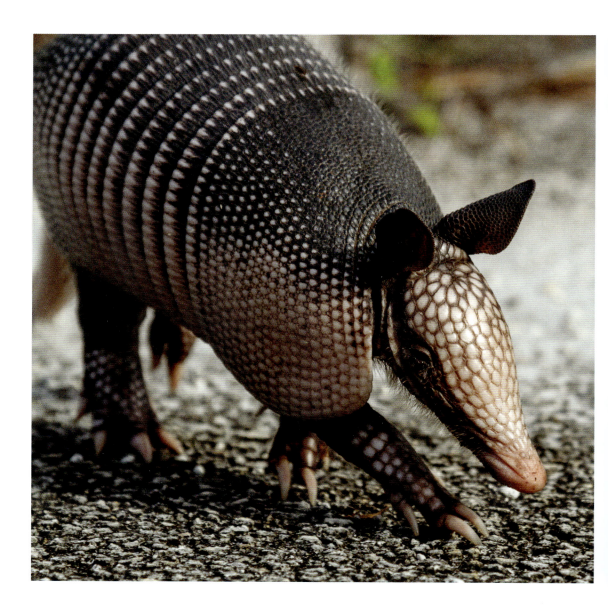

Nine-banded Armadillo (*Dasypus novemcinctus*)

Dense grasses along the fence line of a Central Florida ranch move quickly and erratically. Stems swerve from side to side, the motion maintaining forward momentum through adjacent blades. It has to be an animal. I kneel at a break in the vegetation, waiting for the source of the movement to erupt from the greenery. It's an armadillo, old enough to be independent but young enough not to be fully grown. It sniffs its way along, so intent on scenting worms, grubs, centipedes, and other tasty morsels that it doesn't notice me. It veers in my direction, pausing in my shadow to sniff at my bare ankles. Still, it fails to acknowledge the rest of me looming above. Is it younger than I think? Has it learned predators exist? It's small enough to cup between my palms, and I want to pick it up and protect it from the world, yet I know if it is indeed that young, mom and its three identical siblings are somewhere nearby and my touch will do no good. Instead, I watch it return to the fence, jostling a row of grasses as it disappears.

This wasn't the first time a nine-banded armadillo gained my affections. The previous one had been an adult. I'd watched it dig beneath a saw palmetto for several minutes when all of a sudden, it stepped onto the pavement and walked directly to my bent knee. It stood up on its hind legs and lifted its face to within inches of my own. "Is that your pet?" a woman had asked from across the way. Much as I wished the armadillo's act was one of endearment, I knew better. Furnished with poor eyesight, neither of these animals likely really saw me. The young one hadn't acknowledged my human scent, but the adult had risen for a better sniff. It didn't deem me a threat as it opted against using its tactic of jumping several feet into the air to startle me, but neither did it consider me a friend. It dropped back to the ground, altered course, and disappeared within the next patch of saw palmettos, no doubt in much the same way its now fossilized conspecific ancestors had when they roamed Florida's ancient lands.

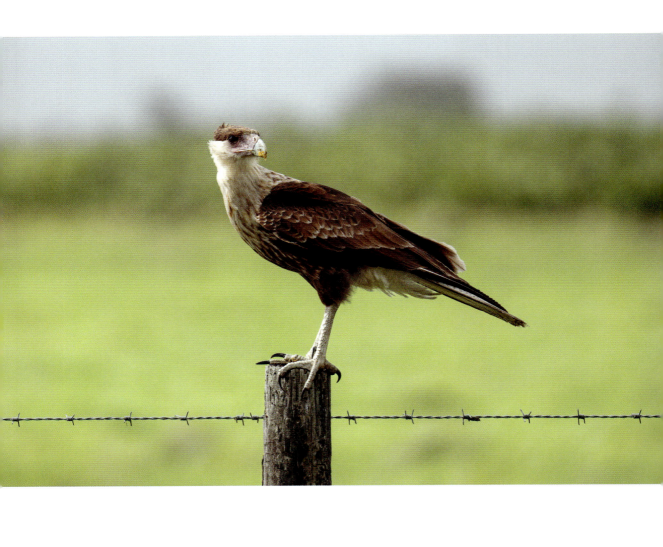

Crested Caracara (*Caracara plancus cheriway*)

A bird pops into view from within tall grasses at the edge of a ranch meadow. It jumps high, appearing to pounce as it returns to the ground with talons outstretched. It seems to fumble, then pounces again. A second bird appears, swerving through the grass while hopping this way and that, herding something toward the first bird. The first bird, smaller, shaggier and with paler coloration than the first, jumps into the air again. A small mammal leaps briefly into view as it escapes talons, then appears again as the larger bird blocks its passage. The larger bird has the bold coloration of an adult Crested Caracara, blue transitioning to pink from the tip of its bill to its eye. I realize this is a parent teaching its young to hunt. The ranches and agricultural fields of Central Florida are apparently an adequate substitute for its native prairie, the same habitat Crested Caracaras use across their range in the Caribbean, Central and South America. It's a widely distributed bird within the region, but the population in Florida has been separated for millennia—an ancient pocket passing the same hunting traditions on from one generation to the next despite the isolation.

White-tailed Deer (*Odocoileus virginianus*)

A grackle appears to float through tall prairie grasses, but its wings are by its sides and its neck is curved downward. Its transport finally appears from the veil of greenery, a white-tailed deer whose neck is also curved downward in synchronous feeding. I'm reminded of African savannahs where oxpecker birds ride along to pluck insects from cape buffalo and other beasts. It makes sense that a similar relationship would happen here in Florida, yet this is the first time I've seen this behavior despite having watched deer all over the state. I've seen deer on beach dunes, in cypress swamps, in pineland forests, in fields of yellow flowers, and curled on a yard lawn in the pouring rain. I've been chided by their warning snorts early in the morning, a clatter of hooves zigzagging away as I watch the white flags of their tail signal retreat. I've been startled by the sudden emergence of a fawn from a nearby palmetto after I'd been silently watching birds nearby for several minutes. It'd been well hidden and had followed its defensive instinct to stay motionless and undetected, but I had lingered too long; the fawn sensed danger. We stared at one another several moments, then it bounded off into the woods to find a new hideout. I've watched a pair of young sibling males spar with their fresh antlers, first appearing to cuddle as they stood neck to neck but looking rather less loving when one caught its sibling around the neck with its spikes, sending the other's hind legs into the air as it tried to twist free. Back in the prairie, the deer and grackle both look in my direction, then the grackle takes flight and the deer bounds away, its white tail beckoning other deer to emerge from their grassy cover to all vault toward nearby trees. Common and ubiquitous in Florida's wilds, this is an animal not without surprises.

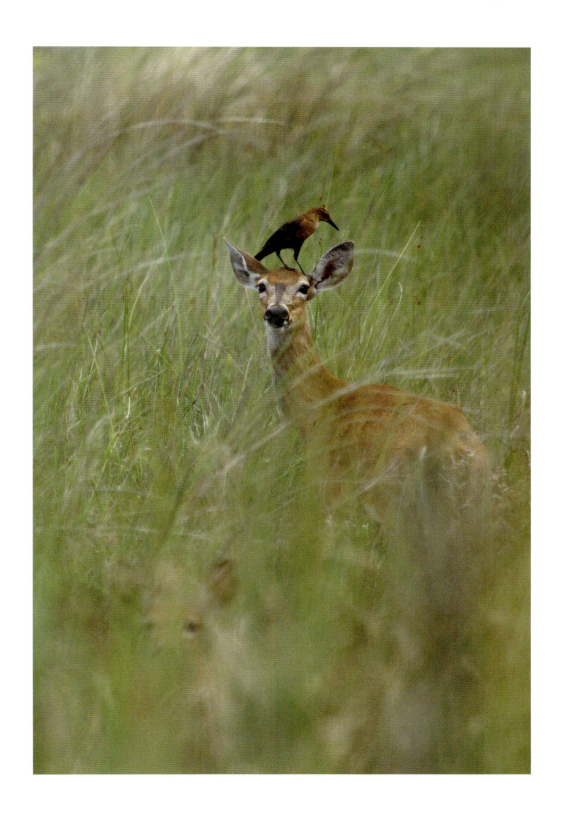

Florida Sand Skink (*Plestiodon reynoldsi*)

Squiggly lines across powder white sand on an ancient dune. It means little to me and my fellow college students on our first Florida field trip, but our professor knows exactly what it means. He races up the slope, dives to his knees, and frantically digs. We watch in amazement as he turns and lifts his cupped hands toward us, sand slipping between his fingers as we crowd in to see his prize—a silvery gray reptile nestled in his palms. Shoveled nose, no external ear openings, transparent lids shielding tiny eyes, and miniature legs that tuck neatly into grooves along a sleek slender body, all equip the Florida sand skink for life within the earth. It's a life that keeps this animal off most people's radars. They're rare enough that I doubted I'd be able to photograph one for this book, but the staff at Archbold Biological Station made my unspoken dream a reality. The Station protects over 5,000 acres of optimal sand scrub habitat, an increasingly rare haven for many endemic species like the sand skink, but protection requires vigilant management. On the day of my visit, a team was weeding out nonnative invasive plants as part of this effort. An intern on his very first day in the field discovered a skink in the roots of one of the plants he'd just pulled. He had the speed and foresight to capture the animal and, as permitted for educational purposes, his supervisor graciously held it long enough for my photography. This was my second sand skink and my first opportunity for intimate study. I watch its little legs propel it through the shallow sand on the bottom of the tub as if it were swimming. When released back to the sand where it had been captured, the skink squiggles out of sight at lightning speed. It's a sand swimmer, appropriate for a lizard found only on Central Florida's ancient dune ridges, a living reminder of the seas that left these shores long ago.

American Flamingo (*Phoenicopterus ruber*)

Snapping shrimp pop their presence in the mangroves off Sugarloaf Key as my paddle slices through glass-like water. It's a tune that often lures me to explore the animals dwelling within this tree's protective roots, but today I'm more interested in a bird lured to the crustaceans in this nursery community. The unmistakable outline of a flamingo contrasts with the pale blue waters before me. The bird bobs up and down as its long legs peddle, stirring the mud below. It dips its elegant neck, submerging its bill to filter food. I wedge my kayak between mangrove roots and stop to watch. The flamingo stands upright, shuffles in a circle, then dips its head again, and again. It's a feeding dance I could watch for hours, but I hear more paddlers behind me. They ooh and aah over the pink bird, steering straight toward it. The bird wades toward deeper water. They follow. The bird lifts its head and honks its call. The paddlers

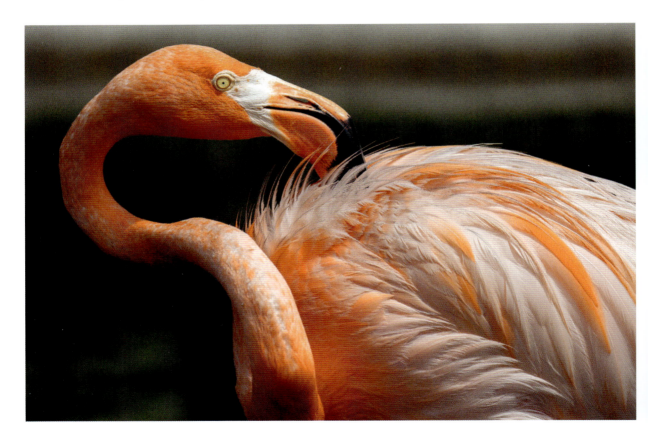

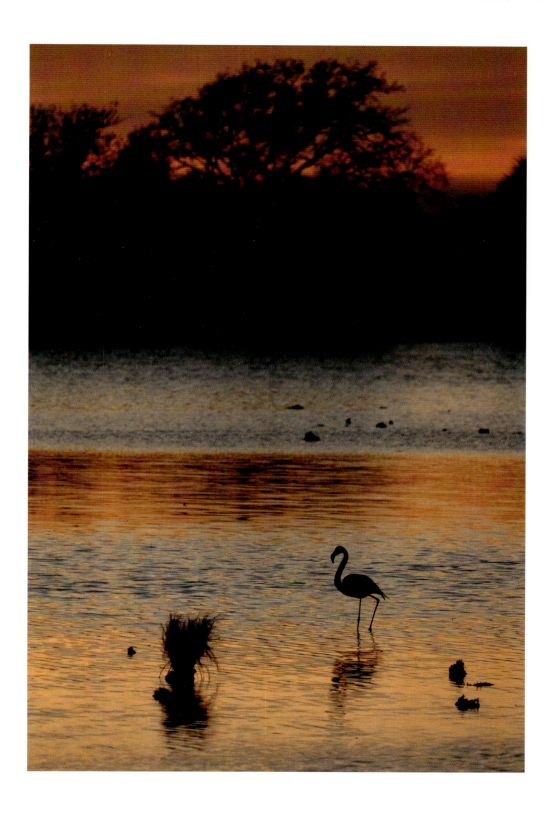

continue, one approaching from either side. The bird calls again. When the intruders fail to respect its warnings, the flamingo spreads its wings and flies away.

Flamingo sightings in Florida are rare enough to attract a flurry of gawkers, including some less than savvy in the ways of wildlife watching, but this wasn't always the case. In the early 1800s, when naturalists such as John James Audubon were first exploring the Florida Keys, he found flocks of flamingos in and around Florida Bay. There was no doubt to Audubon that flamingos were native; they were being eaten in Key West. But hunting and habitat pressures in Florida and across the Caribbean diminished flamingo numbers, and their range retracted, leaving Florida apparently flamingo-less. As iconic a Florida symbol as oranges and alligators, the fact that these flamboyant birds were native was nonetheless forgotten.

The perception of flamingos in Florida became tied to their modern history when the nation's rich and famous incorporated these pink birds into their private collections of exotic animals in the 1920s and 1930s. Entertainment establishments of the era maintained captive flocks, one of the more celebrated being the Hialeah Park Race Track in Miami whose flock was featured in the introductory footage of the popular 1980s TV series *Miami Vice*. Many of these birds, including those at the Hialeah Park Race Track, had been imported from Cuba, reinforcing the notion that flamingos were native to the Caribbean but not Florida and providing a convenient explanation for any rare bird spotted in the wild—must be an escapee.

Like many other Caribbean species in Florida though, the American Flamingo is at the northern edge of its natural range. As flamingo numbers in the region are rising thanks to protections, wild birds are returning to Florida's shores. Flamingo sightings in Florida are sensational rarities for now, but if protections remain and the population continues to grow, perhaps Florida will once again consistently boast flocks of this icon.

Green Anole (*Anolis carolinensis*)

"There's a pair of chameleons over there," a man says to me, gesturing to the boardwalk rail. I look around doubtfully. Chameleons? I know some of these nonnative lizards are living wild in South Florida, but all I see on the rail is a pair of mating green anoles. The male lizard bites the female's neck, pinning her in place as he wraps his tail around hers. They're perfect specimens of the color extremes displayed by Florida's native anole, the male being emerald green and the female dark brown at the moment. That is when I realize the man pointing out chameleons had meant the anoles, referring to them by a common but misleading Florida nickname. True chameleon species belong to a family of old-world lizards famed for their ability to change colors. Although green anoles can shift from green to brown and shades between, they lack the range of colors, patterns, and functional complexity of true

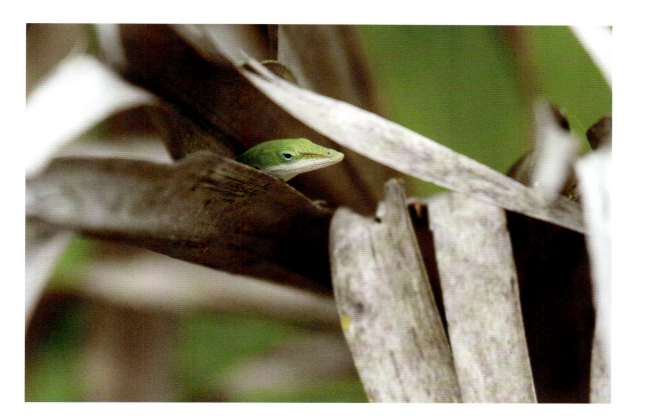

Native · 29

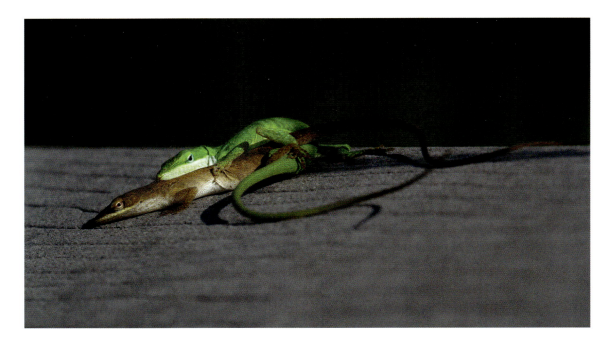

chameleons that control their color change for camouflage, temperature control, or communication. Color change in green anoles, on the other hand, is hormonally controlled. Winners of territorial disputes or those that have successfully pinned a female tend to be green and stressed animals, losing males or subjugated females tend to turn brown.

Florida Spotted Skunk (*Spilogale putorius ambarvalis*)

Eyes glow in the dark, bouncing up and down low to the earth. They move forward, they move backward, then suddenly shift higher. At this new height, they rush forward more quickly, a full-blown charge, then drop back low to the earth where the bouncing begins anew. Above the eyes stretches the elongated body of a squirrel-sized skunk balancing on its front paws, its hind legs spread wide in the air and its tail waving like a starburst tassel. Were I watching this live, I'd by now be covered in rather putrid eau de skunk, eyes and nose stinging from the fumes. But alas, I'm not. My own Florida spotted skunk sighting was but a glimpse. The nighttime bouncing is camera trap footage of a skunk so disturbed by the device in its way that it repeatedly demonstrates its famed handstand display. The smallest and most acrobatic of the skunks, spotted skunks are best known for their handstands, but they have other defensive postures as well. They loudly stomp their forefeet and, relying on the

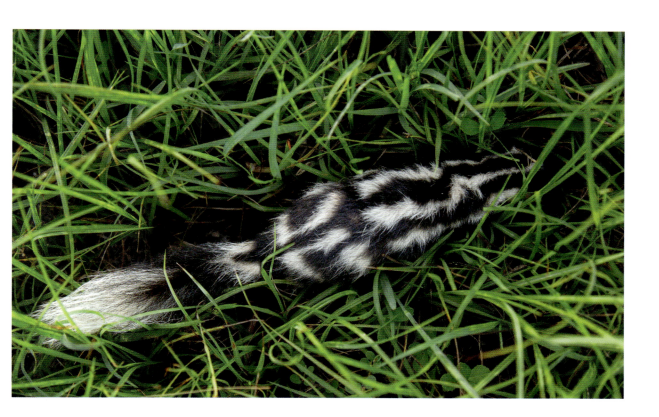

flexibility of their long bodies, contort themselves into a horseshoe shape where both its head and its anal spraying glands are aimed toward the offending party. Spotted skunks are also the only skunks to climb. They're more carnivorous than other skunks and are one of the most complicated to understand genetically. There were thought to be as few as two spotted skunk species at one time, as many as fourteen at another, four were long accepted, but most recent research suggests there are seven species spread from southern Canada through Central America, nearly all of which look identical yet can't interbreed. The complexity is explained by the repeated spreading and retreat of glaciers associated with the Pleistocene, a process thought to have isolated populations of these fast-breeding animals with small home ranges long enough for them to become distinct. It's the same process that has contributed to much of Florida's animal diversity. Appropriately, Florida is home to two subspecies of the Eastern spotted skunk—the endemic Florida spotted skunk in peninsular Florida and the Appalachian or Allegheny spotted skunk in the Panhandle. Good luck telling them apart.

Florida Scrub Lizard (*Sceloporus woodi*)

I shiver in the early spring air, pulling my fleece more closely around me as I stare at a series of lines crisscrossing white sand. This is my second attempt to photograph Florida scrub lizards on the Mount Dora Ridge, one of Florida's ancient beaches now isolated in the center of the state, the very process through which this endemic lizard diverged from the more widely distributed eastern fence lizard. My previous attempt had been in the middle of the day, a time when I thought these ectothermic creatures would be active. They proved too active, faster and more wary than most lizards I've encountered. They skittered under bushes before I'd even spotted them. I'd gotten no pictures, but I had glimpsed their tail drags; and, if my memory served well, the motif in the sand before me promises lizards to come. I watch as the sun emblazes one grain of sand after another as it creeps higher in the sky. As the glow reaches the sand on the opposite end of the clearing from where I sit, one small lizard braves the light. It climbs atop a small sand knoll, closing its eyes as it soaks in the warmth. I can relate. The sun also banishes the shade in which I sit, allowing me to thaw. The little lizard stretches and looks around, inching more fully into the sun. It spots some-

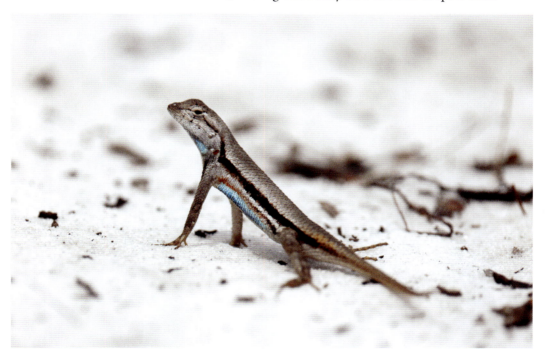

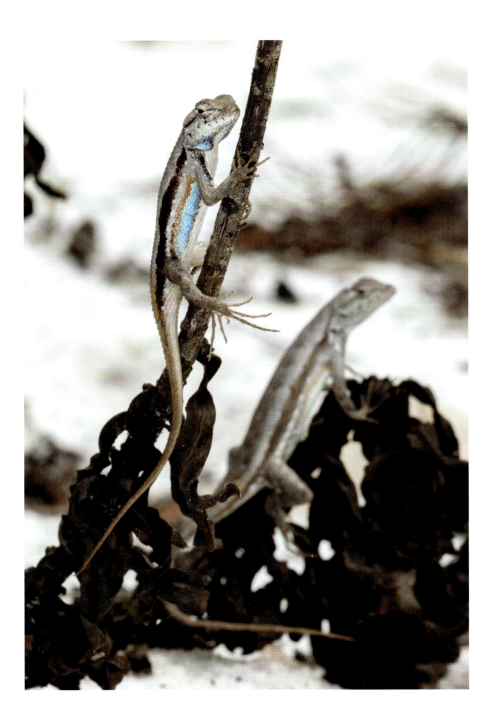

thing, then runs. It dives, sand sprays, and the little lizard comes up with a beetle in its mouth. As it crunches down breakfast, a second lizard ventures into the sun. This one clambers onto a clump of dead leaves, arching its back to reveal the wavy pattern of a female. Breakfast forgotten; the first lizard scales an observation stem just beyond the female. It puffs out its chest, flashing the characteristic black-outlined turquoise throat patch of a male. He pumps his forearms up and down, pounding out alluring push-ups, but to no avail. The female turns away. He tries again. The female leaves. The male sits still a moment, then abandons his perch. He turns his attention to my nearby parked Jeep, scrambling up a tire to pluck a moth from a groove in the tread. He drops below my vehicle, racing from one end to the other, jumping at one thing, pawing at another, and finally stopping to rest at the edge of the shade. I can't blame him for retreating to the shade. It had rapidly transitioned from cold to comfortable and now, as I remove my fleece, to hot. This is a land of extremes, and this is a species of lizard that evolved accommodating those extremes. They need these open sandy patches to serve as their equivalent of a town center—a place to absorb the sun, have a meal, and conduct social business—but they also need the mature pines, oaks, and low shrubs of this scrub habitat to serve as home—a place to sleep, escape predators, and siesta in the heat of the day. What's best for these specialized lizards is also best for their specialized habitat—fire, the only thing that truly maintains this matrix of open sand within the forest.

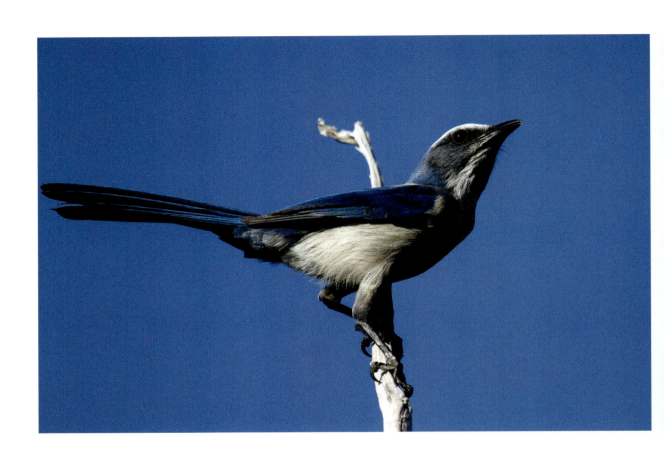

Florida Scrub-Jay (*Aphelocoma coerulescens*)

"Chee . . . chee . . . chee," a single bird rasps down at me from a scrub oak in Ocala National Forest.

"Chee . . . chee," it persists.

Whoomp. Another blue bird lands beside the first, the calls become a gravelly duet.

Whoomp. Whoomp. Whoomp. Three more birds land in the oaks above. I'm surrounded.

"Chee . . . chee chee . . . chee . . . chee," a raucous multigenerational chorus rains down on me.

Even to a novice scrub jay linguist like myself, it was clear I was unwelcome. It is only months later though, when I join Dr. John Fitzpatrick of the Cornell Lab of Ornithology at his field site in the Archbold Biological Station, that I appreciate the complexity of those calls. Had I been a snake, a hawk, or some other predator, the flock certainly would've mobbed me, using different vocalizations to convey to one another whether I was a threat on ground or in the air.

Much of what we know about Florida Scrub-Jays was discovered by multiple generations of researchers at Archbold where, as we drive through pristine scrub, Fitz points out various birds and territories, revealing a complex family tree.

It seems the family that scolds together, stays together. Perhaps there had been a nest nearby the day of my own scolding, which the entire clan would certainly defend. With their only habitat, remaining patches of sand scrub across the central portion of the state, disappearing and deteriorating at unprecedented rates, each territory is a precious commodity. Older offspring help defend the familial territory and assist in raising the newest batch of chicks for several years, perhaps one day to claim portions or nearby lots for their own as I'd seen at Archbold.

"Chee . . . chee chee . . . chee . . ." The chorus had continued even as I backed away and rightfully so. The long-term survival of Florida's only endemic bird species depends on such zealous defense, though no doubt it will take more than just the birds to stop the backhoes and bring ecosystem-renewing fire to the scrub.

Florida Black Bear (*Ursus americanus floridanus*)

The sun rises behind a silhouette of pine needles like a golden orb, sending long shadows across a set of tracks before me in the sand. I step closer. They're fresh, the distinctive ovoid prints that confirm a Florida black bear has recently passed. I study the surrounding vegetation and then follow the tracks until they disappear; but I see no Florida bear. It's a familiar experience, a routine I'd repeated time and again for more than two years as I tried to photograph this iconic Florida animal.

"Oh, don't worry. You'll get tons of bear pictures in Ocala National Forest."

This was a phrase I heard often and one that felt like a curse as I once again stood bear-less in this alleged land of guaranteed success. I'd been hopeful on my first visit when the Ocala campground host warned me that a bear and her cubs frequently visited my chosen tent site. I was pretty sure I'd been within a few feet of one snorting in bushes along a nearby trail, but I'd seen no bears. It set the tone for every other attempt. I'd smothered myself in putrid eau de soil and other scent-blocking potions. I'd worn camo. I'd sat at a site where the local hunters said they always saw bears. I'd used my Jeep as a blind. I'd stalked a yard in the Golden Gate Estates where bears had been weekly, even daily, visitors. I'd haunted the owner's screened patio for ten days straight, to no avail. I remained bear-less.

I was beginning to think that the bears were avoiding me personally and so held little faith when a friend of a friend put me in touch with another Golden Gate Estates resident with bears in his yard. "Yeah, at least once a day," the owner confirmed over the phone. But even as I look at cell phone shots of cubs taken from his kitchen window, I still doubt my own ability to see one. Nonetheless, I pull my Jeep into his backyard, roll down the windows, shut off the engine, and grab my camera—at least there are Wild Turkeys to photograph. But one by one, as darkness falls, the turkeys squawk into running takeoffs, flapping into the surrounding pines to roost for the night. I find myself alone. Convinced my curse remains, I reach for my keys to leave, but at that exact moment, a bear ambles out from behind a saw palmetto. It makes no sound as it approaches; I could've easily missed it. The bear pauses to stare at my vehicle. Then, apparently not caring, continues to the opposite side of the clearing where it plops onto the ground. I desperately click my camera shutter, knowing it's too dark but too excited not to take pictures. Besides, what if this proves my one and only chance?

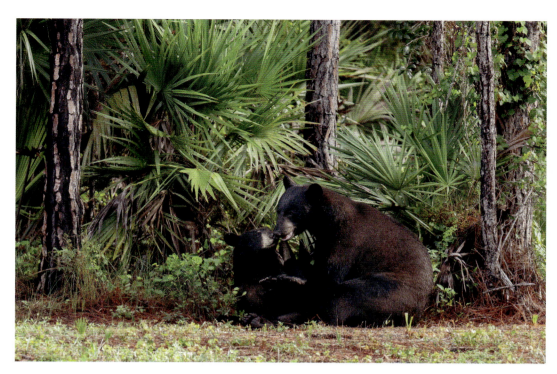
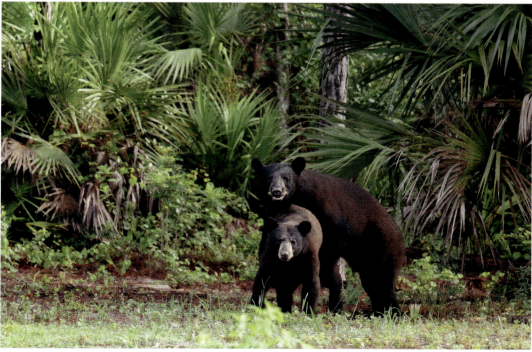

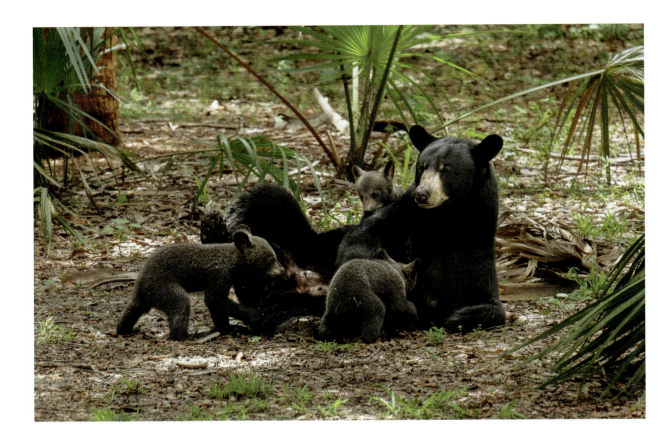

 The next morning, I'm back in that yard before light. I roll down my windows, prepare my camera, and look up to see a bear wandering into the yard. It saunters slowly, sniffing at palms before eventually sprawling onto a patch of ground. Branches arch between us and there's no view from any of my windows. I feel frantic as the sun rises in the sky. Finally, I have a bear in good lighting within photo range but with no view. Should I risk scaring it off by moving or leaving the Jeep? I agonize over the issue, but let wisdom reign—always patience with wildlife.

 The bear suddenly leaps up and tears across the yard, pausing at the edge of the forest within clear shot of my window. It stares at the woods adjacent to where it had just come. I follow its gaze to see a much larger bear emerge from the shadows. The newcomer's nose is in the air; it quickly directs toward the smaller bear. The larger bear strides in that direction. The smaller bear takes a few steps away, then turns to face the larger bear. Would there be a fight? I brace myself for action. The larger bear quickens its step, then, in one motion, grabs the smaller bear from behind. The bot-

tom bear, which I then know is a female, twists about and the pair wrestles across the ground. There's more rolling, more wrestling, and lots of mounting, and then, as suddenly as it began, it's over. The male saunters across the yard and flops into a patch of shade, looking as if he were ready for a postcoital cigarette. The female stands there watching the male, incredulous I imagine. She turns as if to leave, but then heads toward the male instead, resecuring his attention as she passes. He follows and as they disappear into the woods, I collapse into my seat, shaking from adrenaline.

But the day is not yet done. Another bear emerges from the woods. As that bear leaves, a text comes from Anne and Tim—my by then friends at the other house that I'd been stalking in the Golden Gate Estates—a bear just crossed their driveway and was likely to enter the property. My heart booms in my ears as I race across town, hoping beyond hope I'm not too late. Anne motions me onto their screened porch, and as I set down my gear, a large female emerges from the back woods. As the bear passes behind their shed, I sneak off the porch and hunch alongside a hedge near where the bear will pass. The bear settles below a sabal palm twenty feet away and there we sit, watching one another as two years of overdue exhilaration course through my blood. A few months later, I'll sit in this same spot watching a mother bear, perhaps this very same one, as she nurses her cubs, contemplating what feels like a miracle. I've just watched a full cycle of bear life played out in a couple of wildlife-friendly yards.

Great Blue Heron (*Ardea herodias*)

Duckweed-covered waters glow emerald in the evening light, appearing as soft and smooth as a field of moss, disrupted only by the occasional cypress tree. One bald cypress in particular draws my attention, emerging from this mossy moat to tower above the others like a castle. Spanish moss drapes thickly from its branches, as splendid as any royal tapestry. Yet the tree's crowning glory is an amorous pair of Great Blue Herons poised upon their throne of sticks behind a screen of cypress catkins. I've seen many of North America's largest heron's nests clustered in the pond apples at Wakodahatchee Wetlands. I've seen many males proudly deliver sticks to their nest-building mates, even in the pouring rain, and young chicks clap their bills around their mother's in a plea for food, but none of these nests held a candle to this Spanish moss-covered one, standing regally on its own.

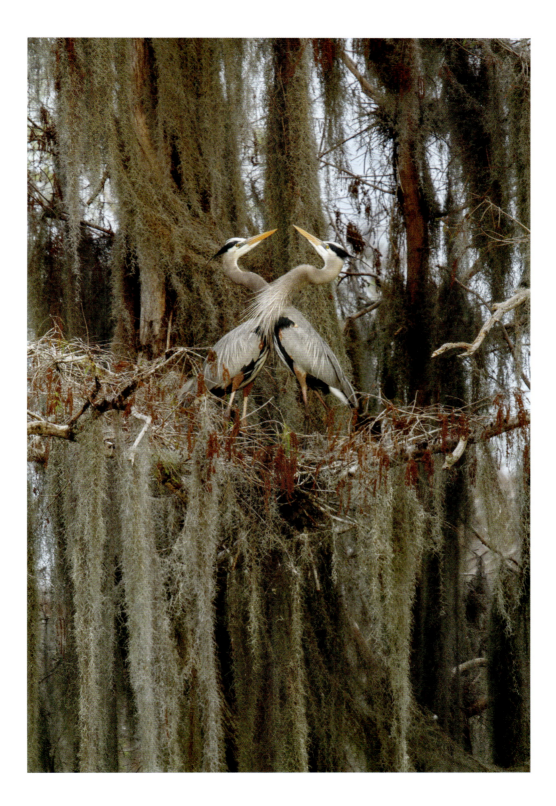

Nonnative

~

A small brown lizard basks in a sunny patch on a boardwalk rail in the Loxahatchee National Wildlife Refuge. It rises up onto its forelegs as I approach and fans the orange flap of skin that stretches from its chin down its throat. Its dewlap glows brightly as it bobs its head, then pumps its arms in a succession of rapid push-ups. These are the battle cries of a Cuban brown anole, and I wonder what I've done to merit such a vigorous display, until I see its intended adversary—a green anole hugging a nearby tree trunk. The green anole turns its head ever so slightly, watching as the brown anole flares its orange dewlap and performs another round of push-ups. The green anole lies still, keeping its own pink dewlap tucked beneath its chin. The brown anole scampers down the rail, stopping directly below the green anole's trunk to flash, headbob, and push up once more. Just as the agitated brown anole appears ready to leap onto the tree, the green anole curves its body 180 degrees and escapes up the trunk toward the canopy. As the green anole disappears from view, the brown anole does one last triumphant round of push-ups and then struts back to its patch of sun. A couple passes as the anole resumes its basking, and I hear the woman say to her husband, "I just love those little brown lizards. We had one in the yard yesterday, you know..."

As the woman's voice fades into the distance, I wonder whether she knows that those little brown lizards are invaders. That the very one she passed sleeping sweetly in the sun had just chased a green anole, Florida's only native anole, up into the treetops, a displacement that has happened all across the state such that many an observer believes the brown anole introduced from the West Indies to be our native anole since the green one is so seldom seen these days.

Brown anoles are far from being Florida's only nonnative species. Eurasian Collared-Doves perch atop Florida palms. Cuban treefrogs from their namesake island breed in Florida ponds. Shells from South American island apple snails litter the shores of Florida's wetlands. Wood slaves, tropical house geckos from Africa, lurk in the shadows around Florida porchlights at night. Wild hogs first introduced

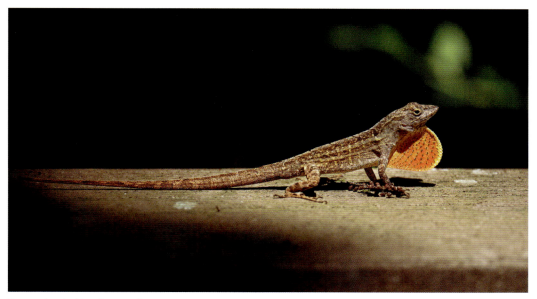

Brown Anole (*Anolis sagrei*)

Wood Slave (*Hemidactylus mabouia*)

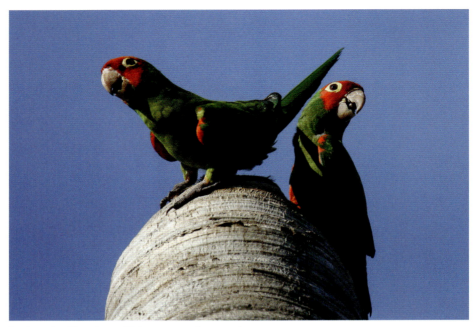
Red-masked Parakeets (*Psittacara erythrogenys*)

from Europe by Spanish explorers in the 1500s rut through Florida forests. These are animals so widespread and commonly encountered across the state that it's easy to understand why they might be mistaken for natives, but the one thing they all have in common is that humans, not nature, facilitated their arrival on Florida's shores.

Some of these introductions were intentional. The Spaniards, for instance, brought not just hogs but also European honey bees, cattle, and horses to provision their settlements in the 1500s and 1600s. These are the first well-documented human animal introductions to Florida and the start of many more, so European contact is used today as the measure of whether a species is native. Cane toads were introduced from South and Central America in an attempt to control sugarcane pest insects in the 1930s. Also in the 1930s, a tour boat captain released rhesus macaque monkeys on an island at the Silver Springs tourist attraction in the hopes of increasing his revenue, apparently unaware that these Asian imports were strong swimmers that wouldn't confine themselves to his island. And any number of well-intentioned but misguided pet owners have freed animals they no longer wanted to care for. Red-eared slider turtles, for example, were sold by the million in the mid- to late-1900s, luring customers with their small size and cheap price, gaining popularity with the advent of

the Teenage Mutant Ninja Turtles in the 1980s. But as those turtles grew beyond cutie size and their care became a hassle, many were released into local ponds and waterways. Likely those owners were genuinely unaware of the potential problems their pets might create for wild native turtles—competition, disease, and hybridization to name a few—or perhaps it was easier to tell distraught children their pets would be free rather than dead, but red-eared sliders are now the most widespread freshwater turtle species outside their native range not just in Florida but around the world.

Other introductions have been less intentional. Brown anoles, for example, likely arrived in Florida as stowaways in the 1800s when ship trade routes provided transport in cargo from their native lands in Cuba and the Bahamas. Brahminy blindsnakes, a tiny fossorial snake from southern Asia that looks more like a worm than a snake, arrived in Florida in the soil of potted plants in the 1970s, a dwelling preference that has allowed it to become the most widely distributed snake in the world. A band of vervet monkeys escaped a medical research facility in the 1940s, a few of which were never recaptured and whose ancestors continue residing near the Fort

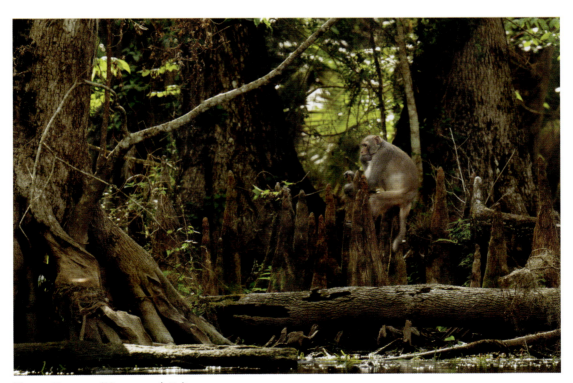

Rhesus Macaque (*Macaca mulatta*)

Nonnative · 47

Lauderdale—Hollywood International Airport. And with Florida being a hub for the exotic pet trade, not to mention Miami being one of the busiest locations both for legal and illegal wildlife imports into the United States, there have been ample opportunities for escapes. Whatever the source, the end result is that Florida tops the nation and is a global leader when it comes to nonnative species. These nonnative animals and plants have advantages over native species in that they're less burdened by competitors, predators, and other biological controls that keep them in check in their native lands.

To be fair, not all nonnative species released into Florida's wilds are invasive, or even survive to reproduce for that matter. When I was taking pictures for my *Attracting Birds to South Florida Gardens* book, I ran across a bird I'd never seen before in Bill Baggs Cape Florida State Park on Key Biscayne. It was a small gray bird with a thick bill and a red rump and tail. It proved to be a Lavender Waxbill, a finch native to central Africa, and my sighting was the first record of it in the wild for Florida.

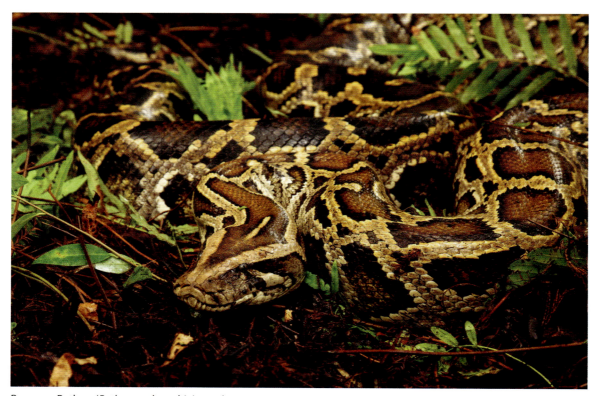

Burmese Python (*Python molurus bivittatus*)

The waxbill I found was no doubt an escaped pet, and the chances of that single bird surviving in the wild, not to mention finding a potential mate of its kind escaped in the same place at the same time, were slim. To my knowledge that Lavender Waxbill was never seen again, and the species certainly hasn't established a breeding population on Key Biscayne.

It takes a critical population mass before a nonnative species can become established. So while hundreds of species of nonnative animals have been released in Florida, only a portion of those have yielded breeding populations, with many remaining confined to limited areas. Small flocks of Red-whiskered Bulbuls from India and Chestnut-fronted Macaws from South America, for example, have thrived and nested in Miami for decades, never leaving the neighborhoods they first claimed as home. Same with the rhesus macaques introduced to the Silver River or the vervet monkeys escaped into the mangroves near the Fort Lauderdale airport, both of which have more or less stayed within their original footprints. These small populations of nonnative animals certainly have localized environmental impacts, but the ones that garner press and require management dollars are the large-scale invaders.

Pythons are today's poster child for invasive species. By the time the potential impact of pythons was being recognized, their population was already beyond control. One of the challenges in managing nonnative species is in recognizing which of the many introduced animals will become the next invader. Which ones will not only breed successfully but will spread across the state, infiltrate our natural areas, outcompete or eat our native animals, and wreak ecological havoc? Attention needs to be focused broadly. Egg-eating tegu lizards from Argentina are rising in number, spreading their range, and establishing a foothold that could very well make them as devastating to our wading bird populations as pythons have been to our mammal populations. Globally, the tiny New Guinea flatworm, a species unlikely to appear on the evening news and yet responsible for extinctions, is considered one of the 100 worst invaders in the world; it has reached our shores, devouring our native snails and other invertebrates. And animals aren't Florida's only destructive invaders. Plants such as melaleuca, small-leaf climbing fern, and Brazilian pepper choke out our native plants and fundamentally alter our environment. Even if all the nonnative animals were removed tomorrow but nothing were done about the plants, we would still eventually lose the natural Florida we know and love. Given that so many of these nonnative species are here to stay, shouldn't our task be to level the ecological playing field—to make sure we don't lose the Florida we know and love?

Vervet Monkey (*Chlorocebus pygerythrus*)

First there's one—a single monkey walking four-legged along the top of a chain-link fence. Then another emerges from the mangroves. It too balances on the fence, perching just above a sign that warns against touching or feeding the monkeys; this is just the beginning. One after another monkey appears out of the shadows, leaping from atop the fence into the parking lot. A mother nurses its baby in the shade of a traffic safety cone. A young male climbs onto a parked airport van, wedging itself between the driver's door and the oversized side mirror to admire its reflection. Another rests atop an automated payment machine. A few settle into a firebush, plucking flowers from which they suck nectar. Several others swarm a parked SUV, some content to sit atop for elevated views while others explore the grille for squashed insects. A pair wrestles across the lot, shrieking and pouncing until one curls into a submissive ball and the other, clearly emboldened by its victory, bounds across the exit lanes to leap onto the window of the ticket booth. The teller inside places her hand against the glass and the monkey matches the gesture from the outside, a high five of sorts. It certainly feels like I'm in a bush airport in Africa, but this is a Park 'N Go lot wedged between the Fort Lauderdale—Hollywood International Airport, the interstate, and the Port Everglades Cruiseport. This unlikely location has served as home to the descendants of fifty vervet monkeys escaped from the Dania Chimpanzee Farm in 1948. The facility served as both a zoo and a medical research import facility. The monkeys that escaped had come directly from their native lands in West Africa. As adaptable habitat generalists, the freed animals made themselves at home in this little patch of mangroves and have survived there even as the city has grown up around them.

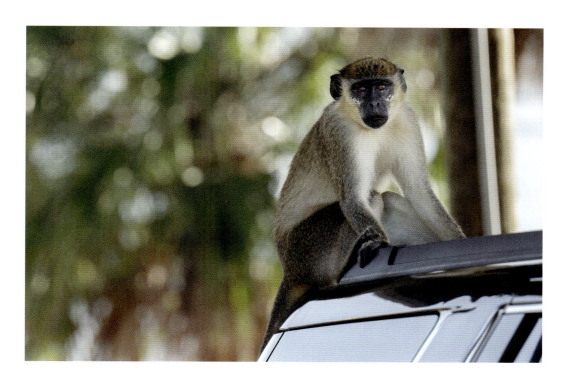
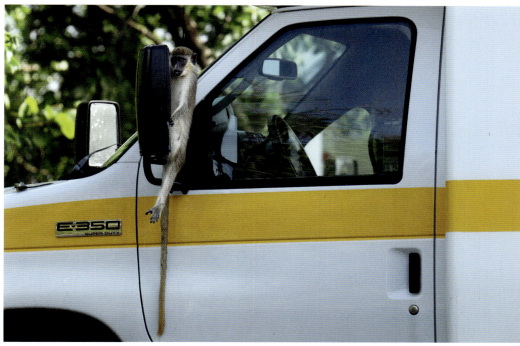

Florida Cracker Horse (*Equus caballus*)

I see the emerald glow of Paynes Prairie through a break in the trees as I make my way along the Bolen Bluff Trail. It's there, in the open grasslands, that I expect to find the park's famed wild horses grazing at a distance, but as I turn down a curve in this forested section of trail, I find myself in tight quarters with a foal and two adult horses. Chestnut mare, dark bay stallion, and buckskin young stand beneath the canopy of a Spanish moss–draped oak, munching tender greens within its shade. Should I proceed? Should I retreat? I don't want to disturb, but the horses seem not to notice me, or at least not to care. I edge past the grazing animals, pausing only when I'm as far away as possible before risking photography.

I can't help but notice how comfortable these animals look among the palmettos, and why not? Their ancestors had been introduced to Florida by Spanish explorers in the 1500s. Derived from Iberian stock, the animals were small, fast, and surefooted. They adapted well to Florida's wilds, roaming the landscape freely along with cattle also first introduced from Spain. Spanish settlers, Seminole Indians, and early American cowboys all relied on these horses to adeptly herd their free-ranging stock. When the cattle industry evolved from free range toward fenced ranches though, stronger quarter horses were preferred over Florida's smaller, more agile breed. If not for a few ranching families, the breed might've been lost forever. Thanks to the Florida Cracker Horse Association established in the 1980s, the number of registered Florida Cracker Horses has risen from just 31 to over 1,000 in the last few decades, and the state manages a few wild populations such as this one at Paynes Prairie Preserve State Park.

As I stand watching the wild horses on the trail, I notice a change in their behavior. It's subtle at first—the stallion stops munching, then lifts his head. The foal sidles closer, then mom too pauses her grazing. My time's up. I take a step backward down the trail. The stallion takes a step toward me. I take a step back. The stallion moves forward; mom and foal now following. I take a few more steps backward, but the trail is narrow and winding. I turn to see my way and quicken my pace, but I hear hooves gaining, closing the gap between us. Finally, a clearing ahead. I step off the trail into the opening, expecting the horses to continue on their way, but the sound of hooves behind me suggests otherwise. I glance to see the stallion still bearing down. If I go much farther, I'll be back trapped on another narrow trail. Instead, I turn to face him. I see that the mare and foal stopped at the edge of the trail, but

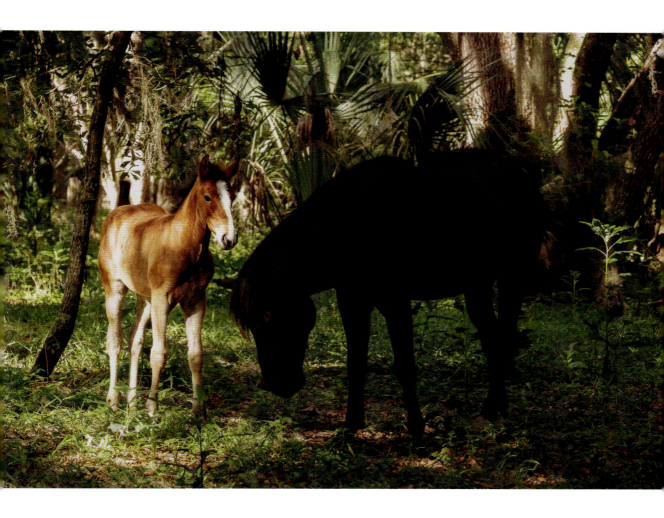

the stallion is indeed right behind me. He takes a few more steps forward. I hold my ground. His nose comes within inches of mine, his nostrils flare, my heart pounds. I lean backward, ready to retreat a step or two as needed, but suddenly the horse turns, apparently satisfied with his intimidation. He rejoins the others and down the trail they go, wild, free, and generous in sharing their space with me.

Domestic Cat (*Felis catus*)

Yellow eyes stalk me as I make my way through a forested urban park. Their owner, a striking cat luxuriously furred in slate gray, shifts from lounging on its side into a crouched position, ready to flee should I prove a threat. It seems far too magnificent an animal to live the rough life of an outdoor cat, subjected to territorial disputes, diseases, vehicles, and predators, all of which reduce life expectancy for these feral animals by roughly two thirds. It's not healthy for the cats, nor for other animals. Nonetheless, humans have spread domestic cats to every corner of the world, introducing this efficient predator to islands where formerly there were none, and in other areas, supporting artificially high densities of cats that kill even when satiated.

Outdoor cats have been implicated in the extinctions of more than sixty species of birds, mammals, and reptiles around the world. In the United States alone, they kill an estimated 2.4 billion birds every year. In Florida, they're playing a significant role in inching endangered populations of the Key Largo woodrat and cotton mouse toward extinction. They've infected several endangered Florida panthers with feline leukemia virus, killing at least five, and are implicated by the Centers for Disease Control and Prevention in spreading toxoplasmosis to humans. It's not just feral cat colonies either, many of the cats haunting Key Largo's endangered rodent populations come from loving homes in the area. Cats are known to roam as far as eight miles away from their homes. Yet cat owners have a hard time imagining their adorable feline, the very one that cuddles into their laps, as a killer. Even after watching video incriminating their own cat of murder, studies have shown that most owners continue to deny any such possibility. Perhaps the owners feel a need to defend the innocence of their pets, but the fact that cats kill for a living doesn't make them bad animals—that's what they were designed to do.

My own childhood cats spent much of their time outdoors, and we never doubted that they killed. They regularly delivered dead mice and lizards to our door, and one time brought a not quite dead bat into the house that created quite a stir. We knew they hunted and we knew they killed, we just didn't appreciate how often or what impact that might have on the environment. Everyone had an outdoor cat at that time, and no one gave it any thought. Perhaps there were too few data, or perhaps, like me, people weren't thinking about the cumulative impact of their pets in a world already straining under other human pressures. But larger environmental issues aside,

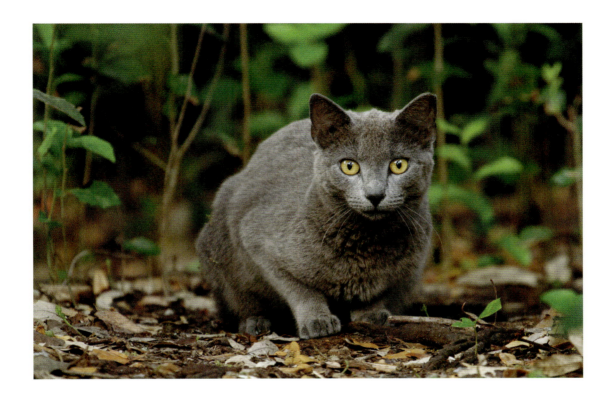

in the end, it's best for the welfare of all animals if domestic cats are simply kept as indoor pets. Let birds fly, reptiles bask, and small mammals scurry while beauties like that yellow-eyed cat from the woods wallow in a warm lap, happily and healthily for many years to come.

Peters's Rock Agama (*Agama picticauda*)

An orange and indigo lizard scampers up the side of a rock. He pumps himself up and down on his forelegs, pounding out adamant push-ups. He pauses a moment like some king on his throne, then repeats more frenzied push-ups. A second lizard emerges from the shadows. It bounds up to the first and looks it up and down. The blue and orange lizard does the same, puffing its chest out as it eyes the brown one. The lizards look nothing alike, small patches of orange and aquamarine on the brown one are the only indication that it might be related to its brilliantly colored companion. But those hints of color on the brown one confirm that she is a female ready to mate, though not with this male. She does her own set of push-ups, then leaves him standing atop the rock on his own. This pairing might've failed, but plenty of others have succeeded. Natives of east Africa, agama lizards were released through the pet trade into several Florida counties where the lizards began breeding in the wild. For now they're mostly found in cities, but they have been spreading to new parts of the state, contributing to Florida's diverse community of nonnative lizard species that now outnumbers native species by nearly three times.

Egyptian Goose (*Alopochen aegyptiaca*)

A chorus of honks fills the air. A posse of waterfowl with brown eye patches and bubblegum pink legs scurries across the lawn. Another group of Egyptian Geese already mill about at the edge of a pond in Key Biscayne's Crandon Park. The honks grow deafening as the gangs merge. They remind me of spectators gathering to watch a fight, and I follow to see what action might emerge. The birds have formed a semicircle and there in the middle, basking at the water's edge, lies an American crocodile. This is a park I've frequented since moving to Florida nearly twenty-five years ago, but the scene before me is one that never could've occurred back then. American crocodile population numbers were still in recovery and sightings beyond Florida Bay were rare. And while Egyptian Geese from Africa had already been reported in the wild in Florida, nesting had not yet been confirmed and their numbers were low. Muscovy Ducks from South America were Crandon Park's marauders at that time, but now there are only a couple keeping their distance from this newer invading waterfowl. No strangers to crocodiles given their origins, the Egyptian Geese are brazen in their assault. They close in on the napping reptile, honking heinously. The crocodile ignores them for a time, but the birds are incessant. They've claimed entire golf courses, city parks, and ball fields, chasing away sports teams with their excrement and hostile nature. I personally was mobbed by these aggressors in Crandon Park before. What chance does this lone crocodile stand against such persistent bullies? Sure enough, the crocodile acquiesces. It eases into the water and disappears from sight as the geese honk in triumph.

Indian Peafowl (*Pavo cristatus*)

Something large crashes onto my roof. I cringe as claws squeal across the metal surface like chalk against a blackboard. Another crash, more piercing squeals. A few more crashes and then the telltale trumpeting. My dog runs to the door, growling her concerns. I open it and we both go out to see a row of peafowl strutting across the roof. Coconut Grove is just one of many neighborhoods in Florida now overrun with these giant birds originally from India. They were first documented in the wild in the middle of the state in the 1950s. It was presumed at the time that they wouldn't breed well on their own in the wild, but if that was true then, they've certainly figured it out since. I see males all over my neighborhood shimmering their cascades of feathery eyes, a cloak of beauty being supported from behind by the bird's actual, hardier tail feathers. The males prance in circles, following females that casually graze. And they fight other males to proclaim their dominance, sometimes mistaking their reflection in a windshield for another male, a situation in which the car owner is the true loser. And then the females disperse, nesting where they can, one choosing my neighbor's fence-top flower pot, before strutting their young through the streets to begin the cycle anew. The impact of these nonnative birds on Florida's environment and its native animals remains largely unknown, but what is clear is that these magnificent animals pit one neighbor against another. Some love them, some hate them, but nearly always based on whether the person focuses on their magical or nuisance qualities.

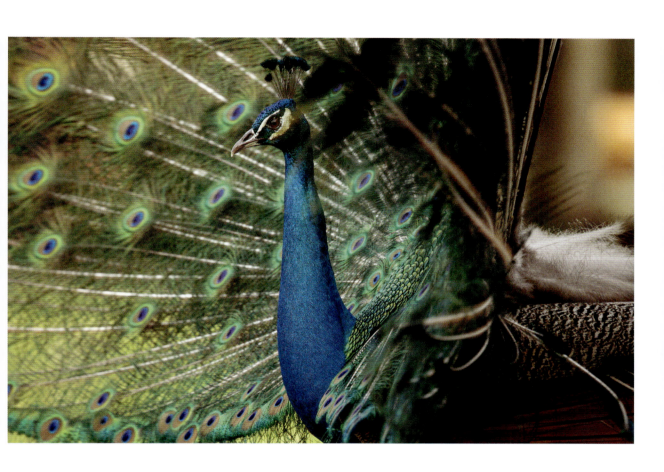

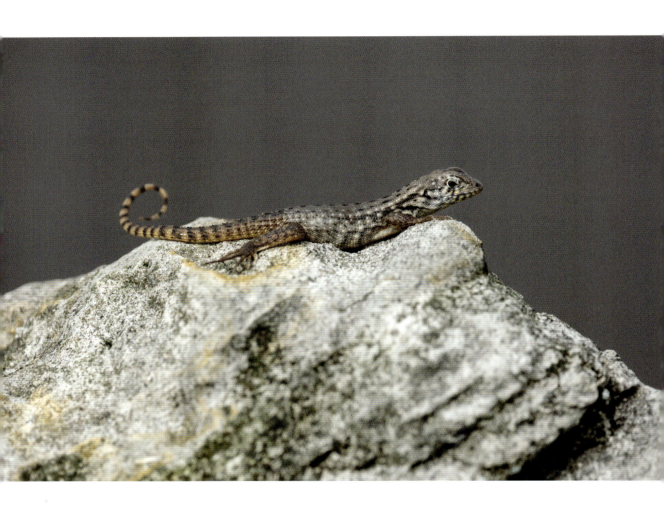

Northern Curly-tailed Lizard (*Leiocephalus carinatus armouri*)

A small lizard with its tail perfectly circled above its back scampers through the gas pumps at my local filling station in North Miami Beach. I follow to confirm but there's no doubt, it's a northern curly-tailed lizard like the ones I'd just been camping with in the Bahamas while studying rock iguanas. Curly-tailed lizards were scattered all across the uninhabited Bahamian island; my favorite was one I called Toughy. He was a large male whose tail had been lost and no longer curled, but that didn't stop him from dominating the area around the kitchen tent. When our research crew sat down to eat, he appeared out of nowhere. Toughy darted after other curly-tailed lizards, iguanas, and mockingbirds, keeping them at bay with a dominance display that included a puffed-out chest, vigorous push-ups, and persistent head bobbing. Statement made, he'd dash among us throughout the meal, gleaning dropped morsels from the sand or, if we were negligent, bravely leaping onto a leg to steal a chip or, once, even half a peanut butter and jelly sandwich. Brazen? Definitely. But Toughy had personality and I'd come to love curly-tailed lizards. What I didn't expect was to find one at my corner gas station when I returned home.

That was a couple decades ago, before curly-tailed lizards became as prominent around town as they are now. It turns out though, they've been in Miami from as early as the 1930s when some escaped from a zoo. Other intentional and unintentional introductions of this species have been speculated, and being native to islands not far from South Florida, perhaps a few even made it on their own during storms. Now, they're patchily distributed all across South and Central Florida and have been spotted as far north as Jacksonville Beach. It's unknown exactly what their impact is, but if Toughy is any example, they no doubt compete with native lizards. All the things that made Toughy so endearing in his homeland make this species an effective invader of new lands in Florida.

Florida Cracker Cattle (*Bos taurus*)

Rain filters through slash pine needles, sliding down palm fronds to moisten an understory of mixed grasses and wildflowers. A herd of cracker cattle stand in the rain, ignoring the drops while dining on mixed greens. A Cattle Egret darts among the bovine legs, jumping in for a tasty insect treat, then twisting out unharmed. It's a classic Florida scene, a blending of the ages.

The backdrop is a fire-maintained habitat that covered much of the state long before the arrival of Europeans. The cattle are of criollo descent, introduced by Spanish conquistadors in the 1500s. One of the oldest and rarest breeds in America, these hardy and heat-tolerant cattle once roamed freely through much of the state. The Cattle Egret is the newcomer on the scene. An African bird evolved to follow large game herds across vast plains, it arrived in North America in the mid-1900s and is now perfectly at home in Florida.

Cracker cattle are the basis of a Florida ranching culture that came into its own in the 1600s, blossoming a couple of centuries before the glorified days of cowboys and Indians out west. While not as widely appreciated, Florida's early cattle days were every bit as colorful with tensions high between Indigenous then later Seminole cowboys versus Spanish-derived vaqueros and eventually pioneer ranchers from the north. Guns and knives settled disputes, and monetary stakes were high even into the 1800s when over 1.5 million cattle were shipped from Tampa and Punta Rassa near Fort Myers to Cuba, Nassau, and Key West.

The extent of Florida's pinelands have been reduced, the days of free-range cattle are gone, and Cattle Egrets roam more freely about the state than their bovine counterparts, but cracker cattle still have a place in Florida's wilds. The Fred C. Babcock/Cecil M. Webb Wildlife Management Area where I encountered this scene is just one of the conservation lands around the state that preserves this Florida heritage breed not just to save history, but as a potential tool to conserve wetlands.

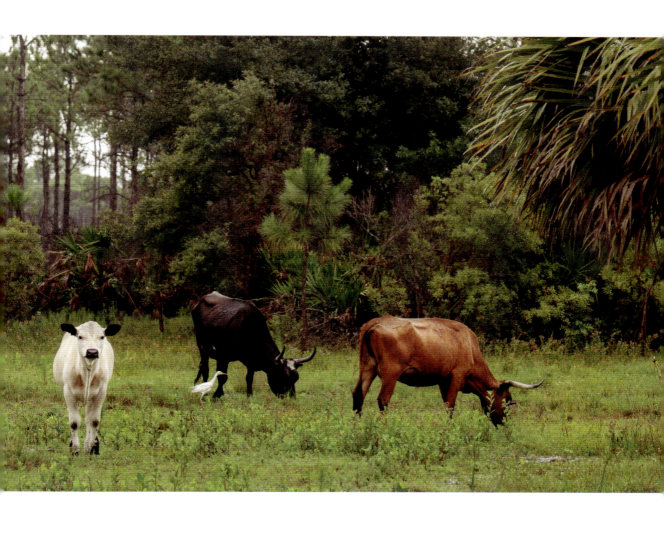

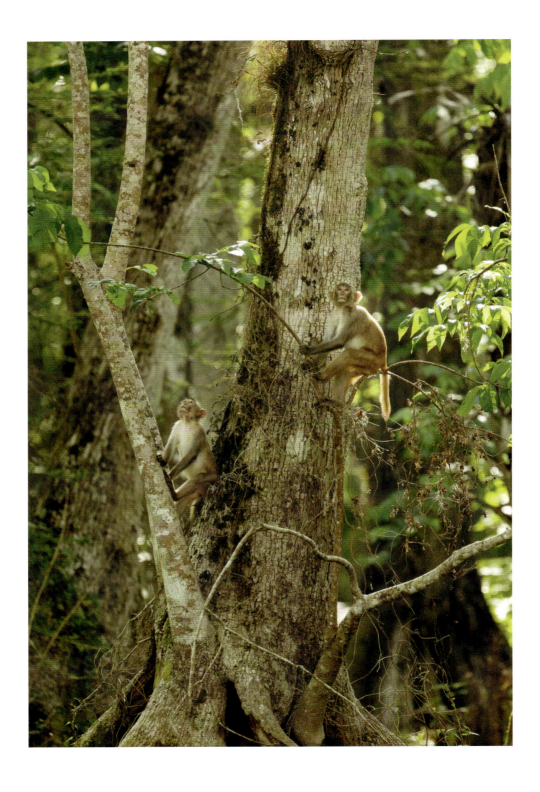

Rhesus Macaque (*Macaca mulatta*)

Torpedo-looking fish ride the clear currents below me. A long-legged bird plucks a snail from atop a floating mat of vegetation beside me. The ridged tail of a crocodilian stirs the glassy waters before me. Monkeys swing between branches above me. It feels like I'm paddling through a tropical jungle, and that is no accident. Although the clear waters of Silver Springs began attracting tourists as early as the 1800s, an enterprising boat captain in the 1930s decided to enhance his jungle cruise by introducing rhesus macaques. He'd allegedly created an island for them in a shallow section of the Silver River, but the monkeys promptly swam away to inhabit the cypress forests along the banks where they've lived ever since. Those six monkeys, and another six the captain added a decade later, were the start of a population that at one point numbered nearly 400. The monkeys are an attraction, thrilling boaters with their antics, but there are ecological and human health concerns.

The monkeys at Silver Springs raided bird eggs from artificial nests in a research study, raising concerns that they may be harming native nesting birds. In the Florida Keys, free-ranging biomedical populations of rhesus monkeys destroyed the red mangrove forests around their islands in the 1970s, causing shoreline erosion and legal battles that eventually resulted in the animals' removal thirty years later. In South Carolina, there's been a rise in fecal bacteria in waters surrounding a free-ranging population of macaques maintained on an island off the coast for biomedical research. Perhaps the biggest concern, given how close boaters get to these monkeys, is that the Silver Springs population is rife with the herpes B virus. So why not remove the monkeys? Because people love them. Hundreds of monkeys were actually trapped from Silver Springs and sold for biomedical research from the late 1990s into the 2000s, but once the public found out, opposition stopped the culling. So for now, the jungle cruises continue with mere disclaimers—signs warning that feeding the monkeys is illegal.

Cuban Treefrog (*Osteopilus septentrionalis*)

A gray treefrog nestles in my garden. It's a beautiful animal, appropriately tucked into the molded lily pad of a frog-adorned lawn ornament. It looks zen-like in its pose, yet I know this nonnative frog is the reason my native green treefrogs have disappeared. Likely a stowaway from the shipping industry, the Cuban treefrog was first observed in Key West by 1928, was documented as reproducing in the wild by the 1950s, and had already spread through much of South Florida by the 1970s. Today, it's dispersed clear up the peninsula with occasional records even in the Panhandle. Larger than any of our native treefrogs and with a voracious appetite for other amphibians, this beautiful but deadly invader has contributed to declines in green and squirrel treefrogs across the state, including in natural areas. What goes around comes around though, and where native frogs are gone, their native predators—snakes, turtles, and birds—have taken to munching Cuban treefrogs instead.

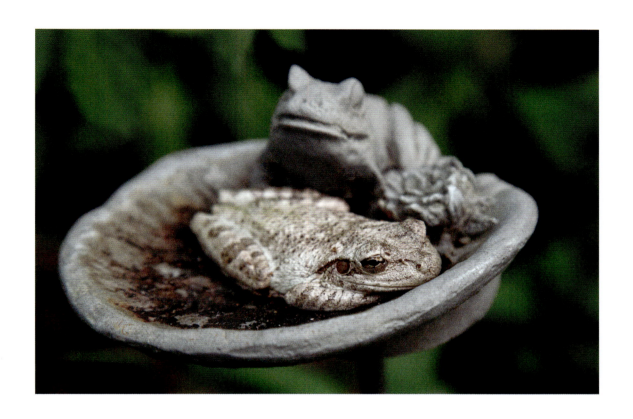

Wild Hog (*Sus scrofa*)

Grasses rustle behind me. I lower my camera, turn slowly, and train my eyes on the moving blades. First a snout, then two eyes, then two pointy ears emerge—a wild hog. I'd seen many signs of hogs across Florida, no small wonder given that roughly half a million roam free, a state population outnumbered only in Texas, but this is the first live animal I've encountered. Before I can lift my lens, the hog is gone. I step into the prairie to pursue it, but somehow this large mammal completely disappeared. I turn back to the wild horses I'd been photographing and realize how appropriate it is that my first wild hog sighting coincided with my first close encounter with Florida wild horses, ancestors of both introduced from Europe long ago. Spanish explorer Hernando de Soto allegedly brought hogs to Florida to provision his expedition in 1539. The population was perpetuated and spread by Native Americans and other settlers who appreciated the self-sustaining food source.

While hunters continue to appreciate hogs, from an ecological perspective, the only good thing about this invasive species may be that it's provided a food source for our recovering panther population. One step into an area where hogs have foraged, however, leaves little doubt as to their destructive nature. When I followed the family pictured here into the woods, it looked like bulldozers had plowed through. Cabbage palms were uprooted, young oaks ripped from the ground, and moonlike craters pockmarked the forest floor. While plants are their primary food source, especially acorns for which they compete with native turkey, deer, and squirrels, hogs also devour the eggs and young of reptiles, birds, and mammals, including at times their own babies. And apart from hunting, wild hogs also fail to benefit humans, costing billions of dollars annually to control and repair their damage to agriculture, infrastructure, and natural areas. Perhaps these facts jade my view as I watch this family of hogs at Myakka River State Park, but it seems they're also destructive to one another, constantly biting, nipping, kicking, and shoving. Then again, their quarrelsome nature is what likely helped them survive in Florida's wilds for nearly 500 years.

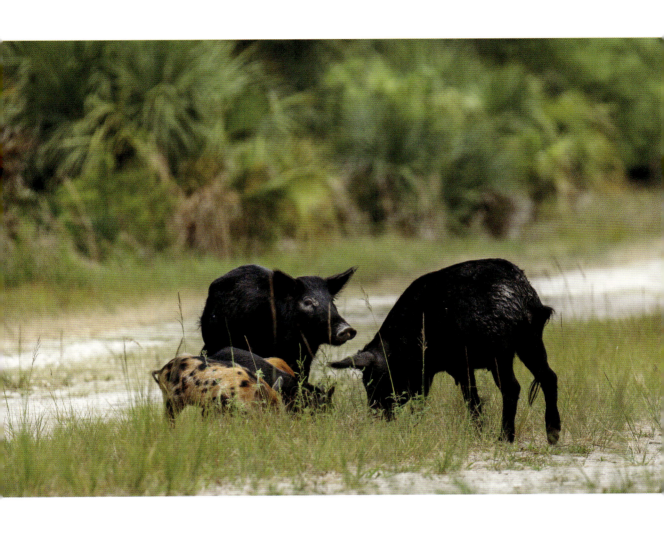

South American Cane Toad (*Rhinella marina*)

I leave my research lab after dark, walking along a sidewalk to cross Florida International University's main campus. The first big rains of the season have arrived and puddles of water riddle the lawns all around. A rolling trill fills the air, the mating calls of cane toads. It feels like mere days later the sidewalks are crawling with toadlets, each of my steps sending a pile of babies hopping away. This is a species that shouldn't be in Florida at all, and yet I see firsthand how it has so effectively spread. Native to South and Central America, cane toads were distributed to various parts of the world as biological control agents. In Florida, they were first released in Palm Beach County in the 1930s to ingest cane beetles from the sugarcane fields, but it wasn't until after several other introductions in various parts of the state that a population became established in the wild in the 1950s. Now cane toads can be found in cities and agricultural areas across southern Florida, extending into the Keys and moving northward with some localized populations even in north and west Florida. Able to reach sizes more than double those of our native toads, cane toads are known to eat not just their native counterparts, but any number of other small animals, plants, dog food, and even feces—nearly anything they can fit into their mouths really. They're also poisonous at all stages of life with adults able to secrete milky toxins from triangular glands behind each eye when annoyed. These toxins have killed any number of native predators in Australia as this nonnative toad has spread across that continent. Fortunately, Florida's native toad predators are familiar with toad toxins from our native species and so are toad wary and have largely avoided this plight. Domestic dogs and cats, however, generally lack such experience. My friend's dog foamed at the mouth after merely sniffing a cane toad, and other pets have fared worse, dying from encounters with these invaders. The cane toad is not to be trifled with.

Burmese Python (*Python molurus bivittatus*)

Tannin-stained waters swirl about my knees as I slog through a cypress dome. The beeping of a radio receiver gets louder, telling us we're closing in on our subject, but I see no serpentine scales draped from branches above. I know pythons disappear in tall grasses, but where in this flooded swamp could a nine-foot python be hiding?

"There," someone shouts.

I follow the pointed finger and squint at the base of a large cypress tree.

"Where?" someone asks.

"In the water," comes the reply.

It's only then that my eyes discern coils of giraffe-style gold and brown patches glimmering faintly from within liquidy shadows. As Artist-In-Residence at the Big Cypress National Preserve, I'd been offered the opportunity to accompany an expedition organized by national park Superintendents Pedro Ramos and Thomas Forsyth, and led by biologist Matthew McCollister and volunteer Mike Reupert, to underscore the importance of their python research. The tagged snake subaquatically wrapped about the cypress trunk was a male whose reproductive drive had gained him a spot in the limelight. He was one of many male pythons attracted to the area by the pheromones of a record-breaking 17.5-foot female that was being held on-site. She served as bait. The goal was research, an attempt to discern whether and for how

Biologist Matthew McCollister radio tracks a python at the Big Cypress National Preserve.

long a gravid female could lure males to an area in the hopes of discovering a more efficient way to find snakes in remote areas.

Natives of southeastern Asia, the python's invasion of Florida began in the 1980s with the increased popularity of keeping exotic reptiles as pets. It's understandable that newbie python owners might have second thoughts a year later when their pet snakes, generally purchased as twenty-inch hatchlings, had already grown to six feet or more. Releases of these unwanted pets in the Everglades, along with a critical mass of pythons escaped from a reptile breeding facility damaged in Hurricane Andrew, formed the basis for today's breeding population. At ease in swamps, grasslands, and jungles in their native land, the Everglades proved an ideal habitat for them with plenty of easy prey. In areas where pythons have lived the longest, there are effectively no more rabbits, raccoons, opossums, bobcats, and foxes.

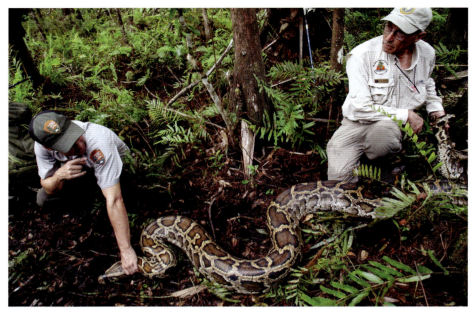
Matthew McCollister and Mike Reupert restrain a python for research purposes.

Larger than any of our native snakes as adults, with few natural predators, and equally comfortable on land and in water, pythons have conquered the Everglades and continue slithering farther afield. It seems not even the ocean poses a barrier as at least one python was discovered basking on a buoy several miles out in Biscayne Bay and another was found swimming fifteen miles offshore in the Gulf of Mexico. As of this writing, pythons have established populations all across the southern mainland from Lake Okeechobee into Florida Bay and upper Key Largo with additional sightings clear up the peninsula including a few in the Panhandle and even one in a bordering county in Georgia.

Aside from their proven adaptability and secretive nature, one of the biggest challenges with pythons in Florida is that there's something universally intriguing about a truly beautiful yet potentially lethal animal lurking in the landscape. They've captured the imagination, drawing hunters and thrill-seekers from across the nation for a chance to conquer this demonized enemy. The reality is, as demonstrated by that python wrapped motionlessly beneath the water for more than fifteen minutes as a dozen people surrounded it in the Big Cypress Swamp, these snakes have little interest in humans. Individually, they're just animals wishing to be left alone in their new home, but the cumulative ecological and economic damage to Florida has been and will continue to be devastating.

Tropical

~

Rhythmic clapping and high-pitched whoops reach my ears as my skiff crosses the sparkling waters of Bird Key Harbor in the Dry Tortugas. The claps and whoops grow deafening as we near a row of mangrove trees. I see the performers tucked within the leaves, male frigatebirds with their wings thrown back and throat pouches inflated into the air like giant red bagpipes. An avian audience soars through the sky, aggregating into a shifting cloud above the performers. A female, distinguished by a smooth patch of white across her breast, crashes down beside an advertising male. His brilliant sac swells but she seems unimpressed. She returns to the sky, narrowly missing a different male coming in with a stick for his own newfound bride to add to her growing nest.

Watching, I find myself transported to Ecuador's Galápagos Islands where I'd spent a day observing Magnificent Frigatebird courtship. It had felt like a once in a lifetime opportunity. Never could I have dreamed then that one day I'd watch the same ballooned displays in what would become my home state. Yet I'm aware, as I watch the billowing red pouches, that the presence of these birds is part of what makes Florida special. Dry Tortugas National Park is the only place in the United States to observe this tropical bird's mating spectacle. It's also the only place in the continental United States where Masked Boobies, another tropical bird I first observed in the Galápagos, nests. Just like the Galápagos, everything about the Dry Tortugas feels tropical—the birds, the sea turtles emerging from turquoise waters beside the boat, the powder white sand I cross to snorkel beach-side coral beds. The Dry Tortugas is indeed tropical, but so is much of the southern half of the state.

Attached to temperate North America but extending into the warm waters of the Caribbean, South Florida is the only place in the continental United States to merit a tropical climate classification. It makes national news the rare winter when temperatures dip into the forties long enough for nonnative iguanas introduced from even warmer climes to fall frigid from their trees. The weather in South Florida is that of

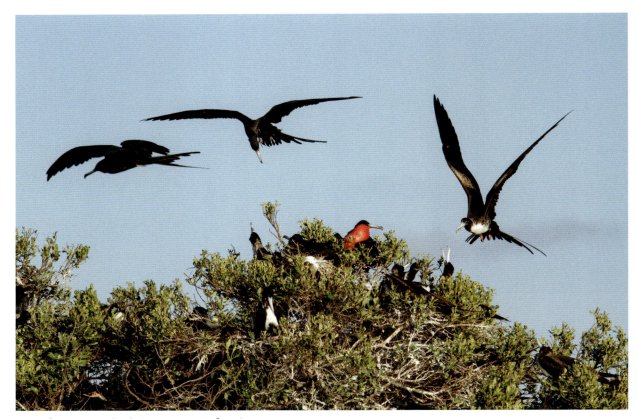
Magnificent Frigatebirds (*Fregata magnificens*)

the nearby Caribbean—by and large warm with rain dictating seasons and periodic hurricanes sculpting the land.

 Just like the climate, many of South Florida's native habitats, plants, and animals are also shared with neighboring tropical islands and beyond. The equivalent of South Florida's highly endangered pine rockland habitat can also be found in the Bahamas and Cuba. I learned many of my South Florida coastal plants studying the diet of rock iguanas in the Bahamas. I've watched wintering warblers flit through the familiar branches of a gumbo limbo tree in Guatemala, the same species of birds I'd watched flit through that same type of tree in my South Florida yard just a month before as the birds migrated through. Many of South Florida's native tropical plants, representing more than 60 percent of the plant species south of Lake Okeechobee, were brought to the state from farther south as seeds in the bellies of migrating birds.

With oceans to cross, most of South Florida's native tropical animals are those that fly or swim. Birds, bats, butterflies, and beetles crossed the sky. Crocodiles, sea turtles, manatees, and land crabs crossed the sea.

Some animals, amphibians, reptiles, and snails, for example, likely rafted over, perhaps enabled by storm winds and seas. I learned the reef gecko, a tiny lizard I'd first encountered under leaf litter while camped on a Bahamian island, as being Florida's only native gecko. Its presence is now attributed to ship traffic since it was first documented in Key West after Caribbean trade routes were already established in the 1800s, but who's to say a few of these island dwelling lizards hadn't already made it on their own? Bahama Mockingbirds, Cuban Pewees, La Sagra's Flycatchers, and other Caribbean birds often show up on our shores individually, staying several days and sometimes months feeding from plants they know from similar habitats back home. I recently watched not just one but two La Sagra's Flycatchers, visitors from

Masked Booby (*Sula dactylatra*)

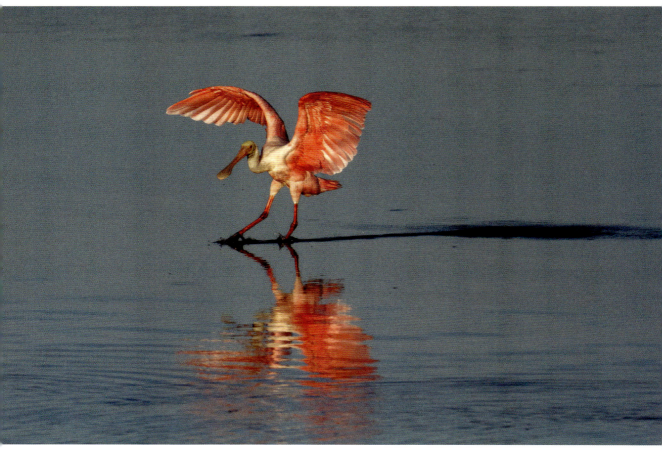

Roseate Spoonbill (*Platalea ajaja*)

the Caribbean never before documented as a pair in Florida, flitting between tree snags investigating cavities in Biscayne National Park. As far as I know, they never found the right hollow to nest in, but perhaps they'll be back with better luck next year. This is how new tropical species become established in Florida—more than one arriving at a time, taking up residence, and nesting in South Florida's tropical lands much as the Magnificent Frigatebirds have. Or myself, for that matter. Every time I see a frigatebird floating above Biscayne Bay in Miami, a relatively frequent occurrence, I'm reminded that I've chosen to live in the tropics.

American Crocodile (*Crocodylus acutus*)

Golden Silk Orbweaver (*Trichonephila clavipes*)

A web glows in the morning light. It stretches several feet between two trees in the forest, invisible from some angles, white threads from others, and a breathtaking matrix of golden silk when viewed from just the right spot. It is a web that has intrigued natural historians, scientists, and engineers for centuries. Stronger and more flexible than Kevlar or steel, with thermal conductivity nearly as high as copper even when stretched, and able to serve as a conduit replacement for damaged nerves, it's no wonder the silk of this beautiful web garners such scientific interest. But these webs are also homes. At the center of the web before me sits its owner, a gold, black, silver, and white female Golden Silk Orbweaver. The largest non-tarantula spider native to North America, it ranges into the southernmost states of the United States from its Caribbean, Central and South American distribution. It's the females that spin these spectacular webs, living on the same one for several weeks and repairing damage rather than rebuilding daily as some spiders do. This female has a suitor, large for a male Golden Silk Orbweaver but a mere speck compared to her. At the peak of breeding season, she may have dozens of males lurking at the edges of her web, but on this day, I see only one. The males have limited sperm and must choose their mating technique wisely. Some opt to mate with several females while others mate with just one whom they guard against other males. The suitor I watch is likely large enough to win such battles, and as he boldly draws near the female, an act that may take weeks to accomplish without evoking her aggression, I decide he must've chosen the guarding technique. Fortunately for him, the females of this species rarely eat their mates.

Reddish Egret (*Egretta rufescens*)

A leap. A turn. A pirouette. Wings stretch back. Toes prance forward. Sharp eyes scan. Another leap. Another turn. The wings stretch overhead. A pause in the action. The bird wraps its wings about its body, staring into the shallows of Biscayne Bay below. Several quick steps forward, then an elegant neck plunges below the water's surface, coming up with a fish pinched neatly within the bird's bill. It is this elaborate dance, a Reddish Egret's equivalent of the two-step with moving feet and lifted wings scaring up prey, that makes me realize an all-white bird I watch at Sebastian Inlet is a Reddish Egret in disguise.

A common color morph farther south in the species' Central American and Caribbean range, white birds are rare in Florida where Reddish Egrets are more typically gray and coppery-red. I'm partial to the richly colored palette myself so this

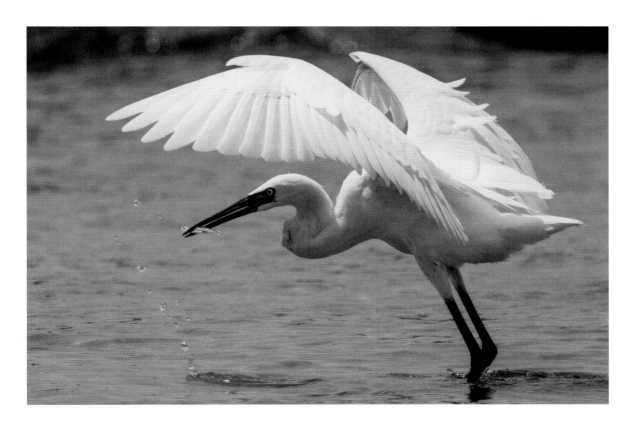

suits me just fine, but I'm aware that seeing either color is a treat; there was a time when both were missing from Florida.

Like many of the state's wading birds, Reddish Egrets were heavily hunted when plumes were prized for fashion in the 1800s. They were hunted to extirpation in Florida, disappearing completely. Fortunately, after protections were put in place, Reddish Egrets began reappearing on Florida's shallow coastal bays and estuaries in the 1930s, and now Florida is one of the best places in the United States to watch this bird pirouette down the shore.

Liguus Tree Snail (*Liguus fasciatus*)

Darkness envelops me as I step from the brightly lit marsh into a tree island, a pocket of hardwood hammock within the Everglades. I wait for my eyes to adjust, then begin scanning trees for arboreal snails. These terrestrial mollusks once glistened from nearly every smooth-barked tree in the tropical forests of Cuba, the Florida Keys, and southern mainland Florida, displaying a range of colors and patterns that tantalized scientists and amateur collectors. Competition was intense. Entire hammocks were burned to ensure that no other collection shared the sometimes hammock-specific shell designs. Between such over-collecting and the fact that nearly all South Florida's native hammocks have fallen prey to bulldozers, it's not so easy to find liguus tree snails anymore. Fortunately, a handful of concerned shell collectors and early staff at the then newly formed Everglades National Park had the foresight to translocate snails of various color forms into the park's protected hammocks. Today, more than fifty officially recognized patterns remain in the wild, continuing to earn this snail its nickname of living jewel.

Blue Land Crab (*Cardisoma guanhumi*)

Scuttling sounds as I approach. Flashes of blue across the sand as a group of Florida's largest terrestrial crab scatters for cover. Silence. Then I notice beady eyes lurking in the shadows of one burrow, the tip of an enlarged claw cautiously emerging from another. Several minutes pass. Finally, one of the giant land crabs braves the open, only to dash once again out of view as a car drives by. Native to tropical coastlines of the western Atlantic from Bermuda through the Caribbean, and from the Gulf of Mexico south to Brazil, these otherwise terrestrial animals are confined to within a few miles of the ocean where their lives begin. Generally shy and nocturnal, they appear to gain confidence during the breeding season when great masses may migrate through neighborhoods, moving under shrubs, climbing over screened enclosures, and crossing roads to reach the sea where the females lay thousands of eggs at a time. It's a spectacle I used to encounter when commuting along Miami's Old Cutler Road on late summer nights. I'm told in the 1950s and 60s the numbers of crabs in season along this route were so pervasive and dense that cars often got flat tires from smashing through the maze of large, sharp claws. Perhaps tires were weaker back then, or perhaps there's cause for concern because I've personally never seen masses too large to avoid merely by slowing or briefly stopping to let them pass.

White-crowned Pigeon (*Patagioenas leucocephala*)

A poisonwood tree rustles above as I walk through a tropical forest in the lower Keys. I stop and look up, watching shifting leaves until finally I spot a flash of white. An elongated pigeon with iridescent green stripes along the nape of its neck and a brilliant white crown steps into view. It clutches a poisonwood fruit in its bill, which it swallows whole. It glances down at me, then returns to its feeding. An otherwise Caribbean bird found in Florida only in the extreme southern mainland and the Keys, it nests and roosts primarily on mangrove islands but travels many miles a day to find fruit in tropical forests. I think of White-crowned Pigeons as shy and wary, staying deep in the leaves like this one in the Keys, but I've also seen them sitting boldly out in the open on telephone wires in southern Miami or one time on a leafless tree branch at nearly head height beside a busy ferry terminal in Key West.

Florida Manatee (*Trichechus manatus latirostris*)

An exhale from the water, a gentle splash as a rounded tail rises momentarily beside my kayak along Biscayne Bay's shore. A few torpedo-looking mammals gathered in a lagoon at the Deering Estate at Old Cutler. A mother and calf in the canal behind my house on Key Biscayne. Another mother and child just off the Crandon Park beach, close enough to wade alongside as they graze a shallow seagrass bed. My various winter encounters with manatees around South Florida, where warm water and manatee feeding grounds largely overlap, thrilled me. It wasn't until I began my quest to see them in Florida's vast but food scarce artesian spring system to the north, however, that I appreciated the complexity of a manatee's life.

I naively assume guaranteed success as I head north in mid-January. It's 60°F, downright chilly by Miami standards, and surely a place named Manatee Springs State Park will host manatees on such a winter morning. I'm wrong; not a single manatee has traded feeding in seagrass meadows for the relative warmth of the spring. I try the Crystal River National Wildlife Refuge and the Blue Spring State

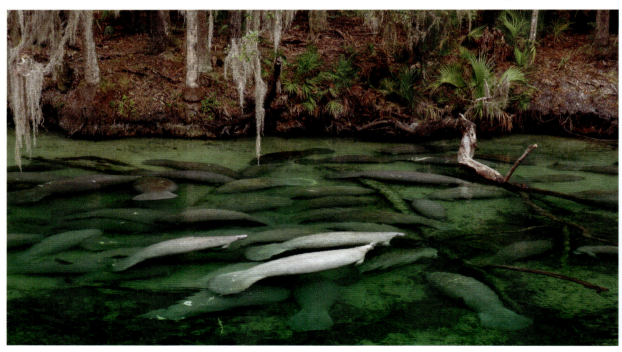

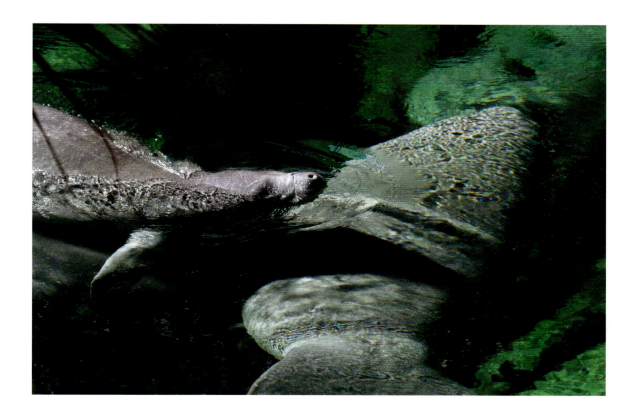

Park, other famed manatee gathering sites, but these too display zero on their daily manatee tally signs. Apparently, my idea of cold isn't the same as a manatee's.

A satisfying crunch of frost greets my foot as I step onto the grass at the Three Sisters Springs on my next visit to the Crystal River. Surely such frozen land means ocean temperatures have fallen below the 68°F tropical manatees require, yet once again I find myself staring into empty waters. I follow the path toward King's Bay, admiring the creek alongside the walk, then realizing it's the reason the springs are empty. The bay teems with warmth-seeking manatees gathered at the mouth of the stream, but it's a tidally dependent connection that now, at low tide, is too shallow for the manatees. The water rises slowly, imperceptibly, but several hours later, as if on cue, a line of manatees swim down the narrow creek to wallow in the thermally constant spring. How did the manatees know this?

Evidence suggests that mother manatees pass their wisdom on to their offspring, sharing cumulative generational knowledge but also adding secrets they've learned during their own fifty- to sixty-year life spans—where the lushest seagrass beds are

Tropical · 93

located, when emergent saltmarsh plants produce nutritious young shoots, where and how to find warm water in winter, migrational maps and schedules. Manatees are creatures of habit, returning year after year to the same summering and wintering grounds, but these inherited routes differ among individuals. Gulf Coast manatees rarely if ever cross over to the Atlantic and vice versa. Other manatees spend all year in South Florida, overlapping with migrants from the north only in winter when a balancing act between the need for warmth versus food controls their movements. Unfortunately, both their warm water and food resources are currently under threat.

As access to natural warm water sources have been reduced by dams, diverted water flow, and development, manatees have discovered new artificial warm water sources at power plants and other facilities. Over time, some manatees have altered their migratory habits, spending all winter much farther north than historically possible. This is a dangerous situation when a power plant shuts down or in a severe winter when there's too little warm water for the number of manatees, leading to cold stress and death.

And manatees are starving. These dedicated herbivores consume tons of seagrass annually, but thousands of acres of natural seagrass have been lost in the last decade or so to pollution-induced algal blooms, boat propellers, warming waters, and silty discharge. In 2021, a record 1,100 manatees died, largely due to starvation, and another 80 or so were admitted into rehabilitation centers to be treated for malnutrition. The situation became so dire that an unprecedented program to feed wild manatees thousands of pounds of lettuce a day was implemented at the Indian River Lagoon. Manatees are Florida's canaries of estuarine ecosystem health, and if recent years are any indication, our marine environment is in trouble.

I had the opportunity to feed a boat-injured manatee at a rehabilitation center where its velvety lips pulled my entire hand inside the pillow-soft interior of its mouth where peg-like teeth tenderly extracted my offered greens. I was surprised by the intimacy and gentleness of the interaction, an exchange that required trust on both our sides. In truth, these gentle creatures have no choice but to trust their fate to humans. I fear we haven't treated them as kindly as that one injured animal treated me, but there is still time to make amends.

Snail Kite (*Rostrhamus sociabilis plumbeus*), Apple Snail (*Pomacea* spp.)

The sky darkens and the temperature drops. I sense heavy rain coming too quickly for me to make it to cover. A raindrop splashes on my shoulder and I tuck below a palmetto frond. I hear a swooshing as I rummage for my poncho; I've got company. A juvenile Snail Kite perches in the adjacent pine tree, a nonnative apple snail clutched in its talons. With specialized curved bills, these tropical birds exclusively eat apple snails across their extensive range from Florida through South America. It was thought that the North American subspecies, mostly found and only nesting in Florida, had a bill shape further evolved to specifically match the small size and shape of Florida's only native apple snail species. Alarms were raised when first one, then two more species of apple snails from South America found their way into Florida's

wetlands. Would they outcompete our native apple snail with their larger size and more numerous eggs? And if so, what would our native snail kite eat? The issue of competition between native and nonnative apple snails proves complicated. There's little doubt, however, as to the Snail Kite's stance on these nonnative invaders. I watch the raptor beside me manipulate the snail in its talons, grasp the soft-bodied animal inside with its bill, then dine upon its nonnative prey, producing an empty shell to add to one of the many piles to be found at the Winding Waters Natural Area.

Geiger Tortoise Beetle (*Eurypepla calochroma floridensis*)

Geiger tree blossoms glow like orange sapphires in the morning light and yet my team of third graders seek yellow diamonds in shadows beneath the foliage. They fan out around the tree, carefully lifting its leaves to peer below. I hear a gasp, "I found one," squeals a little girl. I transfer our thumbnail-sized gem into a magnifying box and pass it around the group. "It's beautiful," says another. Even the most squeamish

child is inevitably enchanted by the Geiger tortoise beetle as its color magically shifts with fluids moving through the cuticle of its hard outer shell. It was a favored highlight on the nature walks I led through the tropical maritime hammock at a seaside nature center on Key Biscayne. I could always count on a good reaction when I told my group that the larvae protected themselves from predators by carrying their feces atop the ends of their tails, lifted above their heads like umbrellas dripping excrement down across their bodies. I could also always count on finding this gemstone beetle on this species of tree, its sole host plant through its entire life cycle. But here's where things get interesting.

While the Geiger tree is dispersed by floating fruit and is found throughout the coastal regions of Central America and the Caribbean, its native status in Florida is contested. Its name honors John Geiger, a wealthy wrecker from whose yard a flowering branch was plucked during John James Audubon's visit in 1832. Audubon depicted the flowers in his painting of White-crowned Pigeons, noting only that the tree was rare in the Keys. Legend extrapolates that the tree in Geiger's yard had been imported from Cuba rather than being a natural element of the Keys' forests. And yet the Geiger tortoise beetle found in Florida, an animal entirely reliant on this one species of tree, is considered an endemic subspecies. I suspect this gem of a tree, once limited to the Keys and coasts of only the southernmost portions of the peninsula but now widely planted as far north as Cape Coral on the west coast and Palm Beach on the east, has sparkled in our tropical forests as long as it has in the neighboring Caribbean—and the Geiger tortoise beetle has sparkled right alongside.

Swallow-tailed Kite (*Elanoides forficatus*)

Bold black and white markings paired with a strikingly forked tail; this is a bird not easily forgotten. I see my first while paused at a stoplight on Sunset Drive in Miami. Sleek and elegant, the kite seemingly appears out of nowhere, swooping larger than life across my windshield. I sit there stunned; the experience so surreal that I wonder whether I've imagined it altogether. Yet the details of that moment remain so vivid that even decades later I picture that bird every time I find myself at that intersection. A bird more associated with forest edges near open habitats, Swallow-tailed Kites arrive in Florida from South America in early spring to nest. They glide across the marsh, acrobatically catching and eating insects in the air. For their young, however, they prefer more substantive food plucked from trees. I watch one morning as a parent delivers half a dozen frogs to its newly fledged young. The juvenile sits

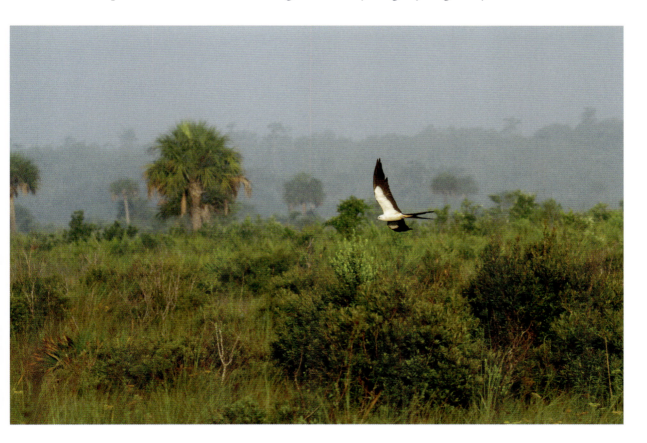

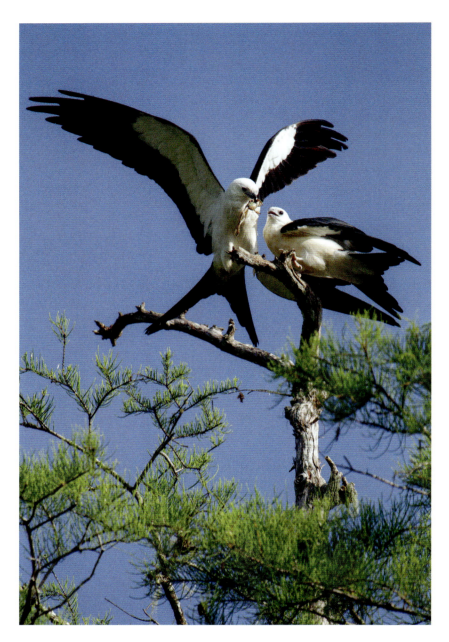

patiently atop a cypress tree, stretching its wings into the wind as if practicing to fly until the adult returns with another amphibian treat. By the end of the summer, this young bird will be strong enough to join the thousands that converge upon Fisheating Creek for one last social affair of the season before heading south for the winter.

100 · *Wild Florida*

Florida Atala (*Eumaeus atala florida*)

A flutter of black wings above my yard coontie draws me to the window. A red body and iridescent blue spots lures me out the door. I circle a small but stunning butterfly as it twirls above my cycads, and I feel triumphant. Atala butterflies once crisscrossed southeast Florida's skies, flitting from one patch of pineland coontie to the next. This fern-looking plant, North America's only remaining native cycad residual from an

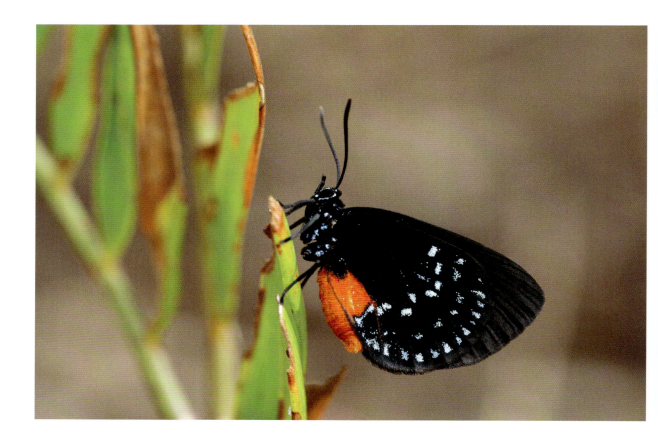

era when dinosaurs roamed the earth, serves as host to the bright red and yellow caterpillars of this tropical butterfly. The brilliant colors are no accident, they warn potential predators of the toxins the atalas have accrued by eating the poisonous coontie. The coontie too benefits from this relationship as atala caterpillar excrement fertilizes the naturally nutrient poor soils of the pineland.

 Less mutualistically, people also used the coontie cycad for its starchy root. Florida's Indigenous Peoples developed a method to remove this plant's toxins through a process of macerating and boiling the root to make bread. It was a method used sustainably for generations, feeding people and Atalas alike. But pioneers in the early 1900s industrialized the method, harvesting several tons a day at its peak to create a starch known as Florida arrowroot. Between overharvest and rampant development of pine and hammock habitat, both natural coontie and the Atala butterflies declined. By the 1960s, the Atala butterfly was considered extirpated in Florida, relying

on populations in Cuba, the Bahamas, and the Cayman Islands to keep the species from extinction. In 1979 though, a naturalist discovered a small population of Atala butterflies on Key Biscayne.

By the time I arrived in Miami in 1998, both the butterflies and their coontie were being reared in captivity and new populations were being established, but the population on Key Biscayne had disappeared. A fellow graduate student at Florida International University, Eileen Smith, had planted coonties at the site where Florida's Atalas had been rediscovered and was doing an experimental reestablishment; her enthusiasm was infectious. I encouraged everyone to plant coontie and found myself instinctively examining the little cycads everywhere I saw them, hoping to see brightly colored caterpillars or at least their tiny white eggs. It was years before I spotted my first wild Atala among a patch of coontie on Key Biscayne, and while I began to see them more regularly around Miami, I was desperate to support them in my own space.

When all I had was a balcony, I planted coontie in a pot. When a landlady let me plant a little patch in front of my garage apartment, coonties were in the mix. When I finally moved into my own place, first on Key Biscayne and then in Coconut Grove, coonties were among the first plants I planted, and yet years passed with not even a munch upon their leaves. My coonties in the Grove had grown chest-high and I'd become convinced that they were too old and tough for Atala butterflies anyway, but then I saw that black flutter outside my window. As I write, red and yellow caterpillars fill my coontie, brown pupae swing from the leaves, and small black, red, and iridescent blue butterflies flit across my yard. Population booms and busts are apparently part of the Atala lifestyle as they eat out one area, then move on while it recovers, but for now I have Atalas in my yard and it feels like a triumph both for this resilient species, and for me.

American Crocodile (*Crocodylus acutus*)

Stars spray across a moonless sky, the only visible light for as far as I can see. Wind whips across my face and I hear splashing against the boat's sides, but even our wake is lost to darkness. I squint ahead, struggling to see the inky islands the helmsman so deftly swerves to avoid as we reach Madeira Bay in the Everglades. It feels like a maze to me, but the driver steers directly to our destination. I step to the bow as the boat slows, grabbing a line and switching on my headlamp as I hear sand scrape across the bottom. I'm about to jump into the shallows when I notice a glint of red glowing in the water. I turn and find an American crocodile gazing into my light.

"That should be mom," my colleague observes.

We watch in silence as the animal sinks out of view. Unlike its notorious counterparts in Africa and Australia, South Florida's crocodile is shy, this female unwilling even to defend her nest against our intrusion.

I wait until the ripples calm, then ease into the knee-deep water. I tie our skiff to a mangrove root and follow a makeshift trail to a sandy mound above the high-tide mark. The mound remains intact, eggs safely buried within, unharmed by floods or raccoons but apparently not yet ready for mom to free the hatchlings we'd hoped to find, mark, and measure. The numbers from this particular nest will be added another day, but the cumulative story from over a quarter century is a positive one.

At the northern edge of its tropical range, this is a species that nearly succumbed to human pressures with fewer than 300 animals thought to remain hidden within remote areas of extreme south Florida by the time it received federal protection in the 1970s. Gradually, the number of nests has increased over the decades and there are now thought to be a couple thousand American crocodiles in South Florida. They've reclaimed old territories throughout the Florida Keys, across Biscayne Bay, and are expanding beyond. I was pleased to add one to my yard species list as it lay on a floating dock in the canal behind my home on Key Biscayne. I've seen them on beaches, in botanical gardens, in marinas, in city parks, and on private golf courses along the coast from the lower Keys up into Palm Beach County, quietly basking like some oversized yard ornament.

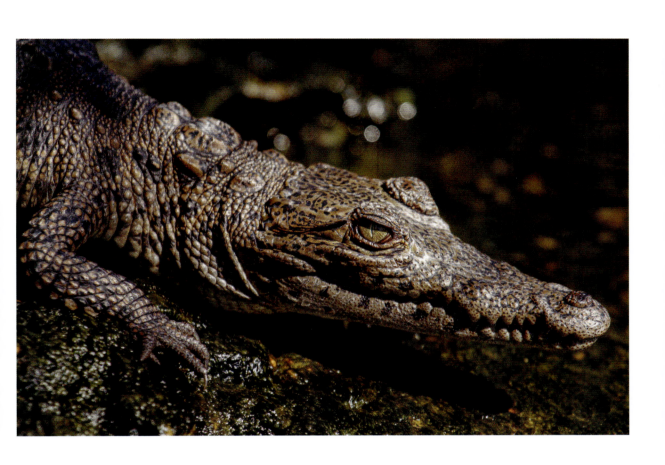

Great White Heron (*Ardea occidentalis*)

A large white wading bird stands in an Everglades marsh, hardly unusual. I nearly walk past without a second glance, yet something about this bird makes me pause. It seems different than the several Great Egrets I've just seen. It's larger, with a hefty bill, and plumes on its head, a sure sign this is no Great Egret. It's a Great White Heron, a bird first described as a distinct species by John James Audubon during his Florida Keys visit of the 1830s.

Audubon painted this large heron with Key West in the background, an appropriate choice given that the Florida Keys are this species' primary nesting ground, and the best place in the world to see this elegant bird. But while Audubon's depiction of the bird as a special Keys resident goes undisputed, his designation of it as a distinct species was challenged 140 years later. It was reclassified as a Great Blue Heron, considered a color morph by some, a subspecies by others, and still its own species by others. The pendulum seems to be swinging back toward accepting the Great White Heron as its own species. International authorities already recognize it as such; the IUCN Red List authority has classified it as an endangered species.

Whatever the taxonomic debate ultimately concludes, the fact is that a Great White Heron was distinct enough to stop me in my tracks that day in the Everglades. It's a sensational bird with a limited South Florida range and declining numbers. Designed to visually hunt fish in the clear, shallow waters of seagrass meadows, Great White Herons, like the manatees, are suffering from pollution-related seagrass die-offs. I'm pretty sure if the Great White Herons could speak for themselves, they'd prefer we humans spend less time debating their species status and more time protecting the marine environment they depend on.

Temperate

A tower of sticks rises from a pond in a Tallahassee city park, consuming the base of a willow tree. I sit quietly on an adjacent boardwalk bench, my eyes roving from the pile to the surrounding water and vegetation beyond.

My cell phone rings. I see it's a friend of mine from Miami, an outdoorsman who has lived his entire life in South Florida and more recently purchased a second home in the Gainesville area. Knowing he'll appreciate my mission, I answer and tell him I'm stalking a beaver lodge.

"Where did you say you were?" he asks.

"Tallahassee," I repeat.

"There are beaver in Tallahassee?" he questions, "I didn't know we had beaver in Florida."

That was a phrase I heard a lot, from Floridians and non-Floridians alike. The tone was always incredulous and I understood. It does seem counterintuitive that an animal made famous by fur trapping expeditions deep into snowy Canadian wilderness, an animal whose scientific name derives from its Canadian range, would exist in a state nicknamed Sunshine and famed for its palm-studded beaches. Yet, as the sun lowers to the horizon, I watch this classic North American mammal glide across Florida waters.

The disbelief that there are beavers in Florida stems partly from a misunderstanding of the animal, a creature that prior to overhunting for the fur trade inhabited nearly every freshwater system in North America, at least north of South Florida. But it's also an underestimation of Florida. It's true that it rarely snows even in the northernmost portions of the Sunshine State; it made headlines when 0.1 inch of snow whitened Tallahassee in 2018, the first measurable snow there in sixty years. But Florida is not without temperate elements. A sign at the Florida Caverns State Park in the Panhandle welcomes visitors to a temperate hardwood hammock, a type of northern forest that creeps into the upper portions of the state and serves as a familiar environment for chipmunks, copperhead snakes, various salamanders, and

American Beaver (*Castor canadensis*)

other North American animals whose ranges extend into the state no farther than the boundary of this habitat.

The Florida Panhandle in particular is a hotspot for temperate diversity, making it unique in this predominantly tropical state. No other area of comparable size in North America has a greater number of frog and snake species, and it also ranks among the top for turtles, salamanders, freshwater fishes, and plants. Poised at the confluence of the Gulf Coastal Plain to the west, the Atlantic Coastal Plain to the east, and the Appalachian Mountains to the north, this topographically rich portion of Florida remained above water and connected to North America throughout the Pleistocene. It served as an upland refuge for a variety of species while the rest of the peninsula submerged periodically as sea levels fluctuated over hundreds of thousands of years. The Apalachicola River, with its headwaters in the Appalachian Mountains, continues to serve as a conduit for temperate species to enter Florida from the north. This helps explain why the Appalachian spotted skunk, a subspecies that occurs only in those mountains, can be found in the Panhandle but nowhere else in the state.

But Florida's temperate flare isn't limited just to this area of northern connectivity; much of our native wildlife derives from temperate North America. As a peninsula surrounded by water on three sides, the only route for terrestrial species was from the north. There was no other way for land-bound animals to arrive. Over the

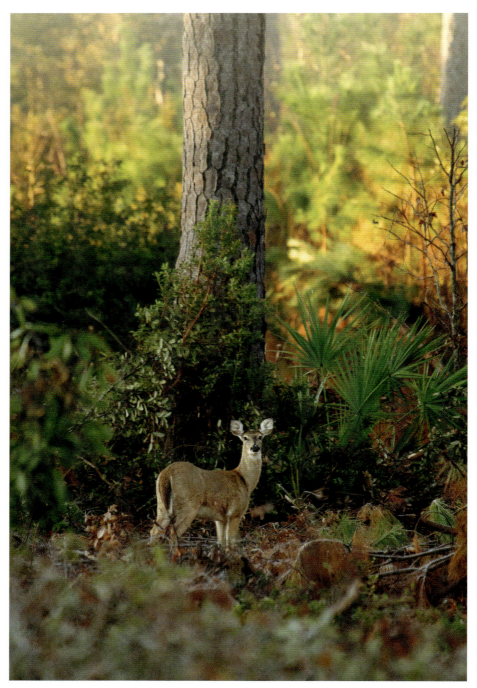

White-tailed Deer (*Odocoileus virginianus*)

Bush Katydid Nymph (*Scudderia* sp.) on Leafless Beaked Lady's-tresses Orchid (*Saciola lanceolata*)

millennia, bears, panthers, foxes, raccoons, squirrels, and deer all funneled through the northern portions of the state, following whatever routes were available at the time with some species arriving in multiple waves. Genetic studies on white-tailed deer, for example, indicate three distinct groups within the state—one in the Panhandle extending into Mississippi, one in peninsular Florida extending along the Atlantic Coastal Plain into Georgia, and one in the southern portion of the state including both mainland and Key deer. These are thought to represent three different dispersals, with the southernmost animals having arrived from the Gulf Coast at a period of low sea level when the Keys were connected to peninsular Florida. As sea levels rose and separated the Keys from the rest of the peninsula, these deer too

Temperate · 111

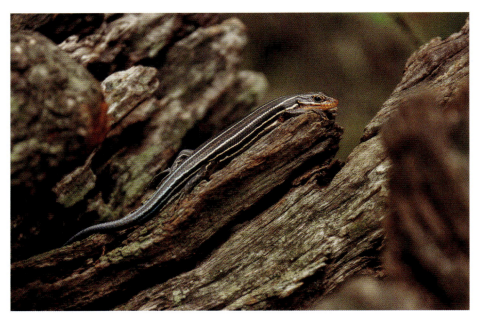

Southeastern Five-lined Skink (*Plestiodon inexpectatus*)

were further separated into different populations that continued to evolve independently. The Key deer is now the smallest in North America and taxonomically distinct enough to merit its subspecies classification. This story of arrival, isolation, and adaptation to the point of distinction is one shared by many animals in Florida. It is the reason that our list of native temperate animals includes such specialties as the Florida black bear, Florida box turtle, Florida cottonmouth snake, and, in the peninsula, the Florida spotted skunk.

From specialized bears to geographically restricted beavers and widespread white-tailed deer, temperate animals are an integral part of Florida's animal life. This touch of temperate, not only in the Panhandle but also as filtered throughout the state, is part of what makes Florida special.

Beaver dam in foreground, lodge in background at Blackwater River State Forest

American Beaver (*Castor canadensis*)

Turn left at the beaver dam? I repeat the unusual directions in my head as I drive down a dirt road outside the town of Milton in the Panhandle. All the beaver dams I'd ever seen were small affairs off mountain streams in Colorado and Washington State, scenes I struggle to transpose to the seemingly flat pinewoods around me. I drive slowly, certain I'll miss this unlikely landmark—until I see it. A wall of sticks and mud as high as my Jeep's window running down the length of the road half a mile or so. Trickles of water puddle on the roadside at a couple of bends, but this is no haphazard structure. This is a feat of engineering holding a massive lake, placid waters stretching as far as I can see back into the pines. One tiny stick lodge stands tucked between a few trunks in the middle of the expanse, no doubt safely hiding the architects. How many generations of beavers had it taken to create this marvel? And this dam turns out to be just one, not even the largest, along this stretch of road.

The very fact that Florida has beavers at all comes as a surprise to many Floridians, and dams as grand and numerous as the ones I saw that day would be unimaginable. And yet for residents of North Florida, beavers are a part of life. It only takes a couple of beaver-seeking hours in Tallahassee city parks for passersby to give me a list of recommended parks with viewable lodges. As I sit on a boardwalk waiting for one of these aquatic denizens to show itself, people pause to tell me of the one or two times they've seen the beavers. Everyone seems to know that the beavers are there, they comment on the lodge and telltale gnawed off sticks, but it seems the beaver's nocturnal habits keep most people wishing and waiting for their chance to see one. As my few day visit comes to an end, I begin to worry that I too will join the wishing masses, but then I see it, on my last night in town, ripples leaving the lodge and heading toward a vegetated bank where a fuzzy brown head pops into view to gnaw on a freshly harvested stalk.

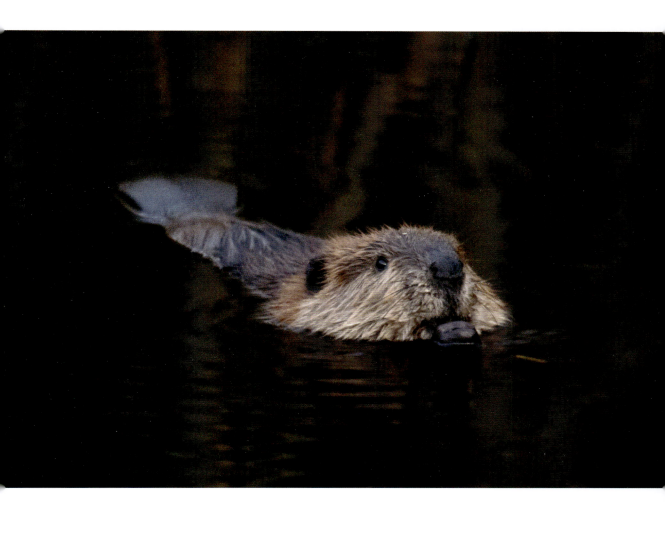

Carolina Wren (*Thryothorus ludovicianus*)

Something flits into the bush beside me as I stand at the edge of the forest at Gilchrist Blue Springs State Park watching the Santa Fe River meander by. The leaves rustle, then a small brown bird darts out, a twig clutched in its bill. The bird lands atop a cypress knee, cocking its tail upright in a characteristic wren manner. It peers in all directions, then jumps and disappears. I ease to the opposite side of the cypress knee and see exactly where the little wren has gone. A jagged opening reveals a hollow in the root, the perfect niche for a Carolina Wren to nest. Tufts of twigs and leaves already tumble out the bottom, but the wren returns with another bill-full. Back and forth they go, both the male and the female delivering one load after another of plant material that they stuff into their hole. Kayakers glide past, a motorboat with its stereo blasting putters by, paddleboarders pass within a few feet, but the birds hardly seem to notice. While largely absent from the greater Miami area into the Keys, this is still one of Florida's most widespread breeding birds, and they don't mind people. They happily nest in flowerpots, mailboxes, nearly anywhere but a proper nest box. I've seen one try to build a nest atop a fishing tackle box hanging in a garage. Still, there's something nice about seeing this popular yard bird out in the wild, nesting in an idyllic cypress knee alongside a beautiful river.

Striped Mud Turtle (*Kinosternon baurii*)

Beyond a veil of willow leaves, the largest striped mud turtle I've ever seen sits on a log, its image reflected in the pool below. Even at a distance, I can see three stripes extending longitudinally along the four inches or so of its domed shell. Far more prominent in hatchlings but faint to missing from adults in some areas, those stripes gained the species its name and help distinguish it from other mud and musk turtles. Native to the southeastern United States, this common though often overlooked turtle can be found everywhere in Florida but the western Panhandle. My previous sightings had been in the Everglades where adults tend to be smaller than those farther north. And I'd mostly encountered this freshwater species wandering across the marsh, something they frequently do after heavy rains, burrowing into terres-

trial shelters when ephemeral ponds dry. Despite the species having been described from a population in the lower Keys, this is a turtle that doesn't tolerate salinity well. There is much concern for the isolated populations in the Keys where rising sea levels are turning freshwater pools brackish.

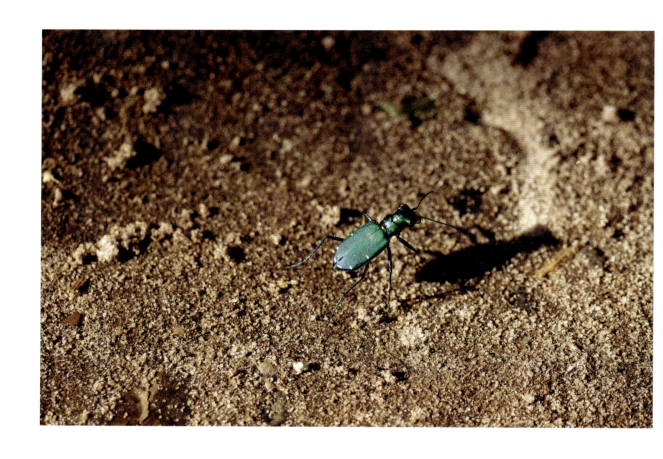

Six-spotted Tiger Beetle (*Cicindela sexguttata*)

A flash of metallic green on the sandy trail through the woods at Ponce de Leon Springs in the Panhandle catches my eye. It's a large beetle like none I've seen before, but the moment I lift my camera, it disappears. The green reappears as I take a step forward, then it's gone. It flashes to my left. I turn in its direction. It disappears. Then it's on my right. I turn clockwise. It disappears. I take a step forward and there it is, on the trail ahead of me. I stand still, and watch this beetle perform disappearing acts all around me. Just like a human magician, speed and unpredictability prove to be the key. Predatory insects that stalk and kill their prey just like their mammalian namesake, tiger beetles are some of the fastest running insects in the world. They move so quickly that not enough light reaches the receptors in their eyes to see, so they must stop to reorient, to relocate the ant, spider, or other insect of their culinary desire, or to avoid robber flies, birds, lizards, and other animals that might eat them instead. Up, down, right, left—the beetle before me adroitly flashes through the air and across the sand, but its temporary blindness is my advantage. As it stops to reassess my location, I photograph what proves to be a six-spotted tiger beetle, a species widely distributed through the eastern half of the United States, but within Florida occurring only in the Panhandle.

Broad-headed Skink (*Plestiodon laticeps*)

A tumble of dry sabal palm fronds lay in a maze alongside a forested trail in the Guana Tolomato Matanzas National Estuarine Research Reserve. I scan the interlocking pattern of curves and spot a sleek lizard. Its large body follows the contours of its perch, its vivid orange head rests on a peak as if on a pillow, and one ebony eye follows my every movement. Had this been a blue-tailed juvenile, it could've been mistaken for either of two other skink species found in Florida, but its size, brilliant head color, and the scales on its upper lip confirm it as a broad-headed skink. The largest skink native to the southeastern United States, it ranges only as far south as north-central Florida, roughly where this one basks on dead palms.

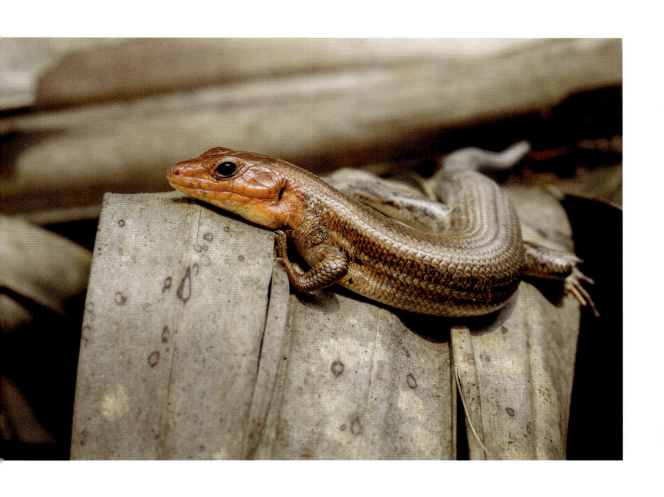

Three-lined Salamander (*Eurycea guttolineata*)

There's something freeing about kicking off my shoes, rolling up my jeans, and walking barefoot through the cool, gurgling waters of a forest stream. I flip rocks and logs, thinking only of the amphibian treasures I might find below. Googly eyes meet my own as I lift my first salamander from its mossy nest. In that moment, in the middle of a college field trip in Indiana, I feel completely at peace and in sync with the earth. It's an experience that influenced my eventual decision to attend biology graduate school with every intention of studying salamanders, not just for their cuteness but for their role as environmental indicators. My salamander project never came to fruition, but not before I'd visited the world's epicenter for salamander diversity—the Appalachian Mountains. The majority of Florida's twenty-nine species of salamanders can only be found in the Panhandle where the Apalachicola River maintains a direct connection to the Appalachian region and its salamander wealth. As I wander down a seepage stream in the Lake Talquin State Forest searching for moisture-dependent salamanders, I stumble on a cottonmouth cooling in mud. It throws its head back in its white-mouthed display as it notes my presence, and I'm relieved I haven't kicked my shoes off this time. But that same content feeling I had in college overwhelms me as I wade along the water's edge. A box turtle also cools in the stream. A frog peers out from a hollow in a mossy log. I'm pleased by a southern dusky salamander larvae we find, but my true zen comes when I gaze into the googly eyes of this three-lined salamander.

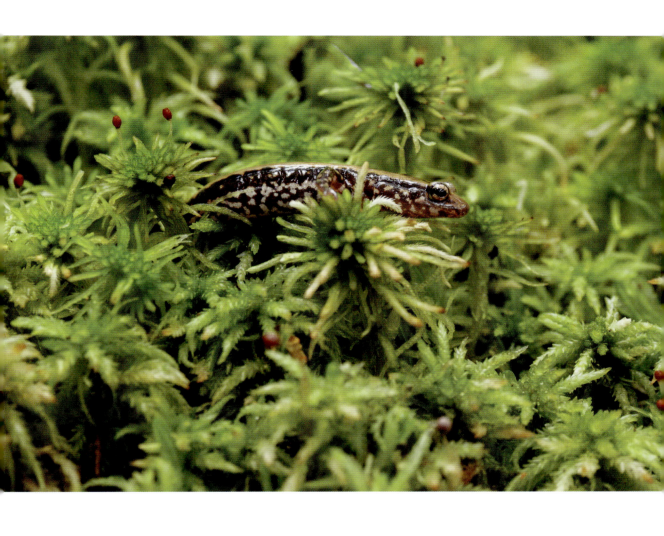

Green Frog (*Lithobates clamitans*)

A Barred Owl naps on a maple tree against an emerald backdrop of leaves in the forest at De Leon Springs State Park. A stream meanders below the resting bird and I follow the trail alongside. Passing an ancient-looking striped mud turtle basking where the stream pools into a pond, I continue along the trail to where the water once again narrows and flows. As I round the next bend, golden eyes glimmer in a patch of sun illuminating a rotting log. A small green frog, more color-appropriately known as bronze frog in Florida, stands out like a statue against this natural mosaic, waiting and watching for insects, fish, or smaller frogs to potentially ambush for food. I'm surprised to find this secretive amphibian sitting out in the open, and even more surprised that it doesn't splash into the water on my arrival. It holds my gaze and continues to pose as I draw closer. Despite being widespread across the eastern United States, I'm near the southernmost edge of its distribution in Florida. Hoping to hear the species' banjo-like call, I'd previously visited a forested pond farther north in its range, a breeding site trilling in frog tunes on the night of my visit, but none from the bronze frog I spotted there. That frog was as silent as is this one on the log. It stays statuesque and silent even as I pass.

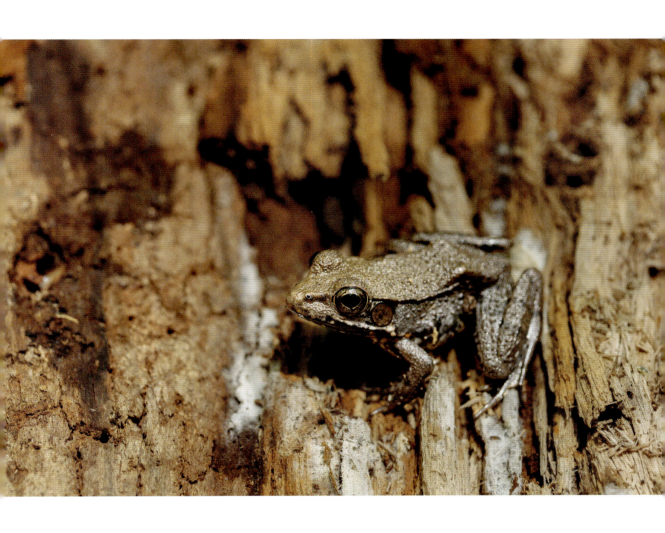

Eastern Fence Lizard (*Sceloporus undulatus*)

I stand listening to the roar of churning class III rapids where the Suwannee River funnels through the high limestone bluffs of Big Shoals State Park. A wall of plants blocks my view, and I'm diverted from my attempts to see beyond as something small and brown dashes past my boot. I turn to watch as a plain-backed male eastern fence lizard leaps onto a tree root beside a stripe-backed female. The male does push-ups to show his intentions, and the female doesn't decline. The male bites her neck and begins to wrap his tail around hers, but before he fully locks into position, a large green dragonfly lands in his way on the female's back. Undoubtedly annoyed, the male attempts to shoulder the dragonfly away. The dragonfly holds its ground. The male nudges again, but the dragonfly stays. The female, having had enough of whatever nonsense is going on behind her, takes off across the leaf litter. The dragonfly takes to the air and the male stands there alone.

The fence lizard suddenly cocks his head toward me and stares, as if noticing me for the first time. I stay still, but his escape instinct is strong. He races along the root of an old tree, then up the trunk. He eyes me, revealing bright blue breeding patches beneath his throat and down his flanks. They're patches I've seen before on Florida scrub lizards farther south, but in a different shade of blue. It makes sense that these two different species would share this trait, it was a population of eastern fence lizard native to the southeastern United States that evolved into the Florida scrub lizard when isolated on Florida's elevated central sandy ridge during a period of high seas. Today there is some range overlap, with eastern fence lizards extending south into Central Florida; but whereas scrub lizards are ground-dwelling animals that require the open sand of healthy scrub habitats, eastern fence lizards prefer forests and, as demonstrated by the one staring me down from the oak trunk, are much more arboreal. The male fence lizard at Big Shoals State Park maintains eye contact as it imperceptibly inches its way toward the opposite side of the tree, making me disappear from his view.

Red Fox (*Vulpes vulpes*)

A red fox emerges from the forested edge of my backyard in Maryland. I watch as it trots across the lawn, pausing to sniff patches of grass where my dog peed the night before. The fox squats at each spot, continuing the scent-marking contest the two have maintained throughout our summer stay. The fox suddenly freezes, eyes fixated on something new in its territory—a dog toy. The fox approaches it slowly, sniffing cautiously. And then, much to my surprise, tosses the toy into the air. It catches it, shakes it in its mouth, runs in a tight circle, then tosses it and catches it again as if mirroring what my dog might've done. It plays with the toy a bit longer, then drops it on the ground to scent-mark before continuing on its way. I later learn from neighbors that this fox prefers lacrosse balls, smuggling them about the neighborhood and explaining the sudden preponderance of white balls in my dog's toy box. This fox feels like part of the family, one of the myriad wild animals I happily share my Maryland yard with, so I'm shocked a few days later to be touring a neighbor's wildlife-friendly yard and hear him complain about nonnative foxes taking advantage of the natural habitat he's created.

"Red foxes are nonnative?" I ask.

"Well, yes," he answers with certainty. "They were brought over from Britain for hunting."

This was news to me. I knew that the sport of fox hunting had been imported from Britain, but the animals? I'd always believed the red fox to be native to North America.

It turns out we were both right. The red fox has the widest geographical range of any carnivoran with native populations clear across the northern hemisphere, including North America. Red foxes were, however, also imported from Europe for the sport, along with packs of foxhounds, and some animals were released into the wild in the eastern United States. At the time of these European fox introductions though, the native red fox was absent. It had a more northern and western distribution and only the distantly related, woodland-preferring gray fox was present at that time. As humans cleared land, the native red fox expanded its range, eventually making its way into Florida. Recent genetic studies indicate that not only are there no European red fox genes within the North American population, but that the North American population is likely distinct enough from old-world foxes to merit recognition as its own species.

So is the red fox native to Florida? It has surely occurred naturally in the Panhandle for as long as the red fox has been in the eastern United States, but just like its expansion into the eastern United States, it seems to be expanding its range in Florida too. Sightings have been confirmed all the way down to Lake Okeechobee, but not yet in South Florida, which brings us to more hunting-induced confusion.

Residents of Coral Gables, in the Miami area, swear up and down to have a population of red foxes derived from the prestigious fox hunts hosted at the Biltmore Hotel during its early glory days in the 1920s. Legend has it that some of those foxes escaped, mated with local foxes, and continue to persist in the area. The problem is that the fox native to South Florida, the only one present in the wild in the 1920s, is the gray fox, which is an entirely different genus and incapable of interbreeding with

Temperate · 131

a red fox. And, despite its smaller size, gray fox generally outcompete red fox. Historically habitat preferences kept these species separate, but even now with blurred lines, they don't choose to coexist and gray fox chase off the red ones. In truth, this hunting legend seems to have perpetuated an ongoing case of misidentification. People don't expect an animal with gray in its name to be red, nor those with red in its name to have gray fur, but in reality, both gray and red foxes have a wide range of overlapping colors in their coats and can be harder to distinguish than one might expect. While the red fox is larger with sharper features and a longer snout, the surefire way to distinguish the two is to look at the tip of the tail—red foxes have white whereas gray foxes have black.

American Alligator (*Alligator mississippiensis*)

I slam on the brakes as I turn onto the bridge heading from Big Cypress National Preserve's Turner River Road toward the Bear Island Campground. Where did all the water go? A month before this had looked like an actual river but all I see now is an oversized puddle glimmering in an otherwise dry riverbed. It's a puddle filled with life though. Dozens of first-year alligators swirl across its surface, their chirps wafting through the air. A few larger babies in their second year of life, still brilliantly striped in yellow but large enough that they will likely move on soon, fringe the edge of the pool. The arch of an armored tail and a pair of eyes are all I see of what likely is the mother.

I've heard about gator holes for as long as I've lived in Florida, but this is the most dramatic example I've ever seen. Perhaps it's a particularly dry season, or maybe this

Temperate · 133

hole is just the most isolated I've visited, others seeming to blend into wetland vegetation with no clearly delineated edge and no way of knowing how deep or wide the water is. This puddle, however, is clearly an oasis, one last reservoir in an otherwise parched landscape. These water holes are actively maintained by the alligators and serve as important sources of water in the dry season for a wide range of animals, though I have my doubts as to how many fish will survive here.

 I return a week later, and a week after that, watching the puddle shrink and the surrounding ground crack as the rains stay away. Just when I think there's too little water even for mom, a second adult appears in the diminished puddle. It's a large male with fresh wounds down its back and tail, suggesting breeding season conflicts have begun. I can't imagine what battles he's won to earn his way into this pool, but there he is, his armored tail alongside mom's. Mom sinks out of view, demonstrating a greater depth to her domain than I'd realized, then reappears coiled at the male's side. She places her chin on his back, then rubs her way down his tail until they once again lay parallel, heads and tails facing opposite directions. The male arches his tail, lifting it from the water to wrap the tip around the female's nose in what looks to be a reptilian caress. This is a performance that can last for hours, a complex courtship likely to include a wrestled test of strength. For now it looks sweet, babies milling placidly about as their mom explores her new date. I choose not to stay though, and by the time I return, the rains have too. The river is back and there is no sign of this mother and her young. They've no doubt moved out into the wet marsh for mom to build a vegetative nest that will start the circle of life anew.

Eastern Six-lined Racerunner (*Aspidoscelis sexlineata sexlineata*)

We spot each other at the same time, a six-lined racerunner emerging from understory scrub and I. It glows turquoise against the dry oak leaves and I can't help but note that it would be obvious to birds, snakes, or other predators. It would stand out even more against the nearby sand of the scrub, coastal dunes, or other open habitats it prefers across the state. I sit still and the lizard accepts my presence, nosing leaves out of the way and flicking its tongue on its quest for insect fare. It darts farther forward, moving quickly and abruptly through the leaves like a pinball propelling between flappers. It pauses, staring intently at something in the shadows. Suddenly it flashes across the sand and I glimpse a second racerunner, one without blue cheeks, a female. As the pair races out of view, I understand the bright blue. It's the time of year when male racerunners are more concerned with impressing females than avoiding the notice of predators. Being the fastest lizards in Florida, perhaps they can afford to let their blue glow.

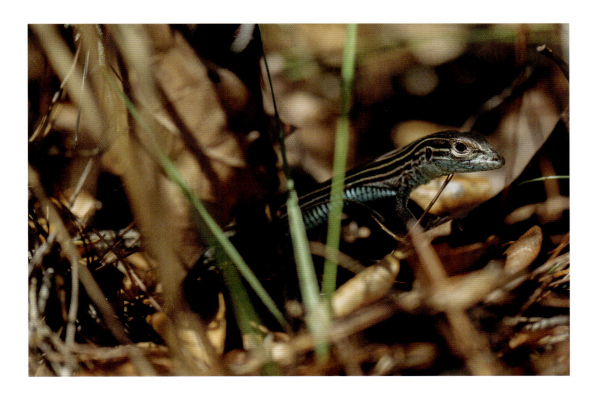

Temperate · 135

Southern Red Salamander (*Pseudotriton ruber vioscai*)

Trees tower above but only the occasional needle palm interrupts the otherwise open understory. I step off a rounded bank into one of the many seepage streams that help distinguish Florida's Panhandle from the rest of the state. I grasp the edge of a rock and lift. Cool, clear water swirls into the void, creating a vortex of sand where I'd hoped to find one of these salamanders. I gently replace the rock, reaching toward another when sounds of nearby splashing draw my attention. I turn to watch my companion, *Wild Wander* host and producer Peter Kleinhenz, excitedly lift his clasped hands from the stream.

"Southern red," he grins, "And this one's really red."

I expect it to glow like a cherry against the carpet of moss Peter places it on, but it's more of a salmon hue with purplish freckles spreading from its nose to sprinkle down its glossy back. As if reading my mind, Peter notes that they range from bright orange to dull brown with most in the Lake Talquin area where we're searching being brown. Beyond geographic variation, their color also fades as they age so this salmon specimen of such a secretive animal is indeed special.

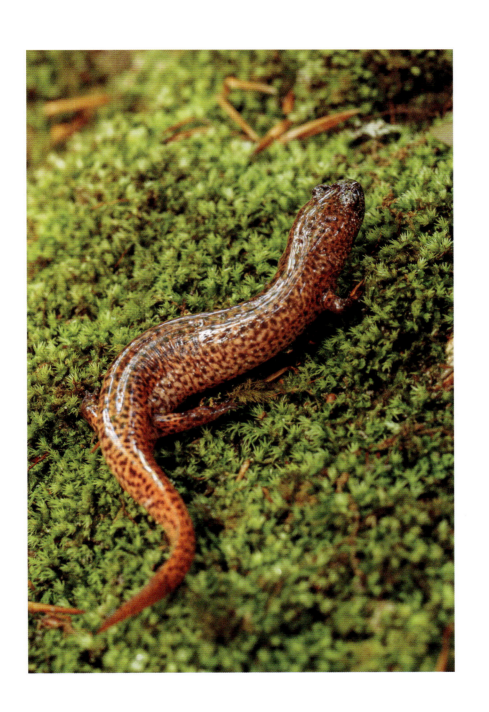

Everglades Mink (*Neovison vison evergladensis*)

Three dark spots tumble across the path in the distance. Mice? They're too long. Squirrels? They're too dark. I approach slowly. Otters? They're too small. The closer I get, the more they look like mink, but surely that's not possible. I'm in the range of the Everglades mink, an endemic subspecies of the American mink so rarely seen that it wasn't even on my list of species to photograph. Yet here they are—three babies wrestling right out in the open. One disappears into thick vegetation as I get into easy viewing distance, but the others are too preoccupied to note my presence. One pounces on the other, wrapping its little arms around its sibling's waist while clenching its teeth into neck fur. The mink on the bottom twists in protest and across the dirt they roll. One breaks free and dashes down the trail. The other bounds after. There's a crouch, another pounce, and once again they roll as one. This is play with a purpose. These tiny carnivores are already honing their hunting skills for their days as solitary adults, stalking fish, snakes, crayfish, birds, and even mammals for food. As the young tumble out of view as abruptly as they appeared, it occurs to me that a mother encumbered with such rambunctious young might be confined to a small home range—I might be able to watch these babies grow. Over the next several weeks, I return to this spot again and again. I watch the growing young tumble across the path, increasingly vigilant and secretive over time. I watch flashes of their fur tunnel through water-side vegetation. I learn their favored waterholes and wait patiently until finally one of the young, no longer a baby, pauses on a log before me. It gazes at me a moment, then marks the spot with musk-riddled scat and disappears behind a cypress trunk.

Mangrove Diamond-backed Terrapin
(*Malaclemys terrapin rhizophorarum*)

A diamond-backed terrapin basking on a rock fixes its eyes on me. Its cheeks glow pink in the evening light and I'm struck by the speckling on its pale blue skin. This is one of the most stunning turtles I've ever seen, but threats have haunted this native of the eastern United States through the ages. First eaten by Indigenous Peoples, harvest increased exponentially with commercial demand for delicacies such as terrapin soup popular through the 1930s, then later for the pet trade, which continues to covet diamond-backed terrapins for their stunning beauty and amiable personality. Yet one of the most persistent threats has been the unintentional death of terrapins in blue crab traps. Limited to brackish coastal estuaries where blue crabs thrive, these carnivorous turtles forage their way into crab traps on their quest for mollusks, fish, and crustaceans, and historically drowned without an escape. The addition of turtle excluding devices and regulations requiring their use has reduced, though not eliminated, this threat, but the cycle continues as new threats from development, sea level rise, and pollution increase. With more than 20 percent of this species' global habitat contained within Florida, and housing five of the seven accepted subspecies, including three endemic to the state, Floridians have an opportunity to brighten the future for this beleaguered animal.

Bald Eagle (*Haliaeetus leucocephalus*)

A shrill cry pierces the sky. I look up to see a pair of Bald Eagles in a dead pine tree. I scan the area for an active nest, but see none. It's only October, perhaps too early in the season for nesting. This pair might just be reconvening at their preferred site after months of solo living, a routine they'll repeat till death do them part. Sadly, there was a period in U.S. history when death often parted pairs. Overhunting and DDT depleted the Bald Eagle population until fewer than 500 nesting pairs remained in the contiguous United States by the 1960s. Fortunately, that's a history hard to imagine now with more than 1,500 nests annually in Florida alone. Florida has one of the largest populations of nesting Bald Eagles in the lower forty-eight with numbers continuing to expand along fish-filled waters. With preferred pine trees in the north, and cypress and mangroves farther south, already claimed by nesting pairs, the numbers of nests on artificial structures such as communication towers are on the rise. I suspect this pair has a good pine nearby as I watch them take to the sky.

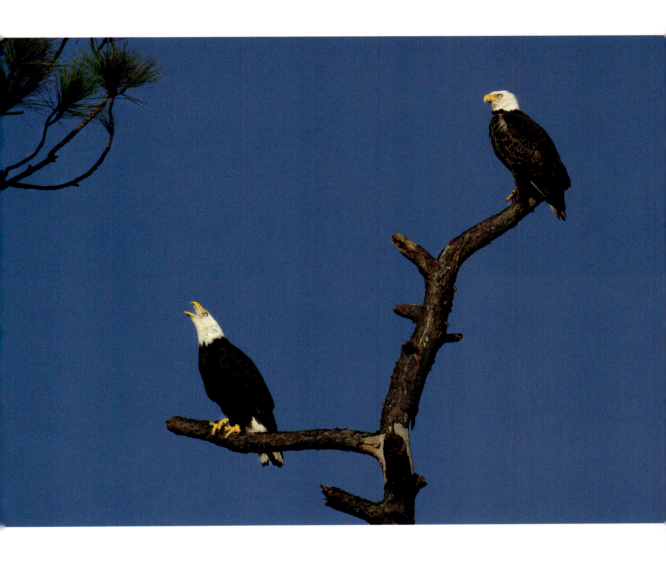

Eastern Lubber Grasshopper (*Romalea microptera*)

A giant orange grasshopper lands on the trail before me, another clings to a marshland sedge alongside. A different grasshopper munches the pom-pom petals of a buttonbush flower while a mating pair swings from the stalk of a nearby Spanish needles wildflower. Everywhere I look, eastern lubber grasshoppers lurk, and I know summer has arrived. They are too heavy to fly far and jumping isn't their forte either, but they walk and climb well, covering everything within range until the eggs are laid. Then there are none for several months, until tiny black nymphs emerge in spring. Their only resemblance to their parents are a few yellow, orange, or red stripes. The preponderance of these colors in the adults is a warning to predators of their toxicity. Expelled with a loud hiss in the form of frothy bubbles, these toxins largely protect them from being eaten, though Loggerhead Shrikes have learned to detoxify these grasshoppers by impaling them on thorns or other sharp objects, leaving them to eat another day. Perhaps this generally effective defense explains why the large orange adults so obviously inundate wetlands in the summer.

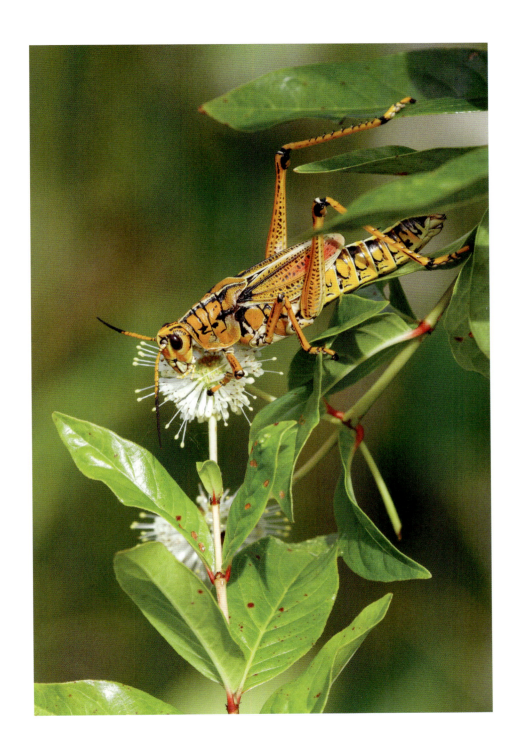

Blended

The pink of dawn spreads across blue waters as I pull into a little oceanside park in the Saddlebunch Keys. Walking to the water's edge, I scan the seemingly endless horizon where the hues of the sky blend into those of the sea. I'm drawn to a different pink as the unmistakable silhouette of a flying flamingo crosses before me. The bird honks as it lands in a protected cove farther up shore, and a green iguana lifts its head to watch. A Brown Pelican crashes onto a branch near the lizard, but the flamingo pays them no heed. The flamingo pumps its legs up and down, churning shrimp and other invertebrates from the nursery floor of the adjacent mangrove forest, then it dips its elegant neck to dine from this aquatic feast. This is how and where I had expected to photograph Florida flamingos—surrounded by tropical species in or around Florida Bay where they historically flocked. But in fact, the first wild flamingo I watched feed in Florida waters was in the Panhandle.

I had envisioned my Panhandle trips would concentrate on geographically confined temperate species like beavers, chipmunks, salamanders, and migrating monarch butterflies, but the first time I drove the nearly 500 miles from Miami to the St. Marks National Wildlife Refuge was to photograph a flamingo. An enormous American alligator basked in the foreground, a pair of Bald Eagles sat in a background snag, and a flock of Blue-winged Teal foraged alongside the pink visitor, an ensemble of temperate species surrounding this tropical icon.

In retrospect it's fitting that my first expedition north was for a tropical animal. While the Panhandle, the region most directly connected biologically to temperate North America, represents the state's temperate climate extreme and the southernmost tip of the peninsula south into the Keys, the region directly adjacent to the Caribbean, represents the state's tropical extreme, there is a blending of these elements all across Florida.

Florida's plants most dramatically illustrate this blending effect. Having learned my native species in southeast Florida and the Bahamas, I know Florida's tropical plants best. I can identify, or at least recognize, most plants I see on a walk through

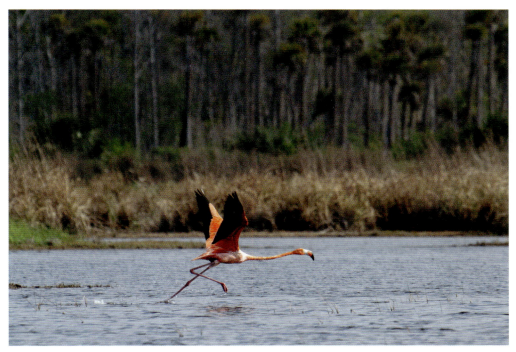

American Flamingo (*Phoenicopterus ruber*)

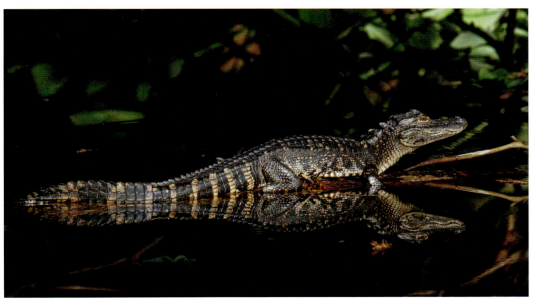

American Alligator (*Alligator mississippiensis*)

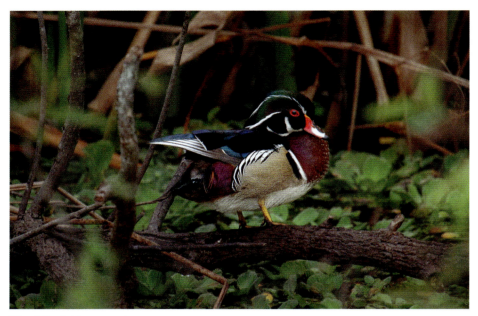
Wood Duck (*Aix sponsa*)

the woods in the Florida Keys or the Everglades, but I begin to lose my edge even just a couple hours west in the forests of the Big Cypress National Preserve where temperate plants more heavily infiltrate. It's a detail best noted in the fall when the tropical hardwood hammocks around Miami stay green, but hardwood forests outside Naples blush as the leaves of red maple trees turn their namesake color and cypress trees lose their needles. The farther I travel north and west, the fewer plants I recognize. Yet the transition is gradual. For both the plants and the animals, the number of tropical species fades moving north through the state, and the number of temperate species increases. There's no distinct line where temperate suddenly outweighs tropical or vice versa, it's more like a temperate-tropical quilt that stretches across the peninsula.

On my journeys around the state, I saw temperate Sandhill Cranes wander the banks of a pond alongside a basking tropical American crocodile on Key Biscayne. I watched a tropical Limpkin snack on snails beside a flock of temperate Wood Ducks while I paddled the Silver River at Silver Springs. A temperate raccoon startled me as I photographed a tropical Mangrove Cuckoo in Homestead. I watched 500 tropical manatees crowd into a tributary of the St. Johns River at Blue Spring State Park in the morning, and an equal number of temperate fireflies fill the air above the water that

very same night. I watched a temperate zebra swallowtail butterfly land on a flower in High Springs, a flower that only moments before held a similarly striped tropical zebra longwing butterfly. I saw tropical green lynx spiders perched atop temperate pitcher plants, hunting insects attracted to these carnivorous plants in Blackwater River State Forest. In the middle of a rookery filled with temperate Double-crested Cormorants in Delray Beach, I spotted the lone nest of a Neotropic Cormorant. I was told by a biologist on a Kissimmee prairie that colleagues of his were surprised to see temperate gopher tortoises so far south, and yet it's a species that occurs on Cape Sable, the southernmost point of the mainland United States where tropical crocodiles and sea turtles nest.

Florida is a melting pot, a place where temperate meets tropical in an ever-changing kaleidoscope. It's a kaleidoscope that will continue to shift as animals move in response to environmental change, but Florida's animals and plants will likely always be blended.

Green Lynx Spider (*Peucetia viridans*) on Yellow Pitcherplant (*Sarracenia flava*)

Monarch (*Danaus plexippus*)

Clouds of monarchs flutter about their favorite nectar plants, turning saltbush shrubs and goldenrods from the yellow of their flowers to the orange of their visitors. A thunderstorm passes and the butterflies huddle together in cedar trees, their wings folded tightly against the raindrops. As the sun reappears and dries those dripping wings, hundreds of monarchs take to the sky. It's a marvel I'd never seen before, but one typical of St. Marks National Wildlife Refuge in October when monarchs traveling along the east coast converge near the historic lighthouse, waiting for a gentle breeze to speed their journey across the Gulf of Mexico.

The multigenerational migration of monarchs was a legend I grew up with. I'd seen pictures of the monarch-festooned trees of Mexico and California in winter. I'd heard tales of their long journey north, taking their time to sip nectar and procreate along the way, sending their offspring on the next leg of the trip and often taking three or four generations to reach the ultimate destination. I later learned about the super generation, migration marathoners hatched at the end of the summer to undertake the lengthy southbound trip from as far north as Canada to overwintering sites in Mexico or California. I understood that there were two migration routes, one to the west of the Rocky Mountains and one to the east, but I thought migration is what defined a monarch—then I moved to South Florida.

I remember being surprised my first year in Miami to see the familiar orange and black wings of a monarch glowing brightly against crisp blue winter skies. Weren't these butterflies supposed to be in Mexico? It wasn't long though before I took their presence for granted, orange adults flitting across my garden, green chrysalis adorning my leaves, and striped caterpillars munching my larval host milkweeds to the ground at all times of year. The longer I lived in Miami, the more I came to assume that this sedentary population of monarchs was just one more of South Florida's many anomalies. Seeing those clouds of migrants in St. Marks National Wildlife Refuge only reinforced my notion that southernmost Florida was an exception to the monarch migration rule, but it's not that simple.

Migration is a critical part of the monarch story, not just because of its grandeur but also because it's believed that every monarch on the planet originated from these North American travelers. Sedentary populations such as the one in South Florida, however, are nothing new. Monarchs are now established in more than ninety countries and islands across the world, including the Caribbean, Central and South

America, around the Pacific, and in the Iberian Peninsula. While some of these newer populations display varying migratory tendencies, most are sedentary and none compete with the distances or complexity of the North American migration.

Although the details of migratory pathways and wintering habits are still being worked out, it's clear that Florida holds a blending of monarchs. As I saw firsthand in St. Marks, North Florida seems to be along the primary east coast migration route with large congregations of butterflies working their way toward Mexico. Some of these migrants stay in Florida for the winter, fueling up on flowers before they or their offspring head north the following spring or summer. Of those that overwinter in Florida, some make it south where it's thought that they sometimes stay, becoming part of this genetically and morphologically distinct nonmigratory population.

Blended · 151

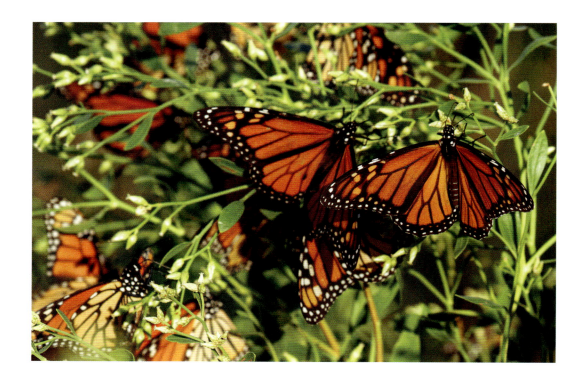

Ironically, as the number of sedentary monarchs in the world is increasing, the number of North America's migrating monarchs is in decline. More than 80 percent of the population has disappeared over the last few decades due mostly to habitat loss and herbicide and pesticide use. These migratory wonders are now listed as endangered. And in another irony, it's people planting milkweeds far and wide that likely helped establish so many sedentary populations. Those plantings might be a detriment to migrants in Florida. The most commonly available milkweed to purchase is a nonnative that unlike its native counterparts continues blooming through the fall and winter, potentially luring migrants away from onward journeys. In this land of blended butterflies, don't we have a responsibility to ensure that the right milkweeds get planted? Much as I love having monarchs in my yard year-round, I'd hate to sacrifice those clouds of orange up north. The monarch migration is a national treasure worth protecting.

Wood Stork (*Mycteria americana*)

Large birds in V formation fly low over Everglades marsh. Their long legs aim downward with pink toes outstretched as they land in a pool at the edge of a boat ramp. They are not the first to arrive. Hundreds of white birds fill the water, spilling into the surrounding golden grass where an outer ring of vultures keeps to drier ground. They are all here to take advantage of easy prey concentrated into this remaining pool as marsh waters receded through the dry season. Great Egrets walk slowly through the open water, their keen eyes trained below where they occasionally dart their bills to come up with fish. Snowy Egrets fly above the water, dragging their yellow toes across the surface to scare up small fish that they lean down from the air to acrobatically catch. White Ibis stick to shallower water, probing the mud with their long, curved bills for crayfish. A handful of Great Blue Herons stand along the edge waiting patiently until a fish large enough to stab comes along. But it is Wood Storks that dominate the scene, pumping their pink toes through the mud to stir up prey while they hold their open bills in the water ready to automatically snap shut upon contact. It's a technique that works well on midsized fish, and warmouth are the catch of the day. The Wood Stork chicks will feed well this evening, and this is

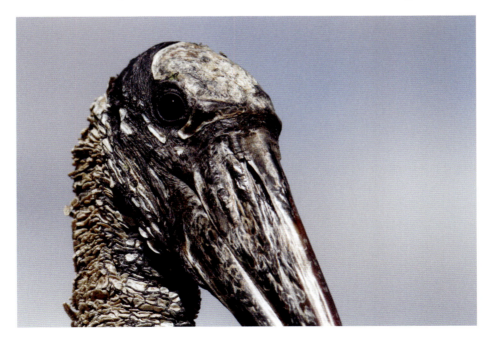

Blended · 153

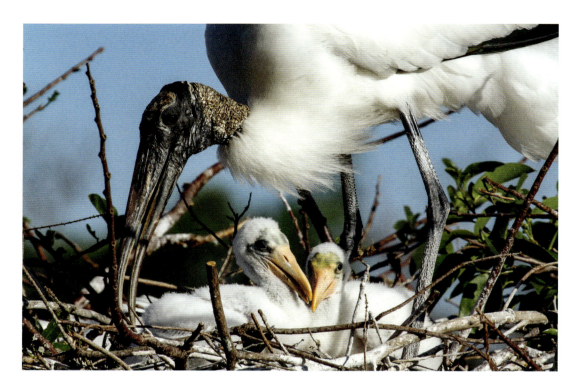

no accident. Wood Storks have finely tuned their nesting to the seasons of the Everglades, doing their best to match the timing of their chicks' greatest food needs to the peak of water recession when prey is most easily captured. But humans have meddled with the system over the last century, diverting water for drainage and our own use without taking into account the needs of wading birds. There always were years of flooding, years of drought, and years where the drying-down process was too fast, too slow, or didn't happen at all; but with human interference, the timing of concentrated food availability became increasingly out of sync with Wood Stork nesting. It became harder and harder for the Wood Storks to feed their young, so much of South Florida's population gradually relocated northward, abandoning the wetlands that had sustained them for so long. But it's fitting that the day I saw that feeding frenzy was the day I'd gone to attend the dedication of the Tamiami Trail Bridge, meant to help restore surface water flow southward into Everglades National Park. It's been a long process and the road ahead is longer still, but people are working to right our past water flow transgressions. Everglades restoration is one of the largest and most ambitious environmental projects in the world, but judging by that feeding frenzy, we're getting there. The Wood Storks will let us know if we succeed.

Eastern Amberwing (*Perithemis tenera*)

Gossamer wings sparkle in the morning light with veins spidering across shades of amber, brown, and transparent patches in the classic stained glass–style of a dragonfly, yet these wings are held upright and separated in a way that looks like a different sort of insect entirely. I move in to closely examine this tiny winged being. Its head is classic dragonfly with bulbous eyes claiming most of the space. Its abdomen is

shorter and thicker than might be expected for a dragonfly and is poised downward, pumping up and down in the style of a wasp. This in fact is this dragonfly's defense, to perch on the tips of grasses and wildflowers while holding its wings and body in a style that mimics a wasp.

The fact that this one is perched in a meadow some distance from fresh water suggests it's a female, a fact confirmed by the amber patches on those delicate wings. Males stick closer to water, venturing into the meadows only during breeding season when they attempt to dazzle females with one of the most elaborate courtship displays of any dragonfly. They sway and hover, alluringly raising their wasplike bodies in the hopes of enticing a female to follow to their waterside nurseries. If she approves, she may lay her eggs in his chosen site, or perhaps she'll return to the meadow to lift her gossamer wings into the sun.

Hispid Cotton Rat (*Sigmodon hispidus*)

A single brown speck in the grass. A hispid cotton rat hunches into a ball; its long hairs halo about its body as it plucks clover from the lawn. Suddenly a photobomb. A second rat bounces across the bottom of my frame. I turn to watch as it tackles a third rat that has emerged into the evening light. That rat shoots into the sky like a jack-in-the-box, bolting away from my photobomber to pluck a blade of grass and calmly chew. Undeterred, the second rat races toward it again, leaping onto its back. Again, the tackled rat propels into the sky, but this time the attacker bites its fur, pulling it down to the ground. A blur of tumbling browns, then one of the rats breaks free. The other pursues. The one being chased dashes behind my bent knee. The pursuer stops and so does the escapee, grabbing another grass blade to munch. But photobomber isn't done. Once my companion wanders from my side, the bomber pounces again. Another jump, another wrestle, an attempted mounting, and I become a human

shield. This pattern repeats, sometimes with prolonged feeding between, but always with the one rat tackling and the other seeking shelter in my presence. The male, for now the genders are clear, has taken to licking his genitals after each attack. What had appeared to me at the time as unwanted advances, turns out to be normal sex in this rat's world. This was the foreplay. Eventually thrusts would make contact and after several minutes of rest, the whole process would begin again with the female birthing up to fifteen young a month later and be ready to copulate again in twenty-four hours. No wonder this is one of Florida's most common and widespread native rodents.

Sandhill Crane (*Antigone canadensis*)

A pair of sandhill cranes forage along a levy in Central Florida. An elegant neck curves toward the ground. A formidable bill gently pulls roots, gleans seeds, and plucks insects from blades of grass to eat. Its partner stands sentry; its neck stretched erect above surrounding reeds. These are Florida Sandhill Cranes (*A. c. pratensis*), a nonmigratory subspecies that calls Florida home year-round. The birds switch roles, reading one another's movements as happens in any long-term marriage. But then rolling bugles tumble from the sky as a flock of Greater Sandhill Cranes (*A. c. tabida*), winter visitors from the Great Lakes region of North America, cross above. The pair before me on the ground straighten. Their heads track the travelers as they trumpet a response. And then silence. The birds return to feeding, one's bill hovering across the grass, the other swiveling a watchful eye across the plains, and both birds towering above me as they walk past where I sit on the ground.

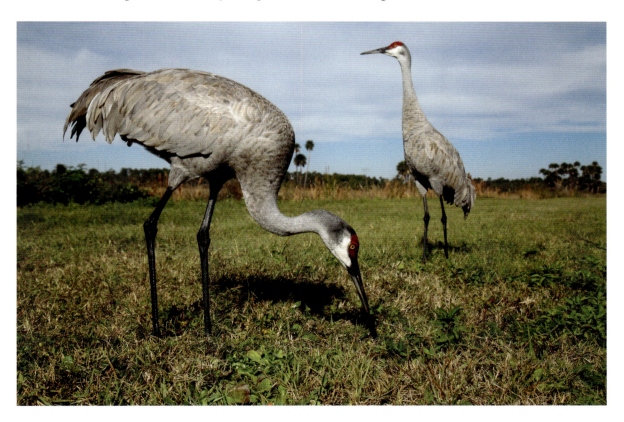

Florida Cottonmouth (*Agkistrodon conanti*)

I step from the midday heat of a marsh into the cool interior of a cypress dome. Gnarled cypress knees outline a glassy pool that shimmers reflected greens and browns. Earth tones fill the space and yet it is another color that commands my attention. Coiled in a spot of sun on a log at the far side of the pool basks the largest cottonmouth I have ever seen, head thrown back and mouth glowing white. Clearly, I've disrupted this reptile's peace, but it's giving me ample warning to right my wrongs. Widely distributed throughout the state, this is Florida's most commonly encountered venomous snake, one I regularly find crossing roads; but, like most serpents, it would rather be left alone than engage. It may be hard to imagine when staring at protruding fangs, but in some ways the white of that open-mouthed display is a flag of truce—I won't bother you if you don't bother me. That day in the cypress dome, I accepted the snake's peace offer and took my leave.

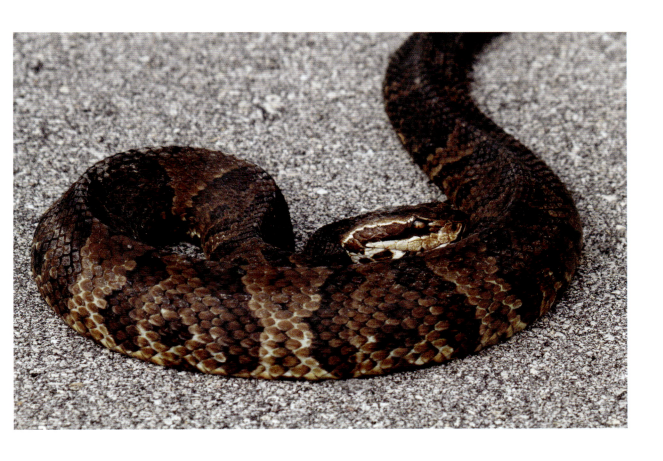

Ruby-throated Hummingbird (*Archilochus colubris*)

A flash of green zips across my yard. Wings beat too quickly to see as the small bird hovers before a firebush, dipping its long bill into first one then another tubular orange flower. A second bejeweled bird appears from out of nowhere. It flares its little tail, flashes brilliant red from its throat, and dives at the sipping hummer. The pair buzz around my garden, chasing, jabbing, and posturing, moving upward, sideways, and downward like mirror images in the sky as they face off for my flowers. Their annual appearance in my South Florida yard marks the coming of winter for me, but I'm reminded of Florida's vastness as a friend in the north of the state laments the departure of hers around the same time. Ruby-throated Hummingbirds are eastern North America's only breeding hummingbird. They nest in the northern and central parts of Florida, even occasionally in the southwest, arriving in late winter to early spring. But in southeastern Florida through the Keys, they're only winter residents, arriving in the fall to spend the season fueling up on our flowers before heading north to nest.

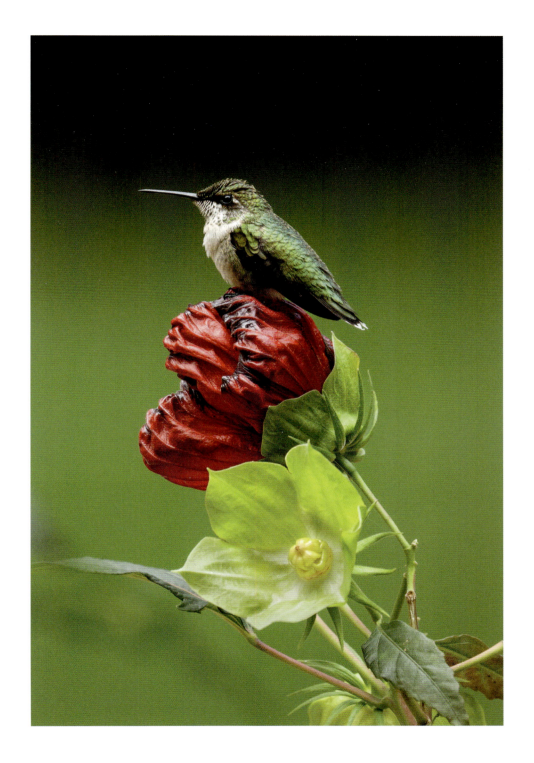

Marsh Rabbit (*Sylvilagus palustris*)

Movement in the shadows beneath a leather fern. Floating oak leaves bob as a small rabbit steps into view. It walks, not hops, quickly and silently, weaving through shoreline vegetation to finally emerge from the shallows onto the bank. It stands on its hind legs, stretching up to grasp the broad leaf of an alligator flag in its teeth. The stem breaks as the rabbit returns to all fours, huddling into a furry ball as it munches its meal. Living up to their name, marsh rabbits spend their lives near water. Equally at home in freshwater wetlands, brackish tidal swamps, and on beach dunes, hungry rabbits thwarted early settler attempts at farming; my favorite example is their eating the young coconut sprouts intended to establish a series of coconut plantations on islands all along Florida's southeastern coast. This is the only rabbit to be found in the lower Keys where it is its own subspecies, the smallest. It seems appropriate that the smallest marsh rabbit shares space with the smallest subspecies of white-tailed deer, the Key deer. Both are temperate species that after isolation, are now thoroughly blended with their tropical home.

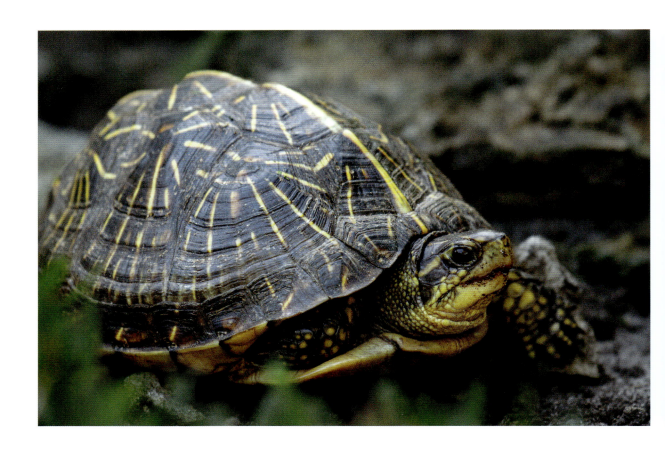

Florida Box Turtle (*Terrapene bauri*)

A small turtle plods across the leaf litter. It doesn't see me sitting on a rock, escaping the midday sun in the shade of the forest. It's a Florida specialty, a box turtle endemic to the state that ranges down into the Keys. The yellow stripes that radiate like shooting stars across its dark shell distinguish it from the eastern box turtle occurring in the Panhandle and farther north. Although Florida box turtles occur in a range of upland habitats, they seem to prefer woodland areas with moist soil like the one I'm sitting in. The turtle before me suddenly snaps its shell shut, a handy trick that fully encloses its otherwise exposed legs and head to protect against predators. Several minutes pass before the bottom shell lowers just a crack. Two eyes swivel in my direction and I realize that I had been the perceived threat. Knowing any movement might instigate another closing, I wait in stillness. The crack widens and a foreleg ventures out. A few more moments and the turtle gets on its way, scurrying surprisingly quickly across the rough terrain.

Wild Turkey (*Meleagris gallopavo*)

A glimpse of yellow beyond a screen of oaks and sabal palms beckons. I abandon my Jeep alongside the road at Myakka River State Park and gravitate toward the glowing field. Hundreds of thousands of yellow blossoms spread across a meadow. I'm so enamored by the scene that I fail to notice a giant alligator sprawled in the shade nearby. The sound of its movement startles me as it lifts onto all fours and trundles away. I venture onto a trail, surrounding myself in the glory of this meadow of tickseed, Florida's official state flower. A herd of deer graze through the petals, lifting their heads, then bounding away as I approach. The wildlife highlight though is Wild Turkeys, wary birds that had been evading me for days in Ocala National Forest. I'd hear them call or spot a tom in full red and blue splendor, but they'd race into thick forest before I could get a good look. Yet here in this field of flowers, as the sun lowers toward the horizon, a flock struts past unhurried. They pluck seeds and insects from the flowers, too absorbed to even acknowledge my presence.

Fireflies (*Photuris* spp.)

Twilight settles toward darkness and the remaining light disappears as I enter a final section of trail at the Blue Spring State Park where giant oaks and sabal palms block the sky. I glimpse a glowing green light. It flickers on and off through the blackness. Then I see another, and another. I spin in a slow circle, feeling like I've stepped into a magical fairy cove as hundreds of fireflies emerge into the night. Trails of light loop before me, the firefly equivalent of a male peacock shimmering its display feathers. The code embedded in the color, timing, and pattern of the flashes is lost on me, but a female firefly watching from the vegetation would understand. She would know this was a male of her species, an important point given that Florida has over fifty species of fireflies, more than any other state. She would also distinguish between the males and would flash the one she liked best, beckoning him to her side to mate. But it's not always so straightforward.

Females in the genus *Photuris,* those that surrounded me at Blue Spring according to firefly expert Dr. Marc Branham, have twisted the language of firefly love into bait. Known as the femme fatales of the firefly world, these are one of the few fireflies that eat during their adult stage, and these females have mastered the art of mimicry. They imitate the flash patterns of other species, luring males with the promise of sex, but then eating them instead. While this may sound like a cruel trick for a cheap meal, there is in fact an element of love—motherly love as the different chemicals extracted from those hapless males are passed along to the female's eggs as part of a noxious cocktail to protect her young.

Walkingstick (*Manomera* sp.)

Something tickles my ear as I tiptoe around a pitcher plant bog in Florida's Panhandle. I reach up to sweep back what I expect to be stray hairs, but my hand brushes something twiggy. I grasp what I expect to be a stick caught in my ponytail and jerk away when I feel instead the tickling of insect toes across my skin. Dislodged by my movement, a long brown insect tumbles through the air. It lands before me on a whitetop pitcherplant flower, and I can hardly believe my luck—it's a walkingstick, happily unscathed. While these invertebrates occur all over the world other than the Antarctic and Patagonia, they're most prevalent in tropical areas. The first I ever saw was in a rain forest in Costa Rica on a nighttime search for frogs. That walkingstick loomed larger than life in my headlamp, appearing more like abstract art than an insect. I've met several of these wonders since, all in rain forests at night. My favorite is the peppermint stick insect from Australia, a bluish green version that smells like its name, a perfumed defense to use when camouflage fails. Florida's most common walkingstick, the twostriped walkingstick, uses a similar defense, spraying a far less tasty-smelling irritant into predators' eyes. Fortunately, my walkingstick hitchhiker was a different species and chose not to punish me for sending it through the air. Instead, it posed placidly on this pitcher plant flower.

Key Deer (*Odocoileus virginianus clavium*)

A rustle in the mangroves. Ripples across the water. A Key deer picks its way through the snorkel-like roots of a black mangrove tree as the sun creeps up the horizon. This is how North America's smallest native deer, a subspecies of the widespread temperate white-tailed deer, lived for centuries—browsing tropical hammocks and pine rocklands, grazing freshwater wetlands and saltmarsh prairies, picking their way through mangrove forests, and swimming from one island to the next in the lower Florida Keys. But everything changed when droves of humans populated their space, clearing habitat and hunting these gentle animals to near extinction in the 1940s. The bulk of the Key deer population is now limited to No Name Key and Big Pine

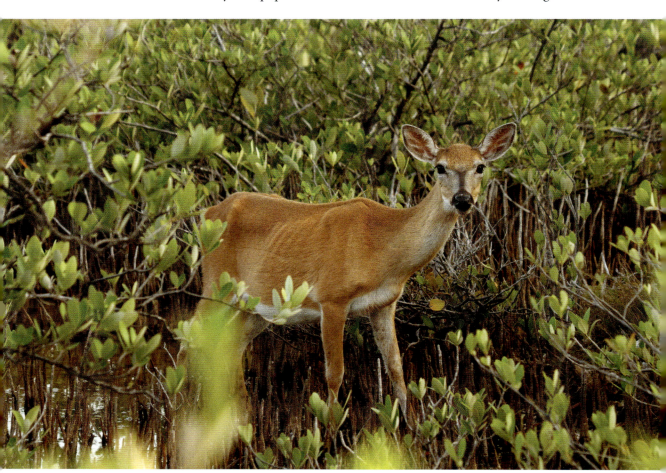

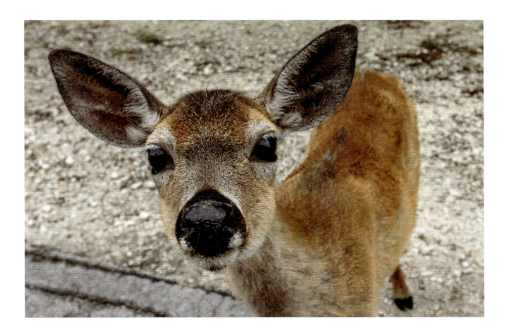

Key where they're protected within the Key Deer National Wildlife Refuge. A drive down nearly any road on these islands today yields sightings, seasonally even fawns tumbling after their mothers and fuzzy-horned bucks who even with eight-point racks stand no taller than chest-high. There can be no doubt of their population recovery, and yet there can also be no doubt that they face a new set of challenges. I watch a young child toss popcorn at a deer, giggling as the animal approaches for more. I watch a young deer dig through an abandoned Burger King bag in a parking lot, lapping up residual ketchup and consuming bits of plasticized paper in the process. I watch another deer chew at a rubber ring that has been lodged around its ankle for so long that the skin has begun to grow around it. And as I roll down my window, yet another Key deer sticks its head right inside my Jeep. It's adorable; yet I find myself ruing the fact that this animal associates cars with food. How long until it joins the annual tally of deer killed by cars listed on the sign along U.S. 1?

Linearwinged Grasshopper (*Aptenopedes sphenariodes*)

A pink thistle stands out against a backdrop of drying meadow grasses. I lean in for a closer view and notice a bright green grasshopper nestled among the petals. This is no usual grasshopper. Look as I may, I see no wings. One of Florida's most abundant grasshoppers in nearly every habitat, though partial to freshwater marshes such as this, its adult wings are reduced to pads too small for flight. This doesn't stop it from gliding through the air. Its large hind legs spring it from one flower to the next where it nibbles petals before moving on. I watch as it hops through the grasses and disappears from view.

Virginia Opossum (*Didelphis virginiana*)

The sun has set and the light is fading. I hurry down an unfamiliar trail, intent on returning before total darkness, until I spot a bundle of fur scurrying toward me. Black eyes glance in my direction from a small white face, a face that reminds me of a valentine heart framed by a pink nose and round ears. It's a gentle-looking creature, not at all living up to its reputation for a toothsome snarl. Still, this is no greeting card; it's a young Virginia opossum on a mission that does not include me. The lack of snarl suggests it feels no threat from me, nor does it feign defensive death. Its eyes and nose remain focused on the trail as I track its course. This is an animal with an undeservedly negative reputation. North America's version of a kangaroo or koala, these marsupials give birth to hairless babies no larger than a dime that must crawl up into mom's pouch where they remain until fully furred and large enough to face the world. As if that weren't enough to save their reputation, they're also efficient with clean-up and pest control. They eat a range of insects, including cockroaches and garden slugs, rotting fruit, dead animals, young mice and rats, and even venomous snakes from which opossums seem immune. No wonder my trail mate saw me as no threat. I watch as the tip of its little pink nose sniffs purposefully along the earth, perhaps on the scent of its first meal of the night.

Roseate Spoonbill (*Platalea ajaja*)

A spray of pink across an azure sky. Dozens of Roseate Spoonbills descend on a shallow marsh, their luxurious color contrasting with the whites of egrets, ibis, and pelicans already staged against a backdrop of golden grass. The pink birds spread across the water, spoon-shaped bills sweeping below the surface ready to snap shut at the slightest sense of a shrimp or fish. I'm drawn to one bird in particular whose red eye glows brightly against the aquamarine helmet of its featherless head—a bird still flaunting its breeding brilliance.

There was a time when Florida Bay was the only place in the state where the western hemisphere's only spoonbill species nested, synchronizing the hatching of their eggs with the annual drying season in the Everglades when their prey concentrated into the few remaining pools to make easier work of feeding their chicks. It was a system of plenty, helping the species recover from the days of plume hunting for fashion when their pink feathers were a commodity. But then new threats emerged

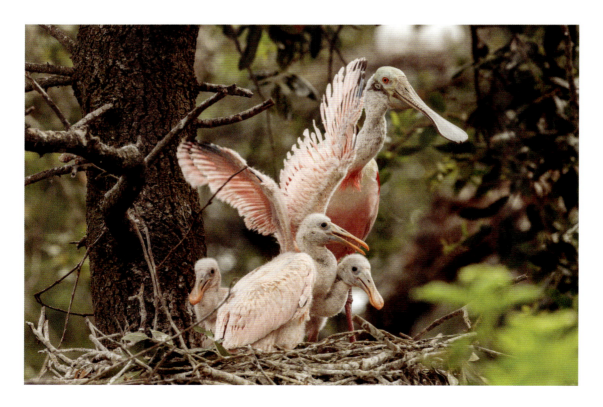

180 · *Wild Florida*

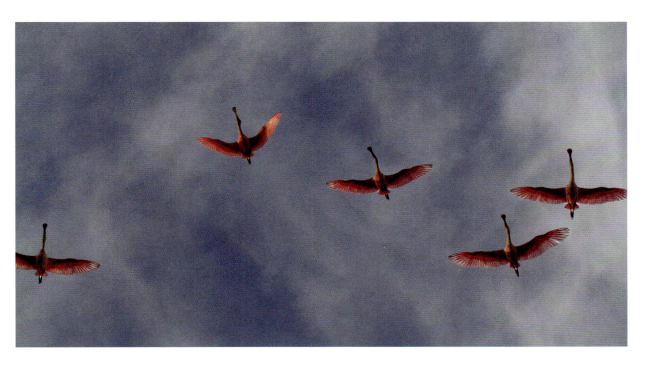

when coastal environments were converted into marinas, homes, and businesses, and freshwater flows through the Everglades were manipulated. Habitat was lost and what remained suffered from too much water in the dry season, too little in the wet season, or inadequate drying periods that didn't sufficiently concentrate prey during the birds' nesting season. Parent spoonbills had to fly farther and farther from their Florida Bay island nests in search of food, initially succeeding to feed all three of their chicks, but as food declined and their flights lengthened, they could only support two of the three chicks, then one, and finally, when parents found no food, they simply didn't return, leaving their entire brood to the jaws of fate.

The good news is that as those Florida Bay nests failed, other nests began appearing elsewhere in Florida, in Tampa Bay, on Merritt Island, in the interior wetlands south of Lake Okeechobee, and farther north along the coast, even moving into Georgia, South Carolina, and Arkansas. Efforts are being made to restore freshwater flows to Florida Bay, but with the added impacts of sea level rise, this may not be enough for the bay to once again host 90 percent of the state's spoonbills. Nonetheless, the fact that this species now pinkens blue skies and brightens browned marshes elsewhere shows a resilience that all species will need as development, climate change, and other environmental impacts alter our planet.

Eastern Gray Squirrel (*Sciurus carolinensis*)

A small gray squirrel scampers down the boardwalk rail at the Grassy Waters Preserve. It leaps onto a cypress tree, climbs partway up, then uses its sharp teeth to strip long strings of bark. Mouth full, it returns to the rail, using it like a highway to reach a nearby sabal palm. It disappears into the palm's crown, then reappears several moments later without the load of bark. It leaps back onto the rail, scampers to the cypress tree, and repeats the process.

Most of us picture squirrels—one of Florida's most pervasive and commonly observed mammals—racing across manicured lawns, lurking beneath picnic tables, sitting on park benches, raiding backyard bird feeders, or stashing stolen peanuts in yard planters. We think of them in urban contexts but as I watch the squirrel before me strip bark for its nest, I'm reminded that they're wild animals. Their habit of stashing peanuts is an urban display of food caching, a behavior that plays a vital role in maintaining natural regeneration of forests across the eastern United States.

Reserves

A swish of dark feathers through tannic water. An Anhinga emerges. A speared fish wriggles from the end of its bill. The bird waddles to shore, stretching its wings as it struggles with its catch. A crowd forms nearby as the bird shakes the fish from side to side. A retired couple RVing from Ohio, a Mexican American family from neighboring Homestead, a group of Chinese tourists, a family visiting from Germany, a Cuban American couple from Miami, and snowbirds from Canada all pause along the Everglades National Park boardwalk named for this bird. The Anhinga, used to people in this protected reserve, ignores the audience. It jerks its snakelike neck up and down, repositioning its prey one millimeter at a time until finally, with one last thrust, it sends the fish up into the air. The fish looks far too large for the bird's slender mouth, but the Anhinga opens impressively wide and catches its prey neatly, headfirst, on its way back down. The onlookers gasp and cameras click as the bird's throat widens, the outline of the fish visible as it slides the extent of the lengthy neck before the bulge disappears from view. This is a common sight at Anhinga Trail, one of the many wildlife wonders that draw visitors not just to Everglades National Park but to protected natural areas across Florida.

The Crystal River National Wildlife Refuge along Florida's west coast roils with manatees on cold winter mornings, along with an entourage of snorkelers seeking their company. The Avon Park Air Force Range in Central Florida manages large tracts of habitat popular with hunters, while also protecting one of the last remaining populations of the critically endangered Florida Grasshopper Sparrow. Blackwater River State Forest lures fishermen to its namesake river and numerous lakes, as well as wildlife watchers hoping to spot copperhead snakes, Pine Barrens treefrogs, beavers, and other animals geographically limited within Florida to the Panhandle. The St. Augustine Alligator Farm Zoological Park tantalizes visitors with the earth-shaking rumblings of giant crocodilians, but protected above those toothsome beasts are the equally tantalizing squawks from dozens of wild egrets, herons, and Roseate Spoonbills nesting in a wild bird rookery.

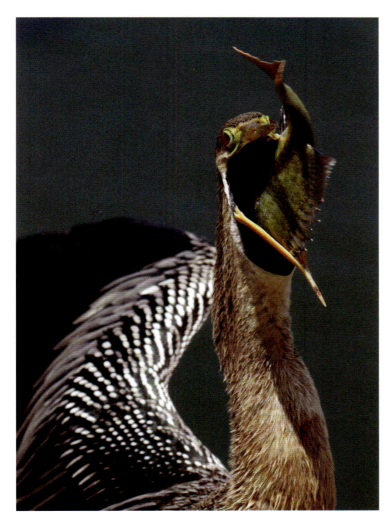

Anhinga (*Anhinga anhinga*) at Everglades National Park

The state in part has the foresight of President Theodore Roosevelt to thank for initiating Florida's life-sustaining network of reserves. An avid hunter and outdoorsman, his presidency came at a time when the vast pinelands of the southeastern United States were logged to decimation, deer and other game animals were hunted to scarcity, and uncountable egrets, spoonbills, and other birds were slaughtered annually to feed an insatiable fashion market. Perhaps for the first time in American history, it was becoming clear that the New World's natural resources were neither limitless nor inexhaustible. In response, President Roosevelt set aside the first national forest reserves and established what became the National Wildlife Refuge Sys-

Reserves · 185

tem, which started in Florida with his declaration of the Pelican Island National Bird Reservation in 1903.

It was the dawning of a new era and many a Florida resident aided in those early efforts. Sebastian-area boatman and pelican defender Paul Kroegel played a vital role in the formation of that first wildlife refuge on Pelican Island. Coconut Grove Audubon Society founder Mary Barr Munroe, former governor's wife May Mann Jennings, and the Florida Federation of Women's Clubs stopped the obliteration of a unique patch of forest to create the Royal Palm State Park in 1916. Everglades advocate Ernest Coe fought vigorously with the help of many others to expand that park from the footprint of Royal Palm Hammock into the more extensive boundaries of Everglades National Park.

The threat to Florida's natural areas eventually shifted away from commercial hunting and logging to development, an ongoing issue that continually requires citizen engagement. Big Cypress National Preserve, where I saw my first Florida panther in the wild, might've been a massive jetport-based development if Marjory Stoneman Douglas hadn't resumed her Everglades conservation work by rallying citizen

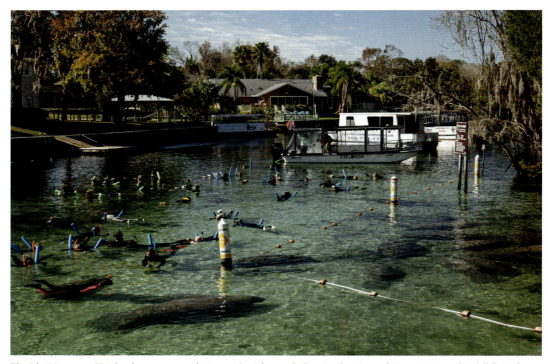

Florida Manatee (*Trichechus manatus latirostris*) with snorkelers in the Crystal River National Wildlife Refuge

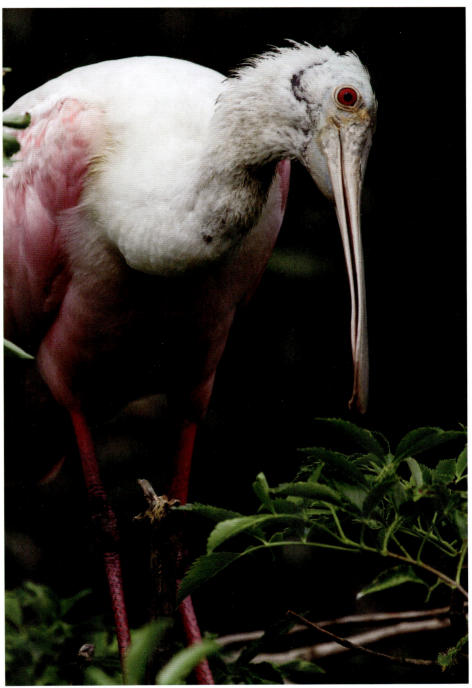

Roseate Spoonbill (*Platalea ajaja*) at the St. Augustine Alligator Farm Wild Bird Rookery

action against it. If not for the likes of citizen-activist Lloyd Miller, County Commissioner R. Hardy Matheson, and Congressman Dante Fascell, Biscayne Bay, where I fish for shrimp and stone crabs and watch dolphins flip through the air, might've been dredged and filled for a giant causeway connecting Key Biscayne to Key Largo, or worse, might've fallen to a deepwater seaport and oil refinery instead of becoming today's Biscayne National Park. The Dagny Johnson Key Largo Hammock Botanical State Park, a stronghold for the endangered Key Largo woodrat, would've been the Port Bougainville development if not for local residents. The Seabranch Preserve State Park south of Stuart, a small patch of scrub habitat where I found surprising numbers of endemic red widow spiders and Florida scrub lizards, might've been condos if not for its neighbors. Another patch of sand scrub was rescued from imminent real estate sale by a group of fourth and fifth graders who had learned about the unique features of this habitat type and the negative impacts of fragmentation. The Eco Troop, made up of students from the Pelican Island Elementary School, undertook a massive campaign that eventually protected seventeen lots of pristine habitat on which they proudly erected a sign that read "From us to you . . . forever."

The people who fought these battles understood that they were saving more than nature, they were preserving their own welfare and livelihoods—protecting their drinking water, the lakes they fished, the seas they swam, the land they farmed, and the woods they walked. And their battles paid off. As of 2021, roughly 30 percent of Florida's lands are under some level of conservation protection. A combination of sweeping federal lands, myriad state-managed parcels, municipal preserves, conservation easements on working lands, and any number of natural areas protected within the private and not-for-profit sectors have helped Florida reach a significant goal. Scientists and environmentalists around the world set 30 percent of protected land as a target to be reached by 2030 in order to curtail the effects of the biodiversity crisis. Florida is already there. It's indicative that every time I arrived in a new part of the state to photograph animals, all I had to do was check the map on my smartphone. There was always a reserve within driving range and by going there, I could be assured of spotting at least a bird or lizard, perhaps signs of a mammal, and with a little research, often even the exact animal I'd gone to photograph. But is 30 percent really sufficient?

The distances between reserves were manageable for me traveling along highways, but what about for wildlife? For some species, small animals that travel only short distances, fragments of isolated habitat seem to work. I ultimately found the tiny, endemic rim rock crowned snake twice in my two years of searching—once at the Bar-

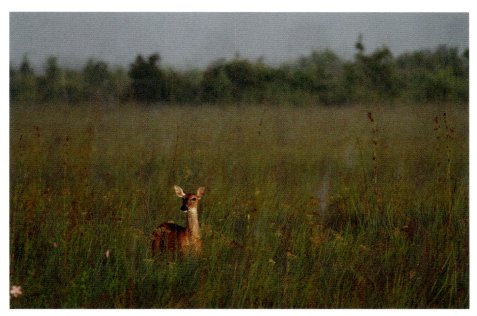
White-tailed Deer (*Odocoileus virginianus*) at Big Cypress National Preserve

nacle Historic State Park in downtown Coconut Grove and once in the Dove Creek Hammock portion of the Florida Keys Wildlife and Environmental Area on Key Largo, both times in parcels of hammock fewer than five acres in size. But what of bears and panthers that travel hundreds of miles? Or even indigo snakes with home ranges of hundreds of acres? For species such as these, the highways that made my commute between reserves so manageable are dangerous, sometimes fatal, barriers. Underpasses help, but the number of roads, never mind housing developments, businesses, and the like, between Ocala National Forest and the Big Cypress National Preserve surely impede movement between Florida's two largest populations of black bear. As of this writing, fewer than 5 percent of Florida's reserves are within six miles of another protected area, which means a lot of travel across roads and developed areas for animals that would prefer to stay out of sight.

From an animal perspective, not only does the distance between reserves matter, but also what fills the space between them. After my first expedition to St. Marks National Wildlife Refuge, I decided to return home to Miami along smaller roads, skirting the entire west coast and stopping at each reserve I encountered along the way. Even after leaving the protective boundaries of St. Marks, I was still surrounded by open pinelands that I'm sure the animals use no differently than those in the ref-

Reserves · 189

uge. The farther south I drove though, the more forests and wildflower fields yielded to houses, strip malls, roads, and parking lots. And with this increase in human infrastructure, the distances between reserves became more and more obvious. These green oases began to feel like isolated islands in a concrete world, and that was from my perspective. I can only imagine how intimidating it might seem to a small animal newly emerged from the woods, sitting at the edge of a maze of highways, looking this way and that for some indication of trees beyond the tires.

It's been estimated that a football field's worth of natural land is lost every 30 seconds across the United States, and Florida is not exempt. I moved to Miami well after Kendall was the Everglades and Pinecrest was pineland, but in my nearly twenty-five years of living in South Florida, I've watched buildings creep along Tamiami Trail toward the borders of Everglades National Park on one side and Collier-Seminole State Park on the other. Miami-Dade County's buffer on the east, the Urban Development Boundary, is repeatedly under threat. Time and again I hear tales of developers working behind the scenes to negotiate lucrative deals to develop agricultural or even environmentally sensitive lands. One of the last remaining patches

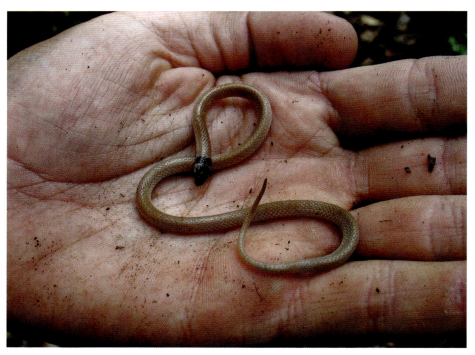

Rim Rock Crowned Snake (*Tantilla oolitica*) at Dove Creek Hammock, Florida Keys Wildlife and Environmental Area

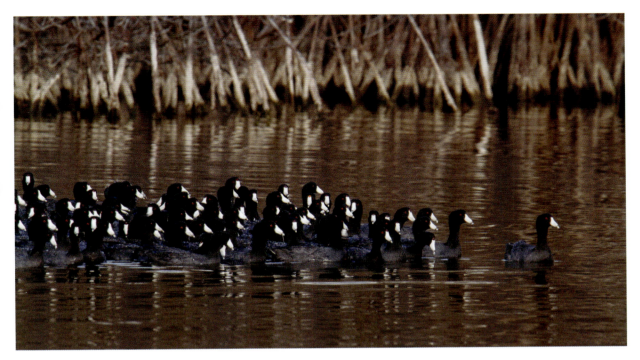
American Coot (*Fulica americana*) at Everglades National Park

of endangered pine rockland, a globally imperiled habitat, was recently converted into a Walmart Supercenter in Miami-Dade County, despite loud public protest. I'm grateful that the majority of Florida's southernmost peninsula was safeguarded into reserves decades ago, but I worry it's not enough.

The tales nearest my home are the ones I know best, but loss of natural area is a statewide issue. It's telling that the Great Florida Cattle Drive, a re-creation of Florida's 500-year-old cattle industry heritage, successfully plotted a 70-mile contiguous course through natural areas on ranches, farms, and public lands in the late 1990s but only a decade later had to zigzag to achieve a 40-mile route as so many lands had succumbed to suburbs. Given Florida is one of the most rapidly growing states in the nation, this conversion of wilderness, rangeland, and agricultural fields to homes and businesses is sure to continue. As a transplant myself, I understand Florida's allure, and it wouldn't be fair or realistic to turn others away. But humans aren't the state's only residents, and all of us, people and wildlife alike, rely on the ecological services of the natural areas protected within our matrix of reserves. As the number of people increases, we need more, not fewer, natural areas to perform ecological services

Reserves · 191

such as ensuring clean water, maintaining fisheries, mitigating climate change, and so much more. And while it's hard to place an economic value on these ecological functions, nature-based tourism, which benefits from Florida's network of reserves, is a multibillion-dollar industry proven to revitalize rural communities when managed correctly, as demonstrated along the Suwannee River Wilderness and Great Florida Birding and Wildlife Trails. Is this not incentive to bolster our reserves, by pairing strategic land protection with smarter, more compact, integrated, and compatible development?

The idea that a landscape-level conservation approach was needed to ensure connectivity between reserves began to take hold in Florida in the 1980s when an initial wildlife corridor map was proposed as a guide to link preexisting reserves. It was a time when rampant development outside of reserves was isolating populations of the Florida black bear and pushing the Florida panther population toward extinction. It was also a time when state and federal governments began securing environmentally important lands in Florida that also needed connecting. Many people, programs, and organizations helped build today's network of reserves, but Florida isn't done.

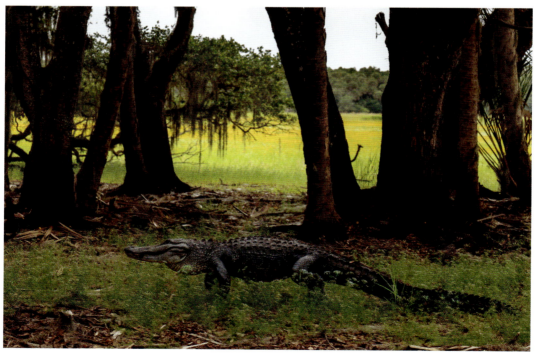

American Alligator (*Alligator mississippiensis*) at Myakka River State Park

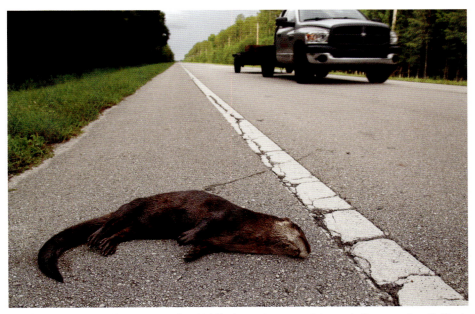

Northern River Otter (*Lontra canadensis*) killed crossing a road through Conservation Collier's Camp Keais Strand

The dream of a Florida Wildlife Corridor, an ambitious plan requiring roughly 8 million acres be acquired to connect nearly 10 million acres of conservation lands already in place, continues inching toward reality; I have faith that Floridians can make it happen. Florida is the state that saved its panther from extinction, surely it can also preserve passages to allow this iconic animal to reincorporate Central Florida and beyond into its range. And as part of this effort, perhaps Florida will once again meet the next set of global conservation targets ahead of schedule—50 percent of its natural areas protected by 2050—ensuring quality of life for all the state's residents, humans and animals alike.

Blond Raccoon (*Procyon lotor*)

I watch a trail of motion in the distance at the Myakka River State Park, a line of rustling wildflowers moving in my direction. As it nears, I catch a glimpse of fur. It's long and soft, light tan on the surface with an undercoat of gray and no patterning. It's fur I don't recognize. A face emerges, framed by white flowers. It's soft, wide around the eyes tapering to a black nose, light fur above and between the eyes, darker on the cheeks but similar to the body in lacking a clear pattern. It's a face I don't recognize for a moment, and yet it's familiar. I watch the animal roam among the flowers. It plucks something from the ground and as two dexterous paws deliver it to the animal's mouth, I know why the face is familiar—it's a raccoon. It lacks the dark bandit's mask and tail stripes so characteristic of the species, but it's definitely a raccoon—a blond one. It's leucistic, producing too little melanin to create the dark pigments needed for patterning its fur. It's not an albino though; its eyes, nose, and paws are black. Animals such as this are rare in the wild, and I feel lucky to share a few moments with this one.

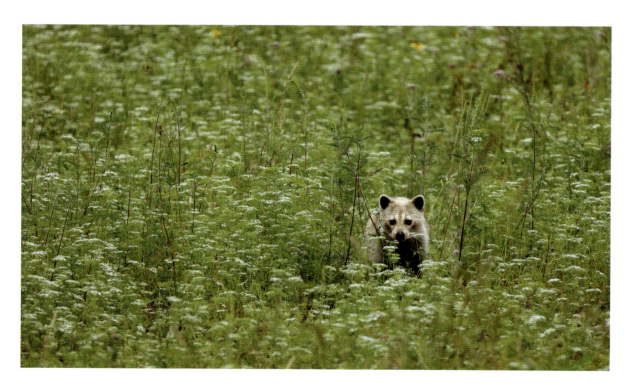

Oak Toad (*Anaxyrus quercicus*)

Bright orange spots hop across the sand at the Archbold Biological Station. I kneel for a closer look and the hopping stops. The toad before me is as elegant as the translation of its scientific name suggests, King of Oak Leaves. It's a lofty name for North America's smallest toad, an animal barely larger than a quarter. And while the sand scrub surrounding us is indeed dominated by shrubby oaks, the title is also somewhat misleading as to where one might find this little amphibian. Widespread throughout Florida, including the lower Keys, it's partial to sand patches in open pinelands where it feeds on ants and other small invertebrates throughout the day. Despite a generally diurnal, terrestrial, and solo existence, oak toad breeding mainly occurs in choruses at night after heavy rains when shallow pools and puddles are available for egg laying. A month or so later, a new royal court of mini-kings will decorate the sand.

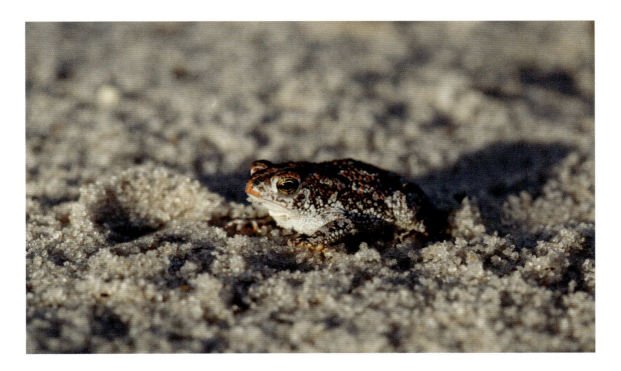

Eastern Cottontail (*Sylvilagus floridanus*)

A cloud of dust as two eastern cottontails burst from dry grasses in the Central Florida uplands of Ocala National Forest. It's March, well along in the dry season but early on in the peak of rabbit breeding season. The pair races in a circle, each facing the other's powderpuff tail as they spin about. Cottontails are solitary by choice, and I wonder whether this is a pair of males disputing a territory or a male courting a female. Either way, the behavior reminds me of a boxing pair of hares I once encountered in England and I hold my camera at the ready. The pair promptly spirals behind a saw palmetto. They reappear on the other side and I watch through a screen of grass as they pause nose to nose. One stretches forward and appears to whisper a secret, sweet nothings one might think except flattened ears against its back reveal a different message. A thump of a paw announces the next round, and the rabbits leap into the air. I hope to glimpse the antics of a courting pair; that the female will spin about, stand upon its hind legs, and box the male in the head. Undeterred, the male will leap above, spinning 180 degrees in the air while the female races and spins below such that they face one another again, a whirling to rival any dervish that continues until an ultimate crescendo into mating. Alas, I'll never know what secret passed between this pair. They resume their chase, creating a new cloud of dust as they disappear into dry grasses.

Cape Sable Seaside Sparrow (*Ammospiza maritima mirabilis*)

"The water is too high. The water is too low. The water is just right. There's too much fire. There's not enough fire. The fire is just right . . ."

I'd recently heard the Cape Sable Seaside Sparrow compared to Goldilocks, and I find myself mentally rewriting this classic fairy tale to better suit the bird as I drive down the main park road of Everglades National Park for my first attempt at photographing this rare and elusive bird. It's spring, dry season in South Florida, and the best time to catch glimpses of these little birds as breeding males pop out from within dense grasses to sing. At the first signs of dawn, I walk to the edge of the marsh and listen for the sparrow's buzzing trill.

First encountered on Cape Sable in 1918, this bird was considered the last new avian species to be discovered within the continental United States, but the honor became sullied when it was later reclassified as one of several subspecies of Seaside Sparrow occurring along the coast bordering the Atlantic and the Gulf of Mexico. Its nearest neighboring subspecies, the Dusky Seaside Sparrow, went extinct after development and drainage had reduced its usable saltmarsh habitat to one small area on Merritt Island, which was then flooded to control mosquitoes around the Kennedy Space Center, making it too unusable. Some water was too high, some water was too low, and without any just right water, the last Dusky Seaside Sparrow died in 1987. It's a situation one would hope not to see repeated for the Cape Sable Seaside Sparrow, a bird that also needs its marsh to dry for nesting season. With the largest restoration project on the planet now focused on restoring optimal water conditions to the Everglades, and the National Park Service diligently conducting prescribed burns, there's hope that all will once again become just right for this little bird.

I see signs of this on the day of my visit. Grasses sway gently in the breeze before me, just thick enough to hide a sparrow's cup-shaped nest six inches above the ground. Not even a low shrub mars the sunny prairie between me and distant tree islands, suggesting that the fire regime is just right. I walk along the edge of the prairie, noting the dry earth below, perfect for parent birds to find seeds, spiders, and bugs, and for ground-bound fledglings to feed when the time is right. On this particular morning, everything looks just right for this Goldilocks bird. I hear a buzzing call and turn in time to see a sparrow perched atop a strand of sawgrass towering above the muhly grasses. It buzzes and buzzes and I know I'm in just the right place to photograph this just right bird.

Bobcat (*Lynx rufus*)

A small and furry animal emerges from the shadows and saunters down the trail before me at the St. Marks National Wildlife Refuge. It's late in the morning, not a time I expect to find wildlife, but the bobcat before me seems unfazed by the heat of the day. It keeps a steady pace, continuing straight ahead without once glancing in my direction. At a fork in the trail, it chooses its own pathway, disappearing into the shade of a large sabal palm. I sneak closer, creeping along vegetated edges and giving the palm wide berth so as not to disturb the cat. It seems well aware of my presence anyway. Once again, without a glance in my direction, the animal emerges from the shadows to stroll down the path ahead of me. It allows me to follow at a distance, pausing now and again in the shade, but reemerging to lead our march down the trail if my attempts to close the gap prove more than the bobcat deems fit. It could easily slip away, but I suspect a tolerance for humans is part of this species' success.

 Widespread across the United States and ranging into both Canada and Mexico, this is an animal that lives among us and yet is mostly undetected. It hunts at night, taking down animals up to eight times its own weight, yet is capable of surviving on insects and small birds as well. I watched a captive bobcat once leap at a bird on the

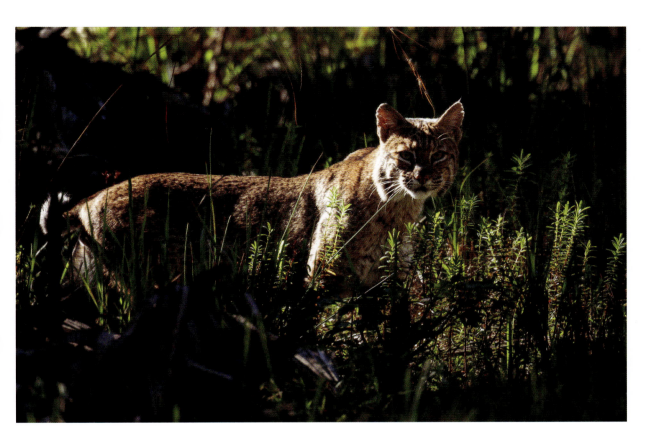

outside of its cage, jumping from its crouched position to hang on the fence at least fifteen feet above the ground. The bobcat doubled its apparent size as its muscles stretched across its back. We both knew it would have had the bird if it had been on the other side of the cage. The bobcat on the trail before me looks small and harmless, yet I suspect it too could double in size if the situation warranted. This cat isn't hunting though, it's merely prowling through its territory, undoubtedly scent-marking it during those shaded stops. The bobcat finally does turn, glancing a final farewell in my direction before disappearing into the woods once and for all.

Island Glass Lizard (*Ophisaurus compressus*)

Even from my Jeep, I can tell the legless reptile crossing the Big Cypress National Preserve road before me isn't a snake. It seems slow and stiff, lacking the fluidity of serpentine motion. It pauses as I step out, permitting me a closer look. An eyelid blinks, an ear opening flares, and lateral folds along the length of its thick body all confirm that this is a legless lizard. One of four species of glass lizards in Florida, I know all too well the origin of their name. While many species of lizards are capable of dropping their tail as a defense to escape predators, glass lizards are particularly fragile. I'd seen firsthand the shattering of a glass lizard's tail, the dropped portion wriggling vigorously to distract predators from the rest of the lizard. It's an energetically expensive ploy but worth the cost so as to live; and the tails grow back, though never quite to spec. Not wanting the shimmering lizard before me to diminish its looks, I keep at an unthreatening distance. It poses, I take its picture, and we both go on our way—no broken glass.

White Eastern Gray Squirrel (*Sciurus carolinensis*)

Morning mist drifts down the Ochlockonee River as sunrise sets the bordering pines aflame. A pair of gray squirrels huddle in a patch of light, warming on an oak branch after the chilly night. A Brown Thrasher squawks from the shade of another oak. A flock of Great Egrets drift past a maze of longleaf pines to settle in an interior pond, the white of their feathers glowing prominently against their surroundings. But what of the white squirrels I'd come to find? Shouldn't their ivory fur also gleam in the morning light? One of just a few established populations of a rare white morph of the eastern gray squirrel, the animals at the Ochlockonee River State Park were intentionally introduced in the 1950s, and clearly have what it takes to survive. Perhaps it was a coincidence but instead of emerging at first light with their gray counterparts, I first saw these pale animals well after the sun was high in the sky when the white of their fur seemed lost in the dappled light, appearing as just another spot of brightness in a patchwork of darks and lights.

Vermilion Flycatcher (*Pyrocephalus rubinus*)

As I drive through the marshes at St. Marks National Wildlife Refuge, a flash of ruby red crosses the road before me. It's the wrong shade of red to be a cardinal, and the wrong time of year for scarlet tanagers to sport red feathers. I turn around and head back, scanning the roadsides as I drive. There it is again—the ruby flash. I pull over and watch as the eye-catching bird darts across the road, then pauses above the water to perform aerial acrobatics, gracefully catching an insect in a midair twirl. The behavior suggests a flycatcher, its brilliant color suggests a Vermilion Flycatcher. More commonly associated with the arid American southwest, they occasionally wander as far as Florida in winter, which is happening with increasing regularity, though still rare. The Vermilion Flycatcher before me beelines to a wooden post and eats its captured insect, then disappears into nearby bushes. A couple pulls up moments later, asking whether I've seen the Vermilion Flycatcher reported on their birding app. I nod toward the bushes and watch the pair rush over, binoculars at the ready. It's hard to know how far they've traveled to add this bird to their list, but spectacular vagrants such as this are one of the reasons birders flock to Florida.

Florida Red-bellied Cooter (*Pseudemys nelsoni*)

I gaze into azure waters at the appropriately named Blue Hole in the Key Deer National Wildlife Refuge on Big Pine Key. The shell of a Florida red-bellied cooter, a species endemic to Florida and southernmost Georgia, rises into view. Two nostrils break the surface for a breath, then sink back under as the turtle lackadaisically explores a mat of floating vegetation. It opens its mouth but before it can take a bite, a second turtle paddles into view. It's smaller than the first and behaves frenetically, positioning itself between the first turtle and its salad, stretching its forelegs toward the first turtle's face and wriggling its fingers. It strokes long nails alongside the larger turtle's cheeks, then gyrates them before its eyes. The larger turtle attempts to swim around, more interested in lunch. The smaller turtle blocks the way, once again waving its nails before the other's face. This is the courtship dance of a male red-bellied cooter, but this female is not wooed. She abandons both the male and her potential meal, jetting into the depths of blue. She deserves to be picky. Female red-bellied cooters often brave the potential wrath of mother alligators to secure their eggs within the alligator's nest, no doubt to benefit from that mother's protective custody. If caught, even the turtle's thick, alligator-thwarting, domed shell might not save her from an angry mama gator. Why risk her life for genes of an unworthy male? As for the rejected male in the Blue Hole, he seems unaffected. He lifts himself onto a rock and soaks in the sun.

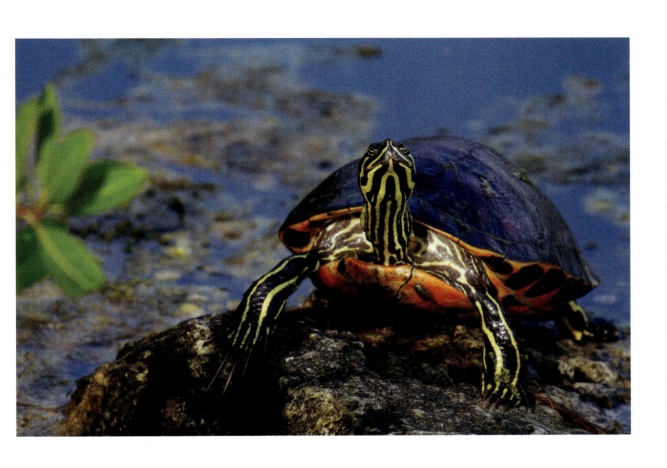

Southern Leopard Frog (*Lithobates sphenocephalus*)

The boughs of a live oak curve above me like the arched portico of a cathedral, inviting me toward a grand expanse beyond. I leave the intimacy of the shade, stepping toward a luscious expanse of green lining the sparkling blue waters of Lake Lou in Ocala National Forest. *Plop. Plop, plop, plop.* A carpet of water lettuce undulates with motion. I move to step closer. *Plop. Plop, plop.* Another round of splashes creates a new wave across the greenery; each move I make sparks a fresh performance. I have no doubt that wary frogs are causing the aquatic commotion, but who exactly? I tuck myself alongside a shadowy border of emergent vegetation and wait. The frogs are slow and subtle in their return, but finally a webbed foot wriggles above a leaf. Toes grip the plant and I watch as one of Florida's most abundant frogs, a southern leopard frog, emerges to perch atop a vegetative throne.

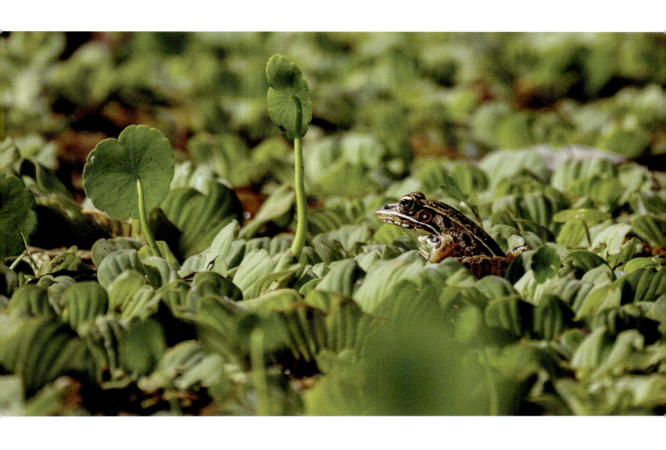

Red-cockaded Woodpecker (*Dryobates borealis*)

Longleaf pine trees tower above. The forest feels open, a rather evenly spaced collection of giants gathered in a grassy meadow. This is the forest that once covered most of the southeastern United States, but now less than 5 percent remains. The patch I stand in at Blackwater River State Forest is the largest expanse I've ever seen. An Eastern Bluebird pauses on a nearby branch. A Blue-gray Gnatcatcher pirouettes through pine needles farther away. The air fills with songs of birds one might hear in any number of habitats, but the one I've come to see depends on fire-maintained old-growth pine just like this. A flash of black and white undulates across the sky in the characteristic flight pattern of a woodpecker. I rush to follow and am not disappointed. A Red-cockaded Woodpecker lands on the trunk of a pine tree. Its small bill probes the bark, plucking and pulling until it draws a grub from some depth. The bird dashes away with the grub still writhing in its beak. Assuming a nest, I watch where it lands and work my way into view of the tree. Sure enough, about a hundred feet up is a small hole in a live pine. It may have taken the entire family group, up to four males and one female, a couple years to dig a cavity such as this. Most woodpeckers prefer dying trees softened by decay and with limited sticky sap, but Red-cockaded Woodpeckers are paid for their hard efforts via rivers of resin that ooze about the hole and deter potential snake predators. The woodpecker returns from another hunting trip, gripping another grub in its bill as it lands by the hole. It disappears inside, then returns empty-billed and I think I hear a chirp from within. Deforestation and fire suppression placed this bird on the federal endangered species list in the 1970s where it has lingered ever since, but continues to hang on. It's a bird worth fighting for because what's good for the Red-cockaded Woodpecker is also good for this diminishing habitat and all the animals and plants it supports.

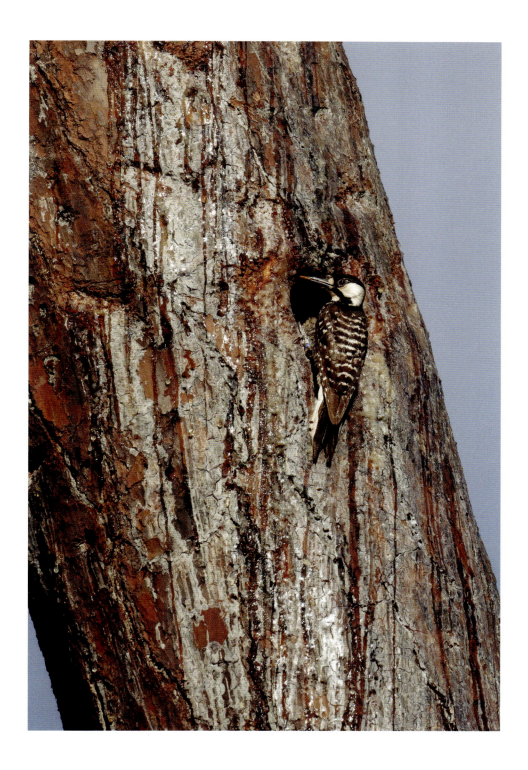

Northern River Otter (*Lontra canadensis*)

A frame of ferns wrap around a tunnel in the CREW Bird Rookery Swamp, standing water on one side, dry trail on the other. Alligator flags grow thick as bamboo beyond the round passage, blocking my view beyond. I pace the vegetative wall, looking for chinks through which to spot a tail, a ripple, or some sign of the tunnel's creator. A pile of crayfish-filled scat among the cypress knees provides my answer—otter.

 Early the next morning I camouflage myself behind nearby ferns and watch. Golden light filters through winter's browned cypress needles. A Pileated Woodpecker raps on a trunk. A Red-shouldered Hawk swoops through the air. Finally, the fern frame rustles and out pops a furry face. The otter heads straight to the cypress knees and adds more crayfish-riddled feces to the pile, then notices me. We watch one another. It takes a few steps toward me, then stops. It veers away, then back in my direction. It approaches lurchingly and in spurts, coming within a few feet before scampering past and diving into the water behind me. I turn and watch as it glides through glass-like amber water, circling widely to round vegetation, then beelining toward me. It tucks below a limb to come right up on the bank below. It stretches out of the water, reaching its nose to within a few inches of me. Its nostrils flare as it tests my scent. I realize I've passed its evaluation as the otter sinks backward into the water, then swims in the opposite direction.

 I'm about to rise and follow along the bank when another otter emerges from the tunnel. This one hustles along the vegetation on the other side of the trail, barely glancing in my direction as it passes. I hear squeals and another otter emerges farther down. It bounds into the first, sparking a wrestling match that rolls back and forth across the width of the path. Another otter appears, then another until a family group of six, likely a mother and her progeny, bounce about the clearing. The party peaks, then one by one the otters retreat to the water. By the time the first joggers of the day arrive, a fern-framed tunnel is the only remaining sign of that raucous otter jamboree.

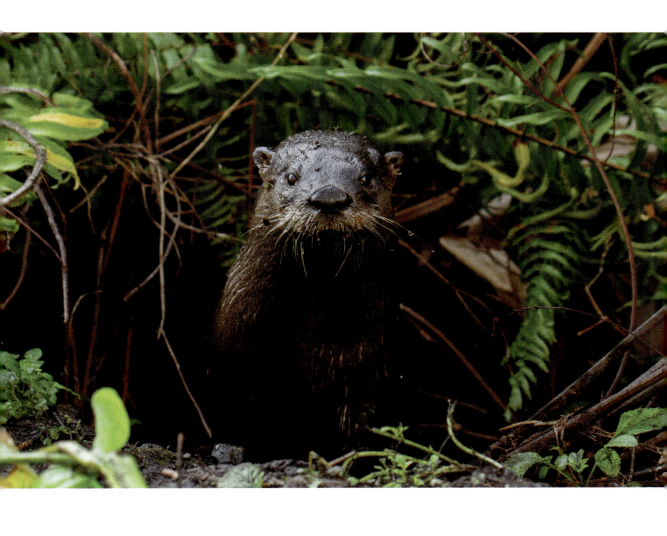

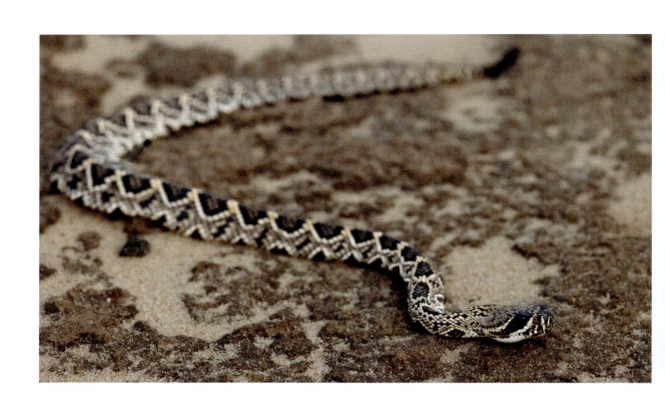

Eastern Diamond-backed Rattlesnake (*Crotalus adamanteus*)

A crack of thunder and the sky darkens. I feel the temperature drop and pull on my raincoat just in time. Buckets of water dump from the sky, a classic summer rain in the Everglades. I'm deep in a hardwood hammock surveying plants and as I struggle to keep my data sheets dry, I notice something bright moving across the leaf litter. A fluid pattern of diamonds glows in the dim light, slowly but steadily approaching. I stare in disbelief, uncertain as to why this rattlesnake, an animal whose temperature depends on its surroundings, would choose to travel during the cool of a rainstorm. But then again, despite generally living in upland habitats, the eastern diamondback is no stranger to water. They easily move between islands in the Keys and have even been documented as far out as the Dry Tortugas, nearly seventy miles from the nearest dry land. I stand motionless in the drizzle as the snake draws near. I'm not nearly as calm as the façade I try to convey by the time the diamonds are within several inches of my boot. I cling to the knowledge that most snakes avoid confrontation, and I'm relieved when this one demonstrates the point. Even this largest rattlesnake species in the world is unaggressive if unprovoked. Unfairly persecuted out of fear and bravado, diamond-backed rattlesnake numbers are declining. Fortunately, attitudes are changing. It's telling that rattlesnake roundups across the region, a southern tradition with historically dire ecological consequences, are being converted instead to wildlife festivals with education at their core. It's a positive trend I hope will continue as I watch the diamonds of my rainy-day visitor sparkle out of view.

Barred Owl (*Strix varia*)

"Hooo Hooo Hooo Hooo."

A Barred Owl call booms through the forest. It sounds close and I head toward the source, but I see nothing. For several days in a row I'd heard this sound, but while I met others on the trail who'd just encountered the caller, I had not. My previous Barred Owl sightings had been shadows in the night, but my goal now is a photograph in natural daylight. It seems this day will be another failure. As I climb into my Jeep in the day's last light, another hoot rings through the air to taunt me.

Owls are far from my mind the next morning as I creep down a trail at the Florida Panther National Wildlife Refuge hoping to see its namesake mammal. I diligently scan bushes, neglecting the trees until it suddenly occurs to me that a panther could be above as well. Perhaps I sense a presence because I look up to stare directly into the eyes of a Barred Owl. It's close enough to reach up and pet, too close for my 400mm lens to focus. The bird watches as I ease several steps back. It watches as I take its portrait, and it watches as I retrace my steps to walk along the trail directly below. It makes no sound and moves little more than the angle of its head; I could easily have passed without noticing it.

Coexistence

I pull to a stop at the busy intersection of Bird Road and SW 72nd Avenue by A.D. Barnes Park in Miami as the light turns red. A mother duck and her teenage chicks stand patiently on the corner of the sidewalk. As the pedestrian light turns green, she steps off the curb. She waddles straight down the paint-striped crossing, her ducklings neatly in a row behind. As they pass before our row of cars, I'm reminded of one of my favorite childhood books, *Make Way for Ducklings*. In the book a pair of Mallards raise their young in an urban park and at one point are ushered across a heavily trafficked road by a friendly policeman. As a child I'd been impressed that the duck family had learned to live in the city. It seems to me now though, as I watch the last of the chicks hop safely up the opposite curb adjacent to the park pond just as the pedestrian light flashes to a halting red hand, that today's animals are even more savvy than those storybook ducks. These ducks no longer rely on human benefac-

A Northern Cardinal (*Cardinalis cardinalis*) quarrels with a perceived intruder into its territory in the wooded parking lot at the Pine Jog Environmental Education Center.

American Crocodiles (*Crocodylus acutus*) bask along a golf course water feature in South Florida.

tors, they seem to have deciphered our traffic system. Similarly, I've watched Cattle Egrets emerge from median plantings at this same intersection to pluck bugs off the grilles of stopped cars, a modern version of the African animals the species evolved to follow. They too cleverly leave the street just as the light changes, leaping back to the safety of the plantings as engines roar to life.

There are many examples of animals that have accommodated to life in a human-dominated Florida. I've watched grackles steal sugar packets off outdoor dining tables, deftly opening the packets and eating the contents. One might think this a one-off lucky break, but I've seen similar antics elsewhere, and those grackles came time and again, always choosing the white packets with real sugar, not the colored ones with artificial substitutes, and they knew exactly how to neatly tear the packets open.

I've watched gray squirrels at a Florida zoo come to attention at the sound of strollers wheeling down the pavement. As a human family paused to gaze at pacing hyenas, a squirrel slipped onto the lower storage area of their stroller and absconded with a mouthful of cheesy puff snacks. This too was no one-off raid. As I watched, squirrels repeatedly plundered the children's snacks they'd learned were reliably stowed in the bottoms of strollers.

When I looked for Key deer in Big Pine Key, locals directed me not to the wilderness trails of the wildlife refuge but to a residential neighborhood where lush lawns

Coexistence · 221

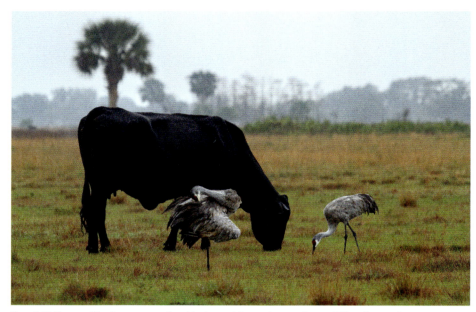

Sandhill Cranes (*Antigone canadensis*) alongside cattle at a Central Florida ranch.

provided superior grazing. Both in southwest Florida and the Panhandle, my quest for fox squirrels led me to golf courses where snack-packed golf carts hold the same enticements as strollers in the zoo. Even my photographs of bears eventually came not from Ocala National Forest where several weeks of searching left me with little more than sightings of fresh tracks and scat, but from residential yards in southwest Florida's Golden Gate Estates where bears glean food and cool themselves in swimming pools during the heat of the day.

Grackles stealing sugar packets and Key deer grazing well-tended lawns in an area more naturally devoid of such tender shoots reveal an inherent animal aptitude for finding resources, but in truth these examples go beyond that. Humans have fundamentally changed the world and its landscapes. The animals best able to make it today are the ones that have learned to coexist with people. Sandhill Cranes graze through ranches and agricultural fields as if they were natural prairie. Dolphins weave through boat traffic to fish in Florida's shallow bays. Flocks of Red-winged Blackbirds gather for easy meals below grain silos. Fox squirrels raid golf carts for food, but they might not have learned this trick if their natural pineland homes had not been all but eliminated from urban and suburban areas. With nowhere else to go, they chose the next closest thing—golf course greenways with treed or even forest-lined edges that somewhat emulate the open understory fox squirrels prefer.

Golden Gate Estates might not be a bear haven had it not been built on a forest these animals once called their own. Even now many of the properties in this development are surrounded by undeveloped lots of natural habitat that at least circuitously connect to protected areas. While it is still part of the forest matrix, and as long as enough native plant cover remains, bears, deer, bobcats, turkeys, and other wildlife can continue to reside there. Even the elusive Florida panther makes appearances on driveways and porches in this neighborhood.

These are examples of animals that have learned to survive in our world, but there are others that have truly thrived. Following the large-scale expansion of agriculture across the continent in the early 1900s, coyotes, a species native to the unforested central and western portions of the country, spread across North America, through Central America, and they're now poised to spread from Panama into South America. Humans further enhanced conditions for coyotes by removing the wolves that had helped keep coyote populations in check. Nonetheless, coyotes have proven themselves capable of secretly living alongside people, even in densely populated cities. I think many Miamians were shocked to discover that coyotes lived among them when one was rescued from Biscayne Bay at the Port of Miami a few years ago. I have yet to see one within my city's limits, but I also live in a neighborhood filled with

A Gopher Tortoise (*Gopherus polyphemus*) grazes in the parking median at Barefoot Beach in Bonita Springs.

Coexistence · 223

gray foxes I rarely see. It is their secretive nature that has allowed these canines to persist in areas with some of the highest densities of humans in the nation.

Perhaps less intuitive, human buildings and other infrastructure can also benefit wildlife. Cave Swallows from Central America and the Caribbean have expanded their nesting range into Florida for this reason. The mud nests of Cave Swallows, originating from Cuba, can now reliably be found attached to bridges and underpasses of the Florida Turnpike in south Miami-Dade County; both the nests and the birds foraging in adjacent open areas are in full view for those who look but generally go unnoticed as cars race by. Barn Owls, woodpeckers, raccoons, opossums, and some bats are adept at finding ways to roost and nest in homes, taking advantage of eaves, open attics, and spaces below roof tiles. Florida manatees find refuge from winter cold in the warm water discharges of coastal power plants. The population of American crocodiles has rebounded in part because they're able to nest on the protected raised banks along the cooling canals of the Turkey Point Nuclear Plant near Homestead. These once scarce reptiles are now expanding their range, claiming pond-side basking space in parks, gardens, and golf courses along the southern coast.

There are pluses and minuses to all of these accommodations. Sandhill Cranes, for example, have learned to coexist in suburban areas but when accompanied by chicks are slow to flee vehicles in the road and are increasingly being killed by impatient drivers. And there are other species that aren't adapting well to the world we've created, especially those that have specific habitat requirements. Florida's various subspecies of endangered beach mice, for example, occur only in natural dunes, which are constantly under threat from development and general beach recreation. Florida's sand scrub endemics also have nowhere to go when development and fire suppression rob them of their restricted habitat.

Just like the animals, we humans are also adapting to a changing world, a world transforming more rapidly than ever before due to our own actions. As the realities of climate change, pollution, and overpopulation dictate our futures, should we not seek solutions that also benefit these animals already struggling to keep up and those that have modified their lives to fit into the world we've created? Manatees have no way of knowing that the long-term health of their planet requires us to shift from nonrenewable sources to solar energy, a shift that will sacrifice the warm water respites they've adopted. How many of these creatures of habit might suffer or die as they're once again forced to pursue new escapes from the cold? Fortunately, people are helping. Efforts are being made in areas like Warm Mineral Springs along the southwest coast to reopen and maintain natural access routes to Florida's thermally

Bottlenose Dolphins (*Tursiops truncatus*) cruise the busy waters offshore Miami in Biscayne Bay.

constant springs, a move that not only benefits manatees but improves ecosystem function for everyone.

Similarly, municipalities have learned mutually beneficial ways to utilize the purifying properties of Florida's marshes. Wakodahatchee Wetlands, a prime wildlife-viewing location, was created by the Palm Beach County Water Utilities Department as part of their water treatment protocol. Similarly, the City of Gainesville Department of Public Works created the Sweetwater Wetlands Park in the early 2000s to manage urban runoff and to restore natural waterflow to Paynes Prairie. The Bayou Marcus Water Reclamation Facility in Pensacola, the Ocala Wetland Recharge Park, and the City of Lakeland's Se7en Wetlands are other examples of water recharge facilities that do so much more than treat water. These areas serve as important natural oases within urban matrices that provide ecological function, homes for our native animals, and recreational opportunities for people. It's telling that the parking lot at the Wakodahatchee Wetlands regularly fills shortly after opening, leaving a line of cars that may wait an hour or more to park on a busy weekend day. It's worth the wait. I regularly watch Wood Storks joust with their bills to defend nests strategically placed just beyond jousting range or am enthusiastically directed by fellow visitors to a large watersnake with babies, an elusive Wilson's Snipe, or a marsh rabbit tucked in among the reeds. The boardwalks at all of these sites are consistently packed with a wide range of visitors; they provide some of the best wildlife-viewing opportunities

Florida Manatees (*Trichechus manatus latirostris*) warm themselves in the outflow at Florida Power & Light's Manatee Lagoon Eco-Discovery Center.

in the state. The fact that people gravitate to these sites suggests that just like the animals, people too are inherently happy to coexist.

On my first visit to Barefoot Beach in Bonita Springs, I sat in a long line of stopped cars not waiting for a parking spot but to let a gopher tortoise mosey across the road. Designated a tortoise sanctuary, there were signs everywhere reminding beachgoers to check under their cars before leaving so as not to squash one that might've taken refuge in the shade. People had come to sun in the sand, yet the gopher tortoises were clearly part of the allure. I watched one tortoise nonchalantly munch its way across the median lawn as bikini-clad paparazzi followed closely, smartphones thrust in its direction.

One of my favorite examples in Florida, a demonstration of what a little human accommodation can do from a coexistence perspective, are the University of Florida's bat houses in Gainesville. Originally built to relocate a colony of bats that had moved into the concrete bleachers of a sports stadium where the stench of ever-growing piles of guano proved antithetical to coexistence, these bat houses are now

very much part of the Gainesville community. Located on the edge of a field of wildflowers opposite Lake Alice, this bat house complex is one of the largest in the world, hosting nearly half a million Brazilian free-tailed, southeastern, and evening bats. On the nights I was there, people began gathering concert-like in the field around the houses an hour before the anticipated post-sunset emergence. Children romped among plots of yellow flowers. Parents spread blankets on the lawn. College kids tossed Frisbees. Grandparents sat on benches. People spilled beyond the field to fill the sidewalk, hushing as darkness settled.

"What kind of bats are they?"

"What time will they come out?"

I heard repeated snippets of conversation whispered daily in the moments of anticipation before the first bat emerged, and then silence. As the initial dribble of bats grew to blacken out the sky, only the whooshing of wings could be heard until the stream of bats slowed to a trickle as final stragglers emerged for the night. The mood and tone among spectators returning to their cars afterward felt much like departing the splendor of the grand finale of a Fourth of July fireworks display. There is indeed something thrilling about coexistence.

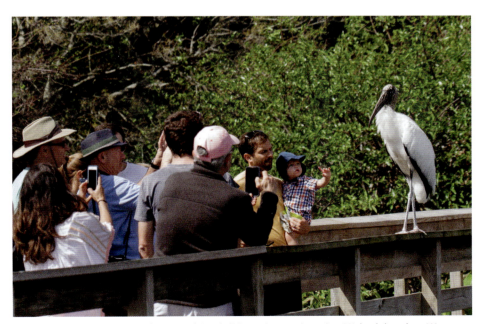

Visitors share a moment with a Wood Stork (*Mycteria americana*) at Wakodahatchee Wetlands, a Palm Beach County water reclamation project.

Brazilian Free-tailed Bat (*Tadarida brasiliensis*), Southeastern Myotis (*Myotis austroriparius*), Evening Bat (*Nycticeius humeralis*)

A lone bat flutters from a barnlike bat house. A Red-shouldered Hawk swoops in from seemingly nowhere, snagging the bat in its talons. A gasp from the crowd gathered to watch the evening's emergence. Bat and bird struggle. The bat flies free. A sigh of relief from the crowd. But the hawk isn't done. It perches on a fence below University of Florida's bat houses, awaiting further opportunity. The crowd waits and watches. The daylight predator finally flies to its own roost empty-clawed before complete darkness falls. A few shadowy silhouettes drop from the bat houses, flapping in circles before crossing the field toward Lake Alice. The emergence has begun. Streams of bats ink out the navy sky, an aerial corps de ballet swirling into the night. They move along the tree line, spiral above the field of wildflowers, then disappear across the lake to consume estimates of 2.5 billion or more moths, mosquitoes, flies, gnats, and other winged insects on this night alone.

Gray Fox (*Urocyon cinereoargenteus*)

A bushy tail drapes down from the fork of an ancient oak tree in the historic Miami City Cemetery. It certainly isn't the whip-poor-will I've come to photograph, nor is it the tail of a squirrel or raccoon that might be lurking in arboreal shadows of a city park. I inch beyond the limb that blocks my view and stare into the bright eyes of a gray fox. One of the only canines capable of climbing, this one is clearly at ease in the arms of this oak. It feels surreal to be locking eyes with this animal—I'd been stalking gray foxes in my Coconut Grove neighborhood for many months after seeing one scramble across the road to squeeze beneath a driveway gate at some ridiculous pre-dawn hour. An online neighborhood chat suggested there were several in the area, kits playing in yards even, but while I suspected one had pooped by my pool, I'd seen none after many hours of staking out areas they allegedly frequented. Yet as I stand surrounded by historic headstones, one of these secretive animals calmly studies me from a perch that is both out in the open and largely hidden from view. How many mourners had this fox watched unnoticed as they lay flowers at these gravestones? Or history buffs looking for the graves of Julia Tuttle or William Burdine? With a range extending well into South America, this more tropically inclined fox is the one

historically found even in the most southerly reaches of the Florida peninsula. An animal of the woods with an incredibly diverse diet and resourceful cleverness, gray foxes have adapted well to the human environment. They thrive in neighborhoods with sufficient vegetative cover, denning below decks, eating roof rats, lounging with pet cats and sharing their food, scaling walls, and napping in trees—watching unnoticed as we humans live our lives among them.

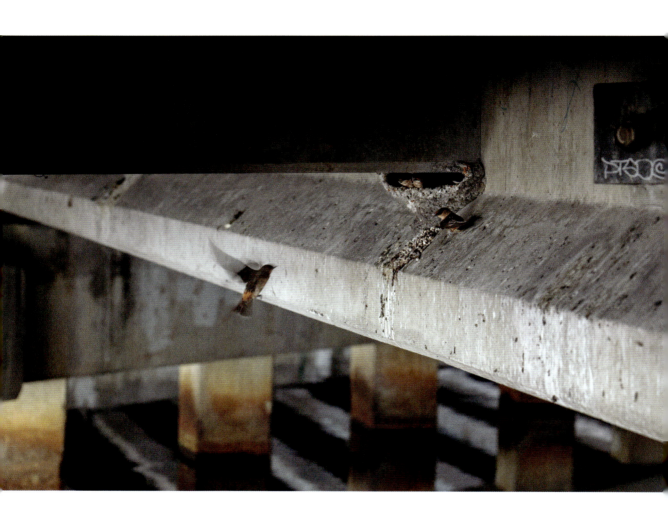

Cave Swallow (*Petrochelidon fulva fulva*)

I pull out of busy Miami traffic and into a crowded strip mall parking lot, easing onto the grassy edge of the canal bank so as not to claim a coveted spot. I make my way to the water's edge and then along the shore to the bridge. I see an apparently homeless man sleeping on the concrete platform below the bridge on the opposite shore, his belongings piled beside him. I wonder whom I might disrupt on my side as I kneel to peer into the shadows, but beams and columns block my view. I take a deep breath and crawl inside. The space is cool and dark, oddly ominous and calming at the same time. I pass several beams, scanning the concrete structures above until I see what I've come to find—a mud nest plastered against one wall like an upside-down adobe oven. Two tiny heads dart into its interior shadows as I stop to watch. I crawl as far away as I can up into the bridge infrastructure, set up my camera gear, and wait.

It's several minutes before one of those small faces reemerges. It looks in my direction but seems not to notice me crouched in the shadows. It turns its focus toward the water below. An adult Cave Swallow zooms into view and the second nestling appears. The two chicks peep and peep, stretching as far out of the opening as they can reach, but the adult doesn't stop. Chirps from farther down suggest this was someone else's parent. The calls die down, and once again the rhythmic sound of cars thumping across the seams above dominates. Several more minutes pass. The chicks look bored, their gazes wandering aimlessly. I too feel listless, but a roar jerks me to attention. A speeding Jet Ski zips through the water, its engine reverberating deafeningly through the tunnel while its wake crashes onto the concrete supports before me. I cover my ears and the chicks pull back into the nest. The water calms, the chicks reemerge, and, eventually, an adult bird appears. This swallow circles below, then lands on the ledge by the nest. The chicks plead, opening their bills wide to accept insects the parent caught in the open air above the canal. I expect the parent to feed and leave, but instead another adult circles in from the light to land on the ledge. Then another, and another. The chicks peep and stretch toward the gathered adults, but no more food is offered. Perhaps these colonial nesters are simply taking a break from their own nearby nests. Birds of Caribbean origin, the ones in Miami likely immigrated from neighboring Cuba. Naturally they'd gather in caves to nest, yet here they are, hosting a graffiti-decorated nest party below a string of cars whose drivers, and likely even the guy sleeping on the opposite shore, are oblivious to their presence.

Scarlet Kingsnake (*Lampropeltis elapsoides*)

Red, black, yellow, black. Red, black, yellow, black. Bands of color flow across the leaf litter. I stop. What's a scarlet kingsnake doing out in the open in broad daylight? It's late in the day, but even at night this primarily nocturnal species spends most of its time buried in the ground, tucked beneath the bark of dead and dying trees, or burrowed in the fibers of a sabal palm crown. Heavy rains might inspire such movement, but it hadn't rained in days. Red, black, yellow, black. The colors seem to blur as the snake races across the ground and then onto the paved nature path before me.

"Is that a coral snake?" a woman asks from behind.

It's not, but the resemblance is no accident. Nonvenomous scarlet kingsnakes share the bright warning colors and patterning of the venomous harlequin coral snake, an animal mammalian predators wisely avoid, and by association, the kingsnake also benefits from this avoidance. But they're not exactly alike. Red, black, yellow, black is the color order for the scarlet kingsnake. Black, yellow, red, yellow is that of the coral snake. It's a subtle difference but important to their bitten prey. People needn't much worry though, both of these species are secretive, likely to flee if encountered, and unlikely to bite unless harassed. In fact, coral snake mouths are too small to easily wrap around an ankle, so the rare person bitten is generally someone who unobservantly stepped on one barefoot or who foolishly grabbed it. And while coral snake venom can indeed kill, there has only been one documented death in the United States since its antivenom was produced in 1967. Florida, of course, holds that record—a man in Lee County who was bitten while trying to kill the coral snake and who chose not to seek medical assistance afterward.

A coral snake did once approach me while I quietly measured an endangered cactus in pine scrub. Unlike the scarlet kingsnake, coral snakes forage during the day, and I got the feeling this one had picked up on my chemical cue. It came directly to me, but just as I thought it was going to nose-butt my boot, it paused. Its tongue flicked the sand between us a couple times, then it veered to the right. Black, yellow, red, yellow. Black, yellow, red, yellow. That day the bands of color that flowed across the white sand were in coral snake order.

Northern Raccoon (*Procyon lotor*)

A mother and three fuzzy young emerge from below a limestone picnic table in a North Miami Beach park. Another mother with older kits emerges from a nearby thicket. More raccoons, undoubtedly other females with their kin, appear from behind a low wall, beneath a picnic shelter, down the trunk of an old live oak, and from the shadows of a winding city park trail. I'm surrounded. The mother with the smallest young keeps her distance, but one of the older kits walks right up to me. It lifts onto its hind legs, black eyes peering curiously from its mask, undoubtedly hoping for a handout. When I offer none, it returns to the milling pack, tumbling into a wrestling match with another young raccoon.

Raccoons thrive in cities where comparatively few predators and widely available human-derived food work in their favor. With few limits on resources, plump city raccoons can be found in large packs such as the one I encountered. And they can be bold. I've snatched an entire box of crackers back from a raccoon who tried to snag it straight off the picnic table beside me. The raccoon had no doubt gotten away with such blatant theft before, its cuteness and dexterous hands permitting the transgres-

sion. But their intelligence shouldn't be underestimated. Even on forested islands where animals tend to be solitary and scrawny, their cleverness reigns.

My first ever camping trip in Florida was at Cayo Costa, separated from the mainland by a ferry ride with all the weekend's food secured in one big cooler. That first night, after the fire was out and we'd retreated to our tents, the sound of rustling leaves closed in. We shone flashlights into the dark and discovered a small troop

of raccoons assessing our cooler. We shooed them away, strapped the lid shut, and thought we'd won. Our food stayed safe, but the next morning we found the strap half gnawed and a hole in the outer plastic of the cooler. We sensed eyes on us during the day as we prepared for another nighttime attack—patching the cooler hole with aluminum from empty beer cans, roping the lid shut and lodging the entire thing beneath the heavy picnic table before retiring for the night. I ignored the rustling that night, certain we'd thwarted further damage. In the morning though, our cooler was nearly dragged free from the table, the rope lay useless on the ground and there was a patchwork of new holes. It was full-blown battle our last day. In addition to our mending, patching, and lodging, we sharpened sticks that we carefully wedged facing outward around our cooler in fort formation. Surely, we could outwit a handful of raccoons. Yet in the morning, our fort was dismantled and the cooler nearly pulled free. Two more inches and the raccoons would've opened that lid and won their feast. Perhaps there are limits to coexistence.

North American Racer (*Coluber constrictor*)

From outside one of my first Miami apartments, I hear a shriek followed by the sound of metal scraping across concrete. I peer out the window to see my neighbor, a tightly muscled and tattooed man nearly twice my size, wielding a shovel as an axe. He prances across our shared driveway, landing one blow after another ever closer to a desperately darting snake. I rush out the door and ask why he's trying to kill it. Adrenaline is too high for a conversation though and we shout back and forth, that weaponized shovel swinging menacingly in my direction. In a moment of clarity, I decide to resolve our difference in the only way I know how—I grab the snake. I shout some final defiant comment before storming down the street, snake in hand. That racer I was able to rescue, but another, one I regularly encountered in a later yard and considered a friend, showed up decapitated on my driveway. It was a statement by a different neighbor, one clearly displeased by the animals I harbored in my wildlife-friendly yard.

I suspect most disgust for animals derives from fear. My shovel-wielding neighbor confessed as much when I returned from releasing our disputed racer at a nearby park. Nearly everyone has at least one animal phobia, and for many, myself included, it's snakes. I was that kid in elementary school who had to leave the room in order to avoid a panic attack when a tame, harmless snake was passed around. Even today, a snake-resembling stick that catches me unaware in the wild can send me flying across the trail. Yet I became a herpetologist, a person who studies amphibians and reptiles, including snakes. After a lifetime of scouting wildlife, a task involving thousands of hours of waiting, watching, and wishing that animals were less furtive, I know firsthand that there's little to fear. Most animals work hard not to be seen, and with a little knowledge and caution, people can avoid negative encounters, particularly here in Florida where even our panther and crocodile are shy and docile compared to their counterparts in other parts of the world.

 I've had an eastern diamondback pass me in an Everglades thunder shower, a coral snake meanders right up to my boot at the Savannas Preserve State Park in Port St. Lucie, any number of cottonmouths have flashed their white mouths at me across the state, and I even had a black cobra as long as the dirt road was wide slither beneath my lifted foot at a game park in Kenya, but not a single one of these venomous snakes paid me any heed. The only time I've ever been bitten by a snake is that day I brusquely grabbed the racer from my yard to save it from bludgeoning. But I think my bleeding made a point. My neighbor declared that if a little girl like me could move a snake, so could he; he promised to leave the shovel in the shed next time.

Burrowing Owl (*Athene cunicularia floridana*)

Long legs scratch at the ground, sending up a cloud of dust that all but masks the tiny puff of feathers creating this storm. An adult Burrowing Owl stands on either side of the pair's energetic chick. As I pull up to the curb, I hear a rasping hiss and the baby disappears. It's the smallest Burrowing Owl chick I've ever seen and so I turn off my engine to wait for another view. Cars zip up and down the residential road beside me. A couple emerges and walks their dog down the sidewalk not too far from the owls and their burrow. Houses surround these birds on all sides. I assume they'll become used to my parked car and allow the chick to emerge, but while one parent flies beyond the rope barricade that quarantines their home from the rest of the empty lot, the other stays firmly near the burrow and hisses each time the chick nears the entrance. They have learned to live among people, but they are still rightfully wary.

 Like the caracara, Burrowing Owls are fundamentally animals of the dry prairie that became isolated in Florida when biological connections to the arid American southwest were lost. Initially restricted to prairie in the Kissimmee area of south-central Florida, Burrowing Owls expanded onto ranch and agricultural lands as fire suppression and human land conversion altered their natural habitat. Today, their nesting habitat includes airports, city parks, ball fields, and residential lots, places with diggable dry land and low vegetation. Once established, Florida Burrowing Owls tend to be full-time residents that continue raising their young in the same burrow year after year. The rock ridge below my own home isn't suitable for Burrowing Owls, but what I wouldn't give to have a family of Burrowing Owls as my neighbors; eating bugs in the day, rodents at night, and possibly allowing me the occasional glimpse of their tiny young.

Big Cypress Fox Squirrel (*Sciurus niger avicennia*)

A small and furry squirrel huddles in the first rays of sun to hit the edge of Loop Road in the Big Cypress National Preserve. It stumbles awkwardly toward the bushes and disappears into the vegetation. It's my first glimpse of the state-threatened Big Cypress fox squirrel and I'm determined it be more than a fleeting view. I creep toward the bushes, squinting into a maze of branches and unyielding shadows. There'd be no way to see the squirrel even if it were mere inches away. I'm about to give up when a nearby cocoplum bush rustles. I watch the movement progress from one side, angling upward until a white nose and black face suddenly burst into view at the top. The squirrel stares at a large ripe cocoplum several inches below. Its tiny paw stretches toward the purple fruit. It's just out of reach and the squirrel strains, shifting its body forward until its entire being tumbles into view. Legs scramble, tail flicks, and the animal catches its balance. It sits a moment, seemingly testing its stability before once again stretching toward the fruit. This time it succeeds. It plucks its juicy prize, using its paws like a wood turning lathe to spin the fruit until every bit of pulp is eaten.

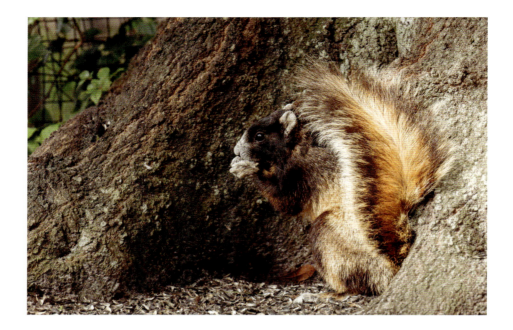

I watch the squirrel repeat its harvest, stumbles and all, several more times, but it's not until the squirrel scrambles into a nearby cypress tree where a much larger, sleeker fox squirrel awaits that I understand the animal's clumsiness. I'd been watching a baby learning to feed itself and, as I later learned, was still naive to humans.

Every other fox squirrel I've encountered in native habitat, both Big Cypress squirrels in southern Florida and the more widespread southern fox squirrel subspecies found in northern and central Florida, has been exceedingly wary. They've all been adults that have instantly bound out of view, including the young one's parent once it noticed me. To find adult fox squirrels tolerant of photography, I ended up visiting golf courses, pastures, and a beautiful, wildlife-friendly yard on the outskirts of Estero. These fox squirrels have become less wary of people as they've accommodated to life in the suburbs where they've learned to use golf courses and other park-like settings with trees and open understory as a replacement for forest homes lost to development and fire suppression. I'm impressed by their resourcefulness and grateful for the photographic opportunities, but I hope there'll also always be animals too wary to pause.

Green Treefrog (*Hyla cinerea*)

I stand at the edge of the pond in my yard. It's nestled into a natural solution hole and outlined in the rock ridge limestone that supports my home. Native mosquitofish swim through the water, keeping those biting insects at bay. A pair of Common Yellowthroat warblers flit about the alligator flag leaves, and I hope they'll find a place to nest. But today my attention is most drawn to the cattails where a green treefrog perches elegantly on a stalk. Nonnative Cuban treefrogs and cane toads have plagued my pond from the start, chasing off Florida's more demure native frogs. And so I'm thrilled to finally find one of Florida's most common and widespread native treefrogs claiming my re-creation of a natural wetland for its own.

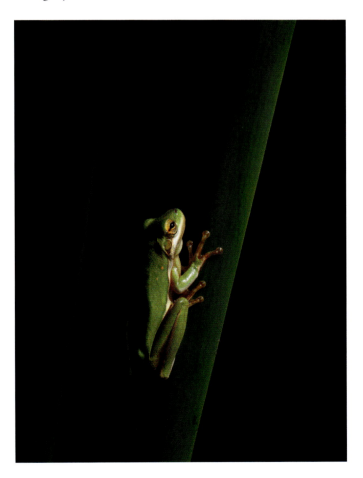

Bottlenose Dolphin (*Tursiops truncatus*)

Sleek gray disrupts the water's surface. A fluke emerges. It rises like a half moon, cascading a waterfall into the air before sinking out of view. Another glistening gray body emerges, and another beyond that. Three, five, seven, I lose count of the number of dolphins as more and more sleek bodies emerge, then submerge. I spot a few individuals I've come to recognize in my years following Biscayne Bay's resident dolphins—one with a drooping fin, one with a notch a few inches down the back of its fin, and one who's fluke looks blunted on the left—yet this is a larger pod than I've seen before, a temporary gathering including many I don't know.

A single dolphin breaks loose from the pack. It jumps in a high, clean arch from undisturbed waters. Another follows its lead and another joins to create the marine equivalent of a double rainbow. Sea World–worthy leaps surround me. These out of water breaches are thought to be one of the ways dolphins communicate. While their clicks and squeals travel far through the water, splash sounds are more localized and provide a more accurate measure of how large an animal is in dominance displays, or may be a quieter way to organize a fishing expedition. I suspect the latter

as the dolphins before me gather into a circle, spinning and spiraling into an ever-tighter knot of foaming water and flashing gray. Fins and flukes rise in and out of the churning pool as they probe the bottom. A cloud of muddied waters encircles the group. A commercial fishing boat chugs past without pause. A speedboat tows paragliders above. A sailboat tacks by. Cruise ships line the dock at Miami's nearby seaport. Any number of boats are within potential view of this scene, yet only mine drifts alongside the action. Several minutes pass before the waters begin to calm. The dolphins spread out, surfacing less frequently and at greater distances from one another. And then, as abruptly as it began, one last dolphin leaps from the water before it too disappears beneath Miami's busy waters.

Coexistence · 247

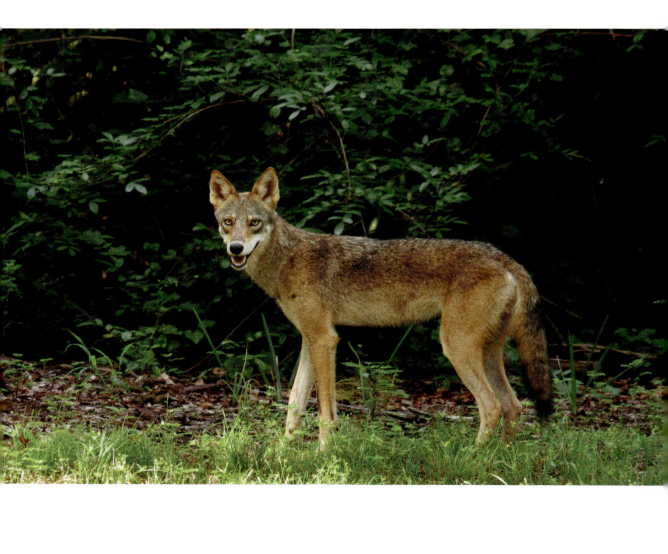

Coyote (*Canis latrans*)

The silvery glow of the moon reflects off Florida Bay, illuminating the shoreline around the Flamingo Visitor Center and marina. A silhouetted figure trots along the Buttonwood Canal retention wall. It's too lanky to be a dog, and yet it's undoubtedly a canine—a coyote. Were coyotes even in Everglades National Park? I question my identification even as I watch the animal stride through the night. It turns out the first confirmed observation for the park had occurred near Nine Mile Pond in 1993, but it wasn't until 2007 that Miami-Dade and Monroe were formally included in the Florida Fish and Wildlife Conservation Commission's tally of coyote-bearing counties. Such is the nature of range expansions though. It starts gradually with early observers second-guessing the very thing before their eyes, requiring photographic evidence to convince both themselves and others of the validity of their sighting. And then one day, it's perfectly normal to have a coyote like this coexisting in a Florida yard.

Gopher Tortoise (*Gopherus polyphemus*)

A gopher tortoise peers into the midday sun from the darkness of its burrow. It takes a few steps forward, then assesses its surroundings from the sandy opening to its home. Delicate mouse paw prints, lizard tail drags, and swerving snake tracks criss-cross the sand in front of the tortoise. Over 350 other animals are known to use gopher tortoise burrows to escape predators or inclement weather, to find food, or even to call home. Yet the irony is that this animal that so generously shares its own home is constantly expected to find a new one.

 I remember being so impressed by the gopher tortoise crossing signs that seemed to be everywhere the first time I visited Marco Island. It was a community proud to host this protected species and still is, but over the years empty lots have transformed into mini mansions. On a recent visit I stopped at one of the few remaining lots, a steep patch surrounded by overly manicured yards on three sides and a busy road on

250 · *Wild Florida*

the fourth. It seemed scarcely enough habitat to support even one gopher tortoise and yet I counted ten visible from where I stood on the right-of-way. One Marco Island resident purchased the vacant land next to his house to ensure the twenty-six gopher tortoises living there wouldn't have to move. It was a generous act indeed, but I was shocked to hear the number. Twenty-six gopher tortoises in one little lot?! These are generally solitary animals in the wild and not likely to live well in such high densities, but they aren't exactly given a choice.

 A friend of mine used to enjoy watching a gopher tortoise graze across her lawn, but its burrow was in the neighboring lot. When developers proposed to build there, a survey was conducted and the gopher tortoise with its burrow was discovered. Despite the fact that it was on the edge of the property away from intended construction and my friend pleaded for it to stay, or be moved to her yard, it was deemed that this poor tortoise needed to be moved to an approved recipient site many miles away. It was of course done to ensure that no harm would come to the tortoise, but I can't help but wonder if there couldn't be a better way. What if instead of relocating and concentrating these tortoises, people learned to safely build around them and to share their homes with this animal that so generously shares its burrow with so many others?

Coexistence · 251

Helping

Something gray and fluffy twists through the leaves of an oak branch. It spins and turns like an acrobatic amoeba playing in the shadows. I pause. I squint and I watch, but what I see makes no sense. What is this tiny creature? Another circus-worthy flip and two yellow eyes fix on mine. Before I've fully registered the gaze, the animal flings itself in my direction and a fledgling screech-owl huddles at my feet. A bike zooms past on the sidewalk, cars crisscross the busy road to my left, and I see a man walking two dogs in my direction. This is no place for a lone baby owl. Knowing a reunion with its parents would be best, I scan the arching branches for a nest or some sign of the adults, but the canopy veils its secrets from view. The owl stares at me unblinking, a sign I choose to interpret as trust as I scoop the unresisting bird into my palms. I wait for a pause in the traffic and cross to what I hope will be a more secure refuge, a sidewalk-less area with a strip of trees and a limestone wall. I find a hollowed branch among the leaves several feet off the ground and tuck the tiny owl inside. I hope it's discreet enough to keep the baby safe from outdoor cats but not hidden from its parents. I bid the baby farewell and continue to my yoga class, but my shavasana is plagued with concern for the owlet. I can't resist the urge to peek into that hollow on my return home. It's empty. For a moment I'm elated, imagining the baby safely back in its parents' care. But then I see it, once again huddled near my feet. Its body is now limp and eyes closed; leaving it would be a death sentence. I swaddle the owl in my yoga towel and rush home.

Those brilliant eyes reopened after a few sips of water and undisturbed rest in a towel-lined box, but I knew I was ill-equipped and unauthorized to serve as owl mom for the next several weeks. What did I know about flying and swooping up mice? Fortunately, the Falcon Batchelor Raptor Rehabilitation Center is a mere fifteen-minute drive from my home and graciously accepted responsibility for my adoptee. Nearly every city in Florida has at least one wildlife rescue center filled with staff and volunteers who are dedicated to animals. These are people who work long hours, sometimes traveling beyond their center walls to extract bats from garages,

Orphaned Eastern Screech Owl chick (*Megascops asio*)

untangle pelicans from fishing line, or tend to opossums whose paws need splinting. They rescue orphaned young of any number of species that need to be reared and taught to hunt and forage on their own before being safely released back into the wild.

Sadly, not all injuries are accidental and some prove permanently debilitating. Uno, one of Florida's most famous panthers, was shot twice, once directly in the face, and left for dead. A good Samaritan found the animal still clinging for life on the roadside. The panther was taken to the Naples Zoo at Caribbean Gardens where a team of veterinarians nursed it back to health. It recovered, though without the use of one eye. Knowing a half-blind panther had little chance of survival in the wild, the zoo instead added the impaired animal to its collection, where Uno's enclosure became one of the zoo's most popular exhibits. When I went to the Naples Zoo to

Helping · 253

try and photograph Uno in 2018, he'd recently passed away, but signs continued to pay tribute to his legacy and I'd wager his contribution to panther conservation as a much-loved ambassador for the species was greater than the average panther living in the wild.

Captivity is not a plight I would wish on any wild animal, but for injured individuals like Uno, or those derived from generations of animals born and raised in captivity, or worse, those who face imminent extinction in their natural habitats, confinement may be the best answer, and animals in that situation have an important role to play. Many people these days, city dwellers in particular, will only ever personally meet nondomesticated animals at zoos, nature centers, and rehabilitation centers. I can attest that it's not as thrilling to meet a panther behind a barrier as seeing one in the wild, but captive ambassadors provide important opportunities for people to learn about these animals firsthand. These encounters can go far in assuaging fears and providing some level of connection with the natural world at a time when that

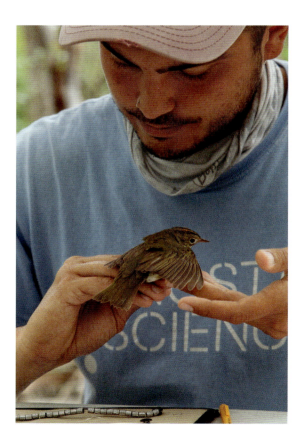

Brian Cammarano evaluates an Ovenbird (*Seiurus aurocapilla*) at the Cape Florida Banding Station on Key Biscayne.

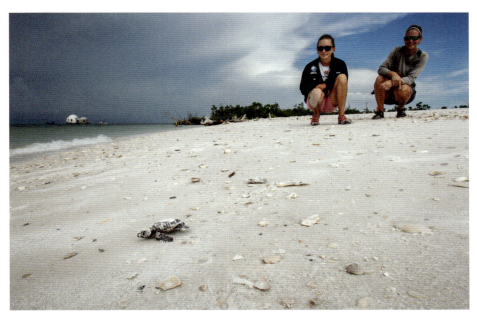

Sarah Norris and Jill Schmid watch a rescued hatchling Loggerhead Sea Turtle (*Caretta caretta*) make its way down a beach in the Rookery Bay National Estuarine Research Reserve.

connection is deteriorating rapidly. The average American child spends less than ten minutes a day of unstructured time outdoors versus roughly seven and a half hours devoted to electronic media. How are they to know and love a world they've never experienced? Now more than ever, there is a need for such ambassador animals and the teams of educators that facilitate positive encounters between people and their nonhuman neighbors.

I heard many a child ooh and ahh as the red wolves at the Tallahassee Museum wove figure eights through the trees of their exhibit, but these captive animals have a role beyond education. These wolves are being strategically bred with animals held at a network of zoos across the country dedicated to the survival of this animal that disappeared from the wild in the 1970s. The ultimate goal is to reestablish populations where they once roamed, such as at the St. Vincent National Wildlife Refuge where several of the red wolves reared at the Tallahassee Museum have gone to live under the oversight of the U.S. Fish and Wildlife Service. Without the countless hours dedicated by hundreds of people, possibly thousands over time, the red wolf would likely be gone. Instead, because of these efforts, both a pair on St. Vincent Island and a pack in North Carolina have reared new generations in the wild.

Helping · 255

Many zoos today have incorporated on-the-ground conservation into their missions. Much of this work is related to animals in their collections. The flamingos squabbling at the Zoo Miami entrance, for example, provided inspiration for their Conservation and Research Department to delve into the origins of wild flamingos in Florida, leading to this bird being recognized as a Florida native species. But the Zoo Miami team has also taken it a step further, turning an eye to the native animals that utilize natural pine rockland habitat surrounding their facility. They've teamed with university researchers, U.S. Fish and Wildlife Service, Florida Fish and Wildlife Conservation Commission, Bat Conservation International, and others to study and conserve some of the area's most endangered animals. I tagged along to photograph what is likely the last population of Miami tiger beetles. And with them I was also able to see a lone Florida bonneted bat hanging out in a picnic pavilion where it was poised to lure a female from one of the artificial roosting sites Zoo Miami and colleagues established. Perhaps with such efforts, these two species won't go extinct in the wild.

It is no small task to keep dwindling species from disappearing, but teams of people have dedicated themselves to doing so. I joined a University of Florida graduate

Natalie Bergeron releases captive-bred Miami Blues (*Cyclargus thomasi bethunebakeri*) at Bahia Honda State Park.

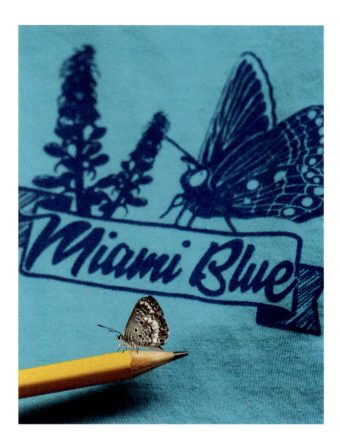

Sarah Cabrera balances a Miami Blue (*Cyclargus thomasi bethunebakeri*) on the tip of a pencil for scale, her University of Florida lab's project logo visible on her shirt.

student in the Florida Keys to watch Miami blue butterflies returned to the wild. I later visited the McGuire Center for Lepidoptera and Biodiversity in Gainesville where those Miami blues had been raised and where I photographed endangered Schaus swallowtail butterflies about to be transferred to Biscayne National Park for release. I joined a biologist from Common Ground Ecology environmental consulting to watch a newly discovered population of Florida Grasshopper Sparrows buzz in the early morning light, a sign of hope in the endless battle the Florida Grasshopper Sparrow Working Group has fought on behalf of this small bird. I was reminded that these battles frequently persist for decades when I joined biologists from the Rookery Bay National Estuarine Research Reserve to monitor loggerhead sea turtle nests, a species that first received federal protection in 1978.

The conservation battles today aren't just to keep endangered animals from disappearing, but also to keep more common animals common. I joined a team of researchers at Big Cypress National Preserve trying to find a more effective way of re-

moving nonnative pythons from the wild in an attempt to protect South Florida's mammal populations that are being devastated by this invader. I joined an Audubon Florida team as they netted black skimmers still asleep on the dune in the predawn hour for population monitoring. I joined the director of the Cape Florida Banding Station on Key Biscayne and her crew of volunteers as they caught and measured migratory birds just as they've done since 2002. At nearly every state reserve I visited in the last couple years, there were signs asking the public to report their skunk sightings to help the Florida Fish and Wildlife Conservation Commission determine

Lance Arvidson of Common Ground Ecology sets up an acoustic monitoring station for Florida Bonneted Bats (*Eumops floridanus*).

258 · *Wild Florida*

Audubon Florida biologist Adam DiNuovo examines a Black Skimmer (*Rynchops niger*) as part of his team's shorebird monitoring program.

the population status of these once pervasive species. This informational plea is a reminder that there are ways for everyone to help with wildlife conservation in today's complex world, even in one's own backyard.

A glance down from a plane as it lands at any of Florida's major airports is enough to see the need from the perspective of a migratory bird looking for a place to feed and rest. The patches of green are generally too few, too small, and too far apart. Just like on the statewide level, Florida needs wildlife corridors within its urban centers to connect the tiny parcels of remaining habitat to one another and to the larger natural areas beyond. Efforts to save persisting patches of natural habitat within city boundaries are essential, but there are also other ways private landowners can contribute to connecting patches of green. In fact, homeowners, condo associations, commercial businesses, and the like hold the key to regreening the urban corridor. This may sound like an overwhelming task, but it can start with just one plant.

What can one plant do? If it's the right plant, quite a lot. Consider an oak, for example. Over a hundred species of vertebrates are known to consume their acorns, not just squirrels and mice but large mammals such as bears and foxes, and birds such as woodpeckers, turkeys, and quails. Florida Scrub-Jays tend their stashes of acorns

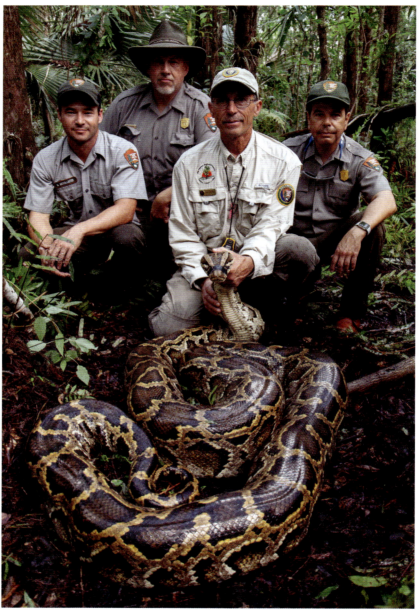

Biologist Matthew McCollister, Big Cypress National Preserve Superintendent Thomas Forsyth, volunteer Mike Reupert, and Everglades National Park Superintendent Pedro Ramos (*left to right*) pose with a Burmese Python (*Python molurus bivittatus*) captured for a Big Cypress National Preserve research study.

all through the winter, the highest quality cache sites being reserved for birds with the highest social rank. Hummingbirds eat oak pollen. The 500-plus species of caterpillars, beetles, and other insects that live on oaks serve as a veritable grocery store for insectivorous birds. Oaks also support entire communities of other plants that benefit wildlife—curtains of Spanish moss in which bats roost and birds nest, spiky bromeliads in whose whorled pools frogs nap, ferns, lichens, vines, and more help convert a single oak into an entire ecosystem. Planting just one oak can turn a few square inches of ground space into hundreds of square feet of canopy that help connect one patch of wildlife habitat to the next. And while not everyone has space for a sprawling live oak, Florida has over twenty species of oak so there's a size and shape to fit most yards. There are also many other wildlife-friendly plants to choose from. It's hard to overestimate the ability of a small native bush or wildflowers planted in a pot on an apartment balcony to provide food or a home to birds, butterflies, lizards, and frogs. Every patch of nature matters, and trust me, if you provide it, the wildlife will come.

When I first moved into my home in Coconut Grove several years ago, it only took a few days for me to realize that there were nearly no animals on my new property. I'd seen a cardinal flit through once and a catbird spent a couple hours exploring the bushes, but it didn't stay and I couldn't blame it. None of the plants were native; they were devoid of any fruits, flowers, and insects that a native bird might eat. And beyond that, the earth below had been suffocated by layers of plastic and river rocks, no doubt to smother so-called weeds in an attempt to maintain aesthetic order.

I immediately ripped up the plastic, took out the nonnative plants, added a water feature, and filled every inch with native plants, including a patch of meadow-emulating lawn filled with a mix of grasses and low-lying native plants, weeds by some standards, that yield purple, white, and yellow flowers at different times of year to support moths, skippers, beetles, and other insects that help bring birds, frogs, lizards, and other animals to my yard. The very day I filled my water feature, a cloud of dragonflies descended to its waters.

After just five years, I've recorded over a hundred species of birds, reptiles, amphibians, mammals, and butterflies in my yard. Red-bellied Woodpeckers, Great Crested Flycatchers, Northern Cardinals, and gray squirrels have all nested there. Zebra longwing butterflies, monarchs, queens, Palamedes swallowtails, and Atala butterflies have all metamorphosed on my plants. I often get to dodge through a maze of butterflies or leap across a black racer snake as I stroll along my garden path. Blue Jays wake me at my bedroom window in the morning, and Chimney Swifts trill

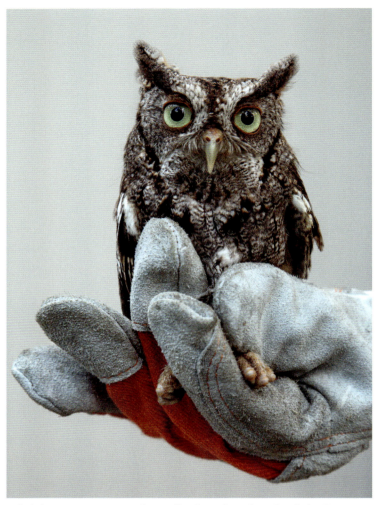

Rehabilitation manager Hailey Möller from the Falcon Batchelor Raptor Rehabilitation Center returns my now fully grown orphaned Eastern Screech Owl (*Megascops asio*) to my yard.

lullabies across the sky as I sit on my porch in the evenings. That tiny screech-owl I delivered to the wildlife rehabilitation center was released into one of my nest boxes once it passed its mouse-catching test, and years later, I still hear it calling from my trees. I have successfully created a yard that emulates nature. It's a wonderful habitat both for me and an entire community of animals. Isn't it time we help out and invite nature back into our lives?

Whether you live in the city, in the suburbs, on a farm, on a ranch, or even out in the woods, the most impactful thing you can do to help wild animals in Florida is to create or maintain natural habitat, but there are many other things you can do as well. Here are a few to consider:

- Plant native plants arranged naturalistically in your yard.
- Use wildlife-friendly lighting at night, leaving dark areas for fireflies, owls, bats, and other nocturnal creatures.
- Constrain your pets by keeping them inside or on a leash.
- Exchange harsh chemicals for natural ingredients and methods of pesticide, herbicide, mosquito control, and fertilizing. And never install fake turfgrass, which causes any number of environmental atrocities including leaching toxins into the soil and contributing to global warming by getting more than 70°F hotter than natural lawns.
- Use window decals to prevent bird collisions.
- Avoid single-use plastics and ensure they're properly recycled or otherwise disposed of when used. Never litter, particularly in coastal areas.
- Use reef-friendly sunscreens or sun-blocking apparel when recreating around or in Florida's springs, rivers, ocean, or other natural waters.
- Choose responsible tour operators and always view wildlife from a respectful distance.
- Ask your representatives to fund programs supporting natural areas, both management and acquisition, as well as wildlife conservation.
- Demand that developments include natural area corridors, use a diversity of native plants in their landscaping, and protect water resources.
- Support not-for-profit organizations that research, educate, and/or advocate for nature, wildlife, and its conservation.
- Volunteer for wildlife monitoring projects like the many sea turtle and shorebird nesting programs across the state.
- Participate in citizen science by recording your wildlife sightings in open access databases such as eBird and iNaturalist.
- Encourage children to get outside and interact with nature.

Eastern Indigo Snake (*Drymarchon couperi*)

The sleek black scales of an eastern indigo snake glisten in the sun as Zoo Miami's Ron Magill positions the animal on a palm frond for me to photograph. It slithers off the frond. Ron wrangles it back on. The snake slithers again. Ron wrangles again. True to the species' reputation though, this animal never complains. Their docile nature, beauty, and impressive size as North America's longest snake, averaging six or seven feet, made indigo snakes popular in the pet trade. It's a snake that shouldn't be underestimated though. If truly riled, it has an impressive hissing display often accompanied by foul-smelling musk and it has no qualms about taking down an eastern diamondback or any other of Florida's venomous snakes for a meal. Unfortunately, these tougher traits have done little to protect indigo snakes from humans.

This is a snake that was once common and widespread throughout the state, but it's telling that I have yet to see one in the wild. The pet trade harvest took its toll, as did the gassing of gopher tortoise burrows by rattlesnake hunters in the northern part of the snake's range where these burrows provide essential winter refuge. The state of Florida protected indigo snakes as early as 1971, and they received federal protection in 1978, but not soon enough to keep the snake from disappearing from the Panhandle.

Today, habitat loss is the main threat to this docile creature. Adult indigo snakes may use five hundred or more acres of both upland and wetland habitats as part of their home range, a requirement increasingly challenging with development pressures and associated roads. Indigo snakes have largely disappeared from the Florida Keys for this reason and are now relatively rare across the peninsula, but there is an attempt to reintroduce them to the Panhandle. The Orianne Center for Indigo Conservation at the Central Florida Zoo & Botanical Gardens has been captive breeding indigo snakes to release into the wild. Over a hundred snakes have been reintroduced at the Nature Conservancy's Apalachicola Bluffs and Ravines Preserve over the last five years; and, although they haven't been observed reproducing in the wild yet, they are surviving. It'll take more efforts like these paired with strategic land conservation aimed at maintaining wildlife corridors, but perhaps one day indigo snakes can once again thrive all across Florida.

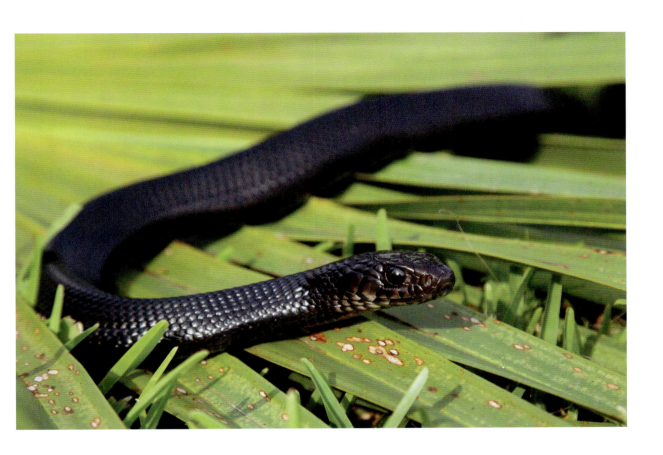

Miami Blue (*Cyclargus thomasi bethunebakeri*)

A filmy cage opens and a plume of tiny butterflies rises into the sky. Iridescent blue wings glisten in the sun as the butterflies spread across the dune. One settles on the delicate white flowers of a scorpionstail plant, another onto the broad leaf of a nightshade, but most disappear into a thorny maze of their larval host plant, gray nicker. University of Florida graduate student Sarah Cabrera, the one overseeing the release of these endangered Miami blue butterflies into the wild, takes me into one of her screened experimental enclosures. She shows me their eggs, their small brown chrysalis, and lime green caterpillars. Her eyes light up as she tells me that their many releases at this site in Bahia Honda State Park are working; the butterflies are now breeding on the dunes by themselves.

This is a butterfly that had seemingly succumbed to extinction after Hurricane Andrew ripped through their only known remaining population on Key Biscayne. It was mourned as the loss of a Florida endemic; a subspecies whose species' range also includes Cuba and Hispaniola. The Miami blue used to be widespread along South Florida's uplands. They were an integral part of the coastal ecosystem, pollinating plants in ways thought to be better than bees and engaging at least seventeen species

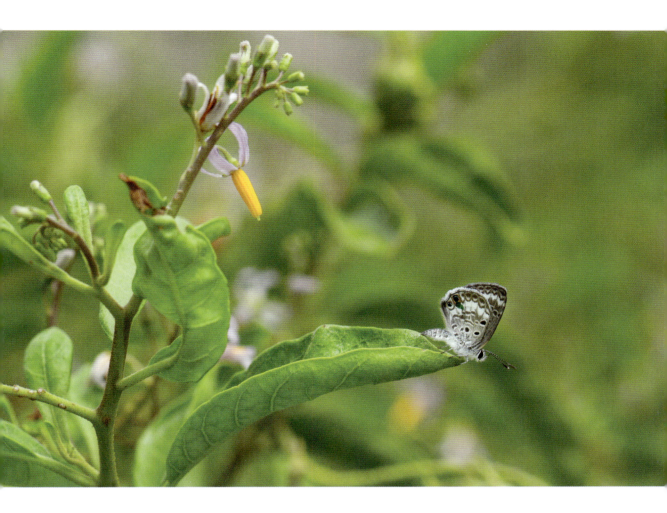

of ants to defend their caterpillars, trading sweet nectar from starlike glands on their backs for guarding services. It was a happily functioning community until large numbers of people began joining the mix, fragmenting coastal habitats, and broadcasting pesticides through the air, inadvertently killing off beneficial and beautiful insects like the Miami blue. For a butterfly that stays within thirty feet or so of its hatching place, the effects were devastating. Fortunately, Hurricane Andrew wasn't the final straw. Seven years later Miami blues were discovered at Bahia Honda State Park, and some years after that on another island in the Key West National Wildlife Refuge. There were pockets of survivors where functional coastal ecosystems persisted, though not enough to ensure this butterfly wouldn't blink out of existence, hence the captive release program to help them survive.

My first experience with the Miami blue had actually been several months before in Sarah's office on Big Pine Key. She'd invited me to photograph some butterflies that had emerged from their chrysalises too late for their scheduled release. At the time of her invitation, she described a cloud of them flitting about her office. By the time I was able to leave Miami to take her up on the offer a few days later, only eight remained. And by the time I slothed through weekend traffic to arrive at her office that afternoon, only one beleaguered individual was left. Its wing was tattered, and it was being bolstered by a melon-flavored energy drink. It left me with the impression of a dainty, fleeting animal. But as I walk the dune at Bahia Honda after Sarah has left, I find hatched wild eggs, a Miami blue caterpillar feeding its ant army, and a butterfly lacking the green ink spot of the captives just released. These weren't fleeting animals, they were survivors—butterflies not just reestablishing a population, but bolstering an entire coastal ecosystem.

Striped Skunk (*Mephitis mephitis*)

I remember leaning across the back cushions of our couch as a kid to stare apprehensively out the window at a skunk rooting through our garden.

"Do you want to go look at it?" Mom had asked.

Was she kidding? I'd heard my dad's tales of a skunk spraying the family dog from beneath his grandmother's farmhouse. The stench had apparently plagued both the dog and the house for years to come. It was not an experience I cared to try. Yet the furry little animal snuffling through our tomato plants hardly looked a villain.

"It won't just spray us for no reason," my mother had reassured as she coaxed me out the door.

She was right. We stood at a respectful distance as the skunk ate a few grubs, then followed its nose into the next yard for another meal.

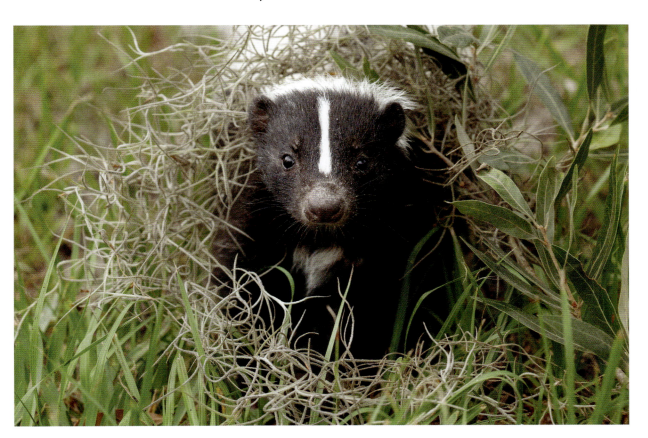

I'm not the first to have unfairly judged this creature based on its odoriferous reputation. While the luxuriously warm black-and-white fur of skunks was coveted by the fashion industry, sellers seemed aware that the animals themselves held a stigma. Beginning in the mid-1800s, skunk pelts were second only to muskrat in numbers exported to Europe, but marketed under such names as black marten or American sable. When truth in advertising laws were inflicted upon the fur industry in the 1930s and 1950s though, demand for striped skunk fur plummeted. While the fur industry never really affected Florida skunks because they don't produce thick winter coats, there's still some global demand, and a small Florida not-for-profit is doing everything it can to rescue skunks from the trade and change attitudes about this often unfairly judged animal.

A pale purple skunk, referred to as champagne by skunk aficionados, rubs soft fur against my ankles as I step into the home of Florida Skunk Rescue activist Brenda Hoch. I've come to photograph one of her naturally colored ambassador skunks that accompanies her to educational events, but my eyes are drawn to a brown one. It struts past, leading me into the living room where an albino one sprawls across the DVD player. Black ones, white ones, smoky ones, ones with broad stripes, thin stripes, and no stripes loop through the space. Who knew there were so many colors? A rattling sound comes from the kitchen and Brenda opens a cupboard to reveal a pile of skunks below a shelf of soup cans.

These are all captive-bred, de-scented animals that Brenda reclaimed from owners who could no longer care from them, or rescued from the fur trade. Her latest rescue, a group of kits just old enough to be separated from their mothers, had arrived earlier in the day. She pulls them from their carrier and places them on a pink shag pillow in the middle of the floor. Three of them huddle together as the resident adults come to inspect, but I watch a bold brown one as it steps free from the herd. The baby marches along one wall, then turns at the corner for its first view of the outdoors through a sliding glass door. Brenda's dog, evicted to the screened porch while the newcomers adjust, lowers its head to examine the tiny skunk. The dog's nostrils flare, the glass fogs, and the little skunk stumbles back, but it doesn't run. It raises its rear, straightens its tail, and stomps its forepaws in warning. How many generations had this skunk's ancestors been in captivity? Yet this one's defensive instinct is as strong as ever.

Leatherback Sea Turtle (*Dermochelys coriacea*)

It looks like a bulldozer has done wheelies up and down the beach, and I know I've come to the right place. I've seen leatherback sea turtle tracks before at one of the highest density nesting beaches in the world at Grand Riviere in Trinidad. The beach there was in constant tumult as hundreds of Mini Cooper–sized shadows emerged from the sea each night, bumping into each other and digging up one another's nests in their quests to lay their own eggs safely in cavities below the sand. No Florida beach supports that many leatherback sea turtles nests and for a long time they were quite rare, but Florida is their primary nesting ground in the continental United States and nest numbers have been increasing since the species was placed on the federal endangered species list in 1970. Direct protections set the stage for this recovery, but leatherback sea turtles seem also to be benefiting from warming seas, overharvest of marine predators, and other changing ocean conditions that have enabled a global

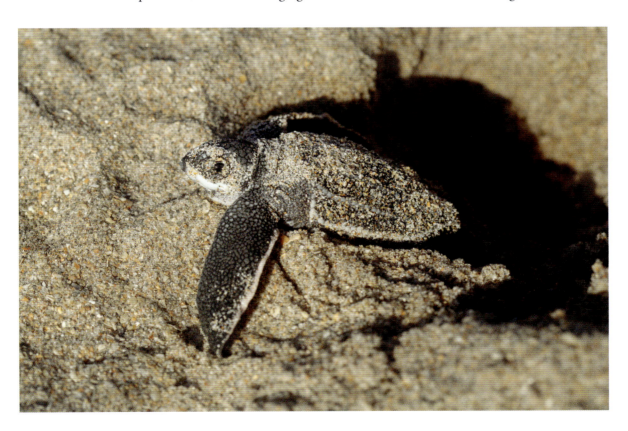

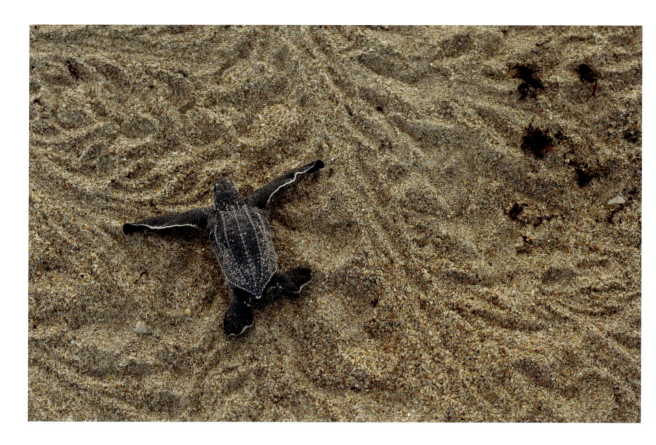

increase in jellyfish populations, creating a grand buffet of the leatherback's preferred food.

I start down the beach, examining the tracks. With the sky lightening rapidly, my chances of seeing a mother are slim, but there's hope for a straggler hatchling. I skip the fresh bulldozing, looking instead for explosions of small tracks indicating babies have emerged from a nearby nest. I pass a posse of crows in the heart of a fresh dig. Yolk drips from their bills as they pull the last leathery turtle eggs from this unfortunate nest. I continue down the beach, finally spotting my first cluster of miniature tracks. I follow them up the dune, and I spot a baby, but it's in the mouth of another avian predator. A Yellow-crowned Night-Heron shakes the small turtle back and forth, rearranging the hatchling until it slides smoothly down the bird's throat. There aren't likely to be survivors here.

I continue along the beach, following yet another flurry of small tracks to the dune. I find a crater where the hatchlings abandoned their eggs. Sand slides down

one edge in a miniature avalanche. I kneel for a closer look. A single eye peers out of a tiny hole, the top of a flipper curls beyond and the tip wriggles back and forth, instigating the small cascade of sand that had drawn my attention. I sit patiently, letting nature take its course, but progress is painfully slow and I worry about the quickly heating beach as the sun rises. A little turtle like this could desiccate before making it to the water. I want to help, but it's important that the hatchling walk down the sand, imprinting on the beach to orient its internal GPS. It's a journey it needs to make on its own.

Once the baby is finally free, I worry that it'll head toward land without the guiding reflection of moonlight on the sea. It seems to know the way though. Each divot in the sand is a mountain valley to overcome, but the turtle flails forward. It falls off a seaweed cliff onto its back, but it shakes, twists, and turns itself upright. The Yellow-crowned Night-Heron lurks toward us, but my presence keeps it at bay. The turtle toils on unaware of the nearby predator, struggling across a flip-flop print and finally landing on smooth, wet sand.

The sudsy edge of the surf laps over the leatherback's body, cleansing the last of the sand from its nest. I glimpse the tiny tooth at the end of its nose that helped it slice its way out of its egg; it too will soon be lost. There will be many more obstacles for this hatchling to overcome, many more predators for it to avoid, but as a wave washes it out to sea, I'm pleased to have been present for its first rite of passage.

Black Skimmer (*Rynchops niger*)

Summer traffic stops me beside a strip of sand along the bridge to Santa Rosa Island. It's a narrow strip of sand, but it's filled with nesting seabirds and I choose to pull off to the side to watch instead of following when the car ahead moves. Black Skimmers dominate the scene with their larger size and bold black, white, and orange colors, but more diminutive Least Terns are tucked between. One of the Black Skimmers deems its Least Tern neighbor too close and squawks an unrelenting complaint. The Least Tern squeaks a response, then turns its back on the larger bird. The skimmer continues barking at the tern. As if it's had enough, the tern takes to the air. It zigzags back and forth above the skimmer, swooping at the skimmer's head several times and unleashing a barrage of its own calls before settling back onto its patch of sand. I suspect this is a dispute that will continue throughout the nesting season. These types of battles occur annually as beach nesting birds compete for space, and may even be escalating as coveted sandy areas are lost to development, intrusions from beachgoers, and sea level rise. Don't these birds deserve their spots on Florida's beaches? One of the joys of summer is watching them jostle in the sand and soar across the ocean, black skimmers dragging their elongated lower bill through the water to feel for the fish they'll snap up to eat.

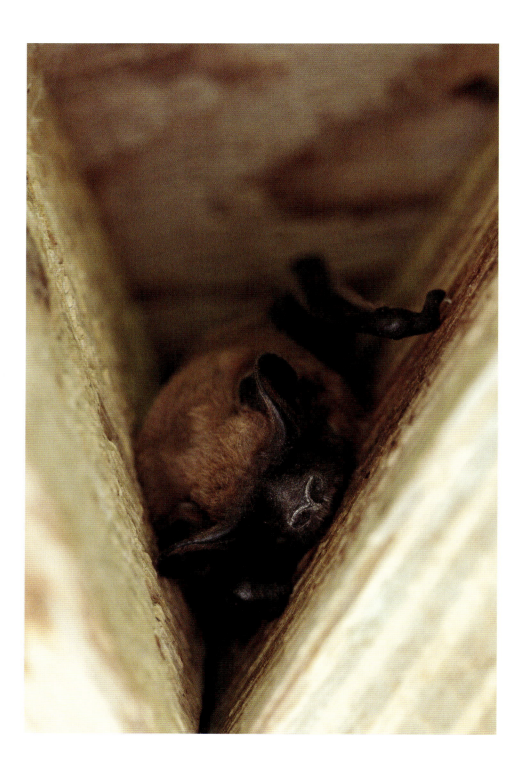

Florida Bonneted Bat (*Eumops floridanus*)

High-pitched chirps reach my ears, a chattering floating from above that I hadn't expected given that most bat sounds are beyond human hearing range. The sound reminds me of girls giggling and I imagine the bats above jostling in the same way girls at a slumber party do when the restlessness of one ripples through the room. I squint at the bat house above, hoping to discern movement in the shadows, but the openings look like mere slits from where I stand. Knowing the Florida bonneted bat is the state's largest bat, I'd thought there might be a chance of photographing them in an artificial roost, but I hadn't appreciated how elevated these roosts needed to be to accommodate this high-flying species. It's only as I stand alongside Dr. Frank Ridgley, Zoo Miami's head of the Conservation and Research Department, beneath one of these towering structures that I understand why his initial response to my photography inquiry had been so doubtful. Not even my longest lens stood a chance here. But the very day after our initial communication, I got another message from Frank: "You must have good Karma." Frank and his team had discovered a young male bonneted bat roosting adjacent to the zoo in a picnic pavilion on the shore opposite this bat house at Larry and Penny Thompson Memorial Park.

As Frank pulls our golf cart alongside the pavilion, a woman on her cell phone abandons the picnic table within, seemingly oblivious to the federally endangered species hanging above. As I enter the space, I realize I too might've easily overlooked the bat; there's no telltale smell of guano, an endearing trait of this species. I look up between the beams and two shiny black eyes peer down at me. The bat's fur is light brown and, even without touching, I can tell it's soft enough to make a plush toy jealous. Living up to its shy reputation, the animal sidles farther into the shadows, lowering its ears to cover its eyes as if wearing the bonnet suggested by its name. Clearly, this roost is too public for a private animal, and far too low to the ground for a bat whose skill is speed rather than agility. There's incentive for this young male to be here though, just across the lake from that established colony.

Florida bonneted bats roost in harems, one male living with several females and their pups. This bat cowering in the corner of the pavilion is likely on the prowl, hoping to lure one of the ladies from across the water. It may work in his favor that these non-hibernating tropical females have more than one breeding cycle each year, though they still only rear one pup in that period. Although he might score a pairing, I imagine he won't be considered partnership material while living in this subpar

accommodation. Frank vows to change that though, and, given his track record of establishing artificial roosts, I'm sure he will.

Just as the woman on the cell phone didn't notice the bonneted bat in the pavilion, the species as a whole has largely gone undetected. Aside from having one of the smallest ranges of any bat in the world, this southern Florida endemic flies too high for traditional bat tracking techniques. Only after this discovery, and with improved bat acoustic monitoring technologies, was it appreciated how widespread this species was across its limited range. Collaborating with Bat Conservation International and others, Frank began conducting surveys across Miami-Dade County and discovered that Florida bonneted bats lived even within Miami's urban center, often relying on the roofs of unaware homeowners. Concerned that roof repairs and upgrades, termite tenting, and bat-squeamish residents might jeopardize these roosts in the long run, the group decided to establish the Miami Bat Lab to educate the public and provide alternate artificial housing. Little was known about how this species might take to bat houses, so expectations were low, but the first house they installed was occupied within three weeks. They installed several more bat houses across the county, careful to place them in darkened open spaces adjacent to swaths of vegetation filled with insect prey for these speedy bats to hunt without impediments, and now, a few years into the project, roughly 65 percent are occupied, hosting over a hundred Florida bonneted bats. No one knows how many Florida bonneted bats there are, but it's a good sign that they've taken so readily to artificial housing and, at least on this one occasion, even a park's picnic pavilion.

Schaus Swallowtail (*Heraclides aristodemus ponceanus*)

Dappled light filters through the leaves of gumbo limbo, seagrape, and pigeon plum trees in the hardwood hammock on Biscayne National Park's Elliott Key. I walk down Spite Highway, grateful that the jagged scar plowed through the forest to discourage it from being made into a park has recovered to little more than a forested trail. A land crab skitters behind a root as I pass. A White-eyed Vireo pauses on a nearby branch. I try to imagine what this might've looked like when Schaus swallowtail butterflies were a common sight, brown and yellow wings fluttering in spots of light. Found only in Florida from Miami through the middle Keys, this tropical butterfly didn't fare well when its hardwood hammocks turned into developments, when pesticides were sprayed indiscriminately into the air to control mosquitoes, and when severe hurricanes wreaked havoc on its few remaining patches of habitat. It earned the distinction of becoming the first butterfly on the federal endangered species list in 1976. Despite the attention though, its numbers continued declining. By 2012, only four butterflies were found in the wild.

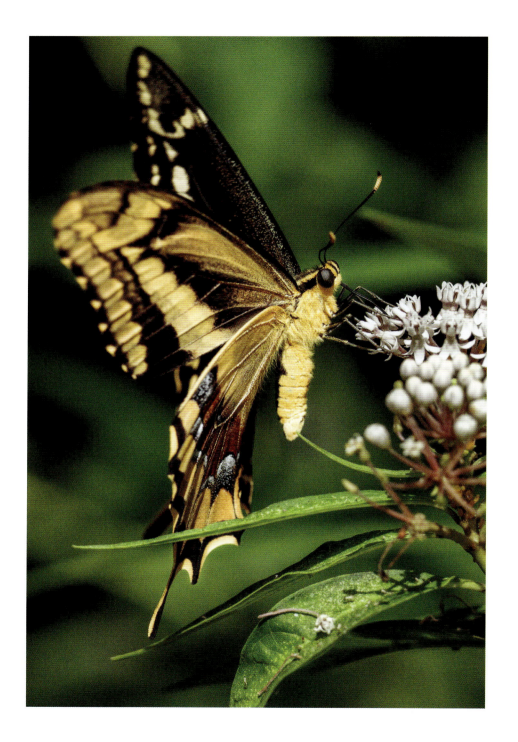

If not for a captive breeding program run by Dr. Jaret Daniels at the McGuire Center for Lepidoptera and Biodiversity at the Florida Museum of Natural History, this butterfly surely would've gone extinct in the wild. But across a table in one of his labs are stretched dozens of clear plastic cups, each with a sprig of wild lime and a Schaus swallowtail caterpillar munching away. Jaret rubs the tip of a paintbrush across one's back and it rears into its defensive posture, protruding fleshy tissues that look like horns from its head while spraying a chemical that smells faintly of citrus. The caterpillar need not worry though, the lab is predator-free and most of these larvae will successfully metamorphose into butterflies that will be released onto Elliott Key and other viable forests on North Key Largo.

Back on Spite Highway, I stare in disbelief as a large yellow swallowtail butterfly emerges from the shadows. Could this be one of those released Schaus swallowtail butterflies? I take pictures without pausing to confirm its identification. I download my pictures as soon as I get home, excitedly scrolling to the swallowtail in the woods. At the time I identify only enough to know it's not a Schaus swallowtail. I abandon the project in disappointment, but as I look back at it to refresh my memory while writing this, I realize it was a butterfly almost as exciting as a Schaus would've been. It was a Bahaman swallowtail, a rare Caribbean visitor sharing the same habitat requirements as the Schaus, an indication that the forest in Elliott Key is ready to house not just released butterflies but wild swallowtails breeding on their own.

Red Wolf (*Canis rufus*)

A canine emerges from the shadows like a phantom. It lopes silently along the fence of its pen as the grays, reds, and whites of its fur shift through mottled light. It coils through a grove of trees, wraps toward the far end of its Tallahassee Museum enclosure, then does a figure eight back through the trees. It's a pattern I watch this animal repeat several times with methodical steps and an expressionless face, until one time its ears perk up. Its muscles visibly tense as it shifts its ears to isolate a sound I can't hear but that has clearly caught this wolf's attention. With no warning, it gallops to a hollow stump at the edge of the trees and leaps. Balanced on its hind paws, it presses its nose against a crack in the wood and claws at the spot with one front paw, then the other. The wood does not yield. The wolf circles the stump, approaches from a different angle, and paws again. Still, the wood does not yield. The wolf relents, disappearing back into the shadows. When the coast is clear, a Carolina Wren emerges from a nest at the exact spot in the stump the wolf had failed to breach. I find this glimpse of the wolf's hunting instinct inspiring. This is a species whose imminent extinction was declared in the 1960s, whose biological extinction in the wild was declared in 1980, and whose very existence on the planet might've been exterminated if not for the help of captive breeding programs.

Slightly smaller than a gray wolf but twice the weight of a coyote, the red wolf once reigned across southeastern North America. As humans claimed the landscape and intensively hunted predators, red wolf numbers declined until all known remaining wild animals were brought into captivity in the 1970s to ensure the long-term survival of the species. The goal was to restore red wolves to their rightful range, the nation's first attempt to reintroduce a predator into the wild and the blueprint for later reintroductions such as gray wolves at Yellowstone National Park. Anchored by roughly 250 captive animals held at various zoos and sanctuaries across the nation, as well as a couple of controlled breeding populations on isolated islands such as the St. Vincent National Wildlife Refuge off the Florida Panhandle, the program has had its ups and downs. It's largest success has been the establishment of a free-ranging population at the Alligator River National Wildlife Refuge in North Carolina, the heart of the red wolf's historic range. At its peak, the population supported over 150 wolves, but that number has been declining and is now below 30 with the last 4 wolves introduced all found dead by roadsides within months of their release.

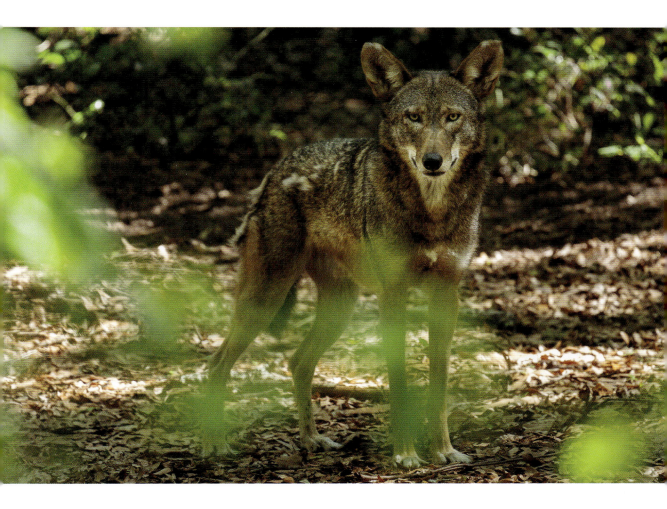

Discouraging? Absolutely. But these animals and the teams of people supporting them do not give up.

 I spent a college summer working at the Point Defiance Zoo and Aquarium in Tacoma, Washington, the first zoo to rear a litter of red wolves in captivity and the one that initiated the Red Wolf Species Survival Plan. I'm not sure any of the wolves there during my tenure had experienced life in the wild, but they knew its call. Like clockwork, every morning, their howls sent goose bumps down my arms as their individual calls merged into a haunting plea that wafted through the surrounding forest and out across the Puget Sound. Just like the one I'd watched pawing at a nest it couldn't see, this pack clung to its wildness.

There may be additional hope for the species. A phantom population of hybrid canids was discovered on Galveston Island in Texas. They were the results of the type of coyote—red wolf pairing that had occurred when red wolves were too scarce in the wild to find mates of their own species. This particular population had been isolated from other coyotes and maintained red wolf genes, some that had been lost to the species when only fourteen individuals served as founders for the captive breeding program. This and similar populations along the Gulf Coast of Texas and Louisiana may provide a new path toward the recovery of the world's rarest wolf.

Loggerhead Sea Turtle (*Caretta caretta*)

We meet at a boat ramp near Marco Island just after sunrise. Mangroves whiz by and calm waters part as our boat weaves through the Ten Thousand Islands to land on a sandy white beach on the south end of Cape Romano Island. I follow two biologists from the Rookery Bay National Estuarine Research Reserve as they head down the beach, checking known nests and assessing fresh digs. We pass a few false crawls, tracks in the sand where a female emerged from the sea but for one reason or another retreated before laying her eggs, and then they find what I've been hoping for—a freshly hatched nest. The sand beneath the nest's protective cage has collapsed, dried egg shells are scattered, and a series of tracks in the sand suggest that at least some hatchlings made it to the sea. Jill Schmid and Sarah Norris lift the cage away and begin to dig. They record how many eggs hatched, how many were killed by ants, how many babies otherwise died in the nest, and how many survivors remain. The remaining turtles are ones that likely hatched a bit late, missing the mass exodus of

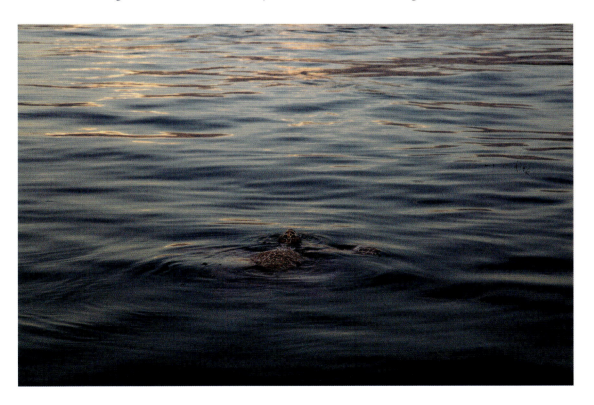

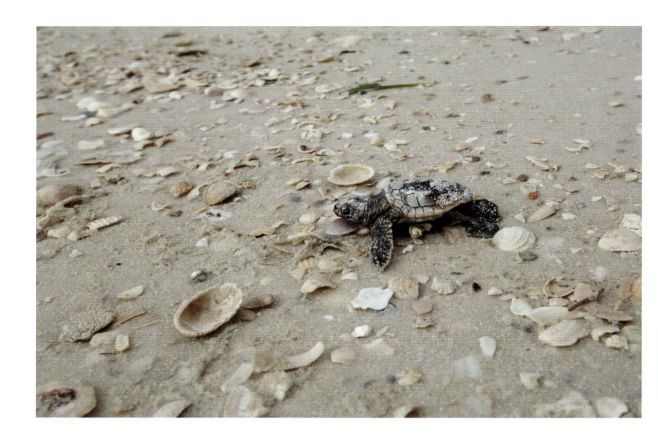

their siblings. Jill and Sarah lift the tiny turtles from the nest, measuring them one by one before setting them free on the sand. Their flippers flap hard as they tackle the terrain, circumventing sticks, tumbling over shells, and scaling seaweed until finally waves tug them into the Gulf of Mexico. This particular nest was of a loggerhead, Florida's most abundant sea turtle. The Sunshine State serves as the epicenter of loggerhead nesting in the Western Hemisphere, accommodating roughly 90 percent of the nests in the northwest Atlantic region with the highest concentration occurring along the east coast from Brevard south to Palm Beach. Densities of loggerhead nests aren't as high where we are in the southwest portion of the state, but every nest counts for an endangered species such as this. It's the reason Jill, Sarah, their colleagues, and volunteers are so dedicated to helping. They watch vigilantly, covering new nests with raccoon-proof cages, monitoring progress, and giving stragglers like these a chance to make it to the sea.

Florida Grasshopper Sparrow
(*Ammodramus savannarum floridanus*)

I'd been warned that all things Florida Grasshopper Sparrow were highly guarded and that the chances of me being granted access were less than miniscule. I understood. I expected nothing less for a bird teetering on the edge of extinction with at one point fewer than thirty pairs in the wild. So, it's with deep gratitude and reverence that I follow Lance Arvidson of Common Ground Ecology onto a private ranch to photograph this endangered bird.

 I feel as if I'm entering a dimly lit sanctuary as we step out of our vehicles into the fresh morning air. It's too dark to see far and I carefully place my feet in Lance's tracks to limit my impact. We hike in silence across the field, then stop at the edge of what Lance knows is a male's territory. Even shrouded in predawn gray, I can tell this is like no ranch I've seen before. Palmettos, low shrubs, and tall grasses stretch in every direction; the soil beneath me is soft and spongy, a far cry from the dust-covered bare ground I'd walked across at a different ranch the day before. That soil had felt

like pottery with only a few scraggly weeds and tough, nonnative grasses growing in its cracks. This morning's pasture, however, resembles the Florida Grasshopper Sparrow's native prairie, a habitat found only in south-central Florida; and, like many of Florida's unique environments, one that has been vastly reduced with over 80 percent now gone, mostly converted to agricultural pastures.

Habitat loss was initially blamed for the declining numbers of Florida Grasshopper Sparrows, a subspecies that unlike most other Grasshopper Sparrows does not migrate, making it more susceptible to site-specific threats. But even on large tracts of well-maintained prairie on conservation lands, the numbers of Florida Grasshopper Sparrows continued to plummet. There were many other possibilities—flooding of nesting areas, nonnative fire ants, pesticides, disease, or climate change—but there were no clear answers. New tracts of prairie were purchased for protection, nonnative plants were removed, fire regimes were perfected, hydrology monitored, ants killed, low nests raised, fences built to keep out larger predators . . . little effort was spared, but the numbers of sparrows continued to drop until it was deemed that even more drastic measures were required and captive breeding began.

By the time I join Lance in the field, things are looking optimistic. Over 200 captive-bred Florida Grasshopper Sparrows had already been released into the wild. Some had nested, some had even paired with wild birds. A massive project to restore the Kissimmee River and its prairie, part of the larger ecosystem these little birds depend on, was about to be completed. And then there was the miracle I was about to behold; Lance had discovered a previously unknown wild population of Florida Grasshopper Sparrows.

Lance holds a speaker up in the air while I hold my breath. He hits play and the insect-like call that gained this bird its name buzzes across the prairie. There's a faint response way off in the distance, then there's rustling in the grass before me. A small bird emerges, but only long enough to fly off. We work our way across the territories. As the first golden ray of sun stretches across the field, a male boldly lands on a low bush before us to buzz a response. This one has leg bands—orange, silver, yellow, blue—it had been banded at a different site in 2017. It feels as if we've found a treasure, and truly it is. Not only is the population of Florida Grasshopper Sparrows larger than previously thought, but this sighting confirms gene flow among the remaining pockets of birds. As Lance shows me rare plants on our way out, I can't help but also marvel at this site, this beautifully maintained ranch with plant diversity to rival any protected land. It too is a treasure, a role model for coexistence between people and animals, a highly endangered, endemic animal at that.

Miami Tiger Beetle (*Cicindelidia floridana*)

A young tiger waits within its lair, watching, ready to pounce on incoming prey. But this is not the furry, orange tiger of India—this tiger awaits ants and other small insects; it's the larvae of the Miami tiger beetle, so small that its head measures no more than the "We" of the "In God We Trust" embossed on a penny. Yet the tiny face peering out of its tunnel clearly means business, its poised claws and alien-style jaw ready to strike passing insects at lightning speed. Anchored to its burrow by a hook, the larvae springs back out of sight as quickly as it appears, dragging prey deep into its lair. I'm impressed, but then I notice a metallic blending of copper, greens, and blues as an adult appears on the scene and draws my full attention.

With a fringe of white fur, this sleek beetle looks like it could model in a fashion magazine, but the fringe has a more functional purpose. As an animal powered by summer sun, these fine white hairs prevent it from overheating by repelling warmth

radiated from the open sandy ground it prefers. When it turns to face me, I see more clearly its relationship to the menacing larvae I've just met. The beetle's razor bill is paired with scythes on either side that curve together into a deadly insect-trapping snare. If the Miami tiger beetle was the size of its mammalian counterpart, it would command respect. Instead, this beetle, small enough to have avoided detection until the 1930s and then thought extinct until rediscovered in 2007, requires our help to defend it.

Less than 2 percent of its endangered pine rockland habitat remains. The entire population of the Miami tiger beetle is relegated to the largest remaining tract of pines outside of Everglades National Park, an area around Zoo Miami called the Richmond Heights complex. From the beetle's perspective, it could use more fire to maintain open patches, but a more imminent issue is development. One large stretch of formerly undeveloped pineland in this tract has already been bulldozed into shops and homes, another project threatens, and there will no doubt be more development pressures in the future. The Miami tiger beetle survived one extinction proclamation, shouldn't that be enough? If only this beetle were large enough to dazzle the masses with its beauty, and perhaps defend its home with those formidable jaws.

Reflections

I press my childhood cheek against the window of an overly crowded Philippine minibus. I strain to see past the never-ending wall of buildings, watching for my first glimpse of coconut palms waving before sparkling waters. Smog belches from the flamboyantly painted minibus ahead, and I watch a woman on the street press a handkerchief across her nose and mouth. I was ten at the time, commuting with my

Black-necked Stilt
(*Himantopus mexicanus*)

family between my father's weekend post where we lived in a two-room apartment above the neighborhood dump in a Manila slum and our rural home in the neighboring province of Cavite where he taught during the week. Manila was one of the largest and most polluted cities in the world then, a veritable sea of sooty cement. Each week I lived for an escape from that purgatory of gray, and the green of those coconut palms symbolized vegetation to come. My breathing relaxed as concrete gave way to thatched huts, fishing villages on stilts, and luscious rice fields. It felt like heaven to finally step off the bus into the fresh air and shade of a mango orchard near our home. But over the few years we did that commute, I had to wait longer and longer for those coconut palms to appear as the city crept along the coast. The last time I visited, roughly eight years later, there was a brand-new highway that provided no coastal views. Where once there had been rice fields and rural villages, there was only an extension of gray. And even before the city reached our Cavite door, we rarely

Florida Panther (*Puma concolor coryi*)

American Alligator (*Alligator mississippiensis*)

saw animals. There was no forest left. The one and only tropically colorful bird that showed up in one of our trees was quickly shot down with a slingshot by a boy I'd never seen before.

I've experienced firsthand what life is like without nature, and it's not pleasant. We rely on natural areas and wild animals for any number of ecological services but also, as I discovered at ten, our own overall well-being. My grandmother wasn't a particularly nature-loving woman, but in her final years, confined to a shared room in a nursing home, one of the things that brought her pleasure was a bird feeder that flitted with life just outside her window. Fortunately, as I hope this book helps reveal, Florida still has a lot of animal life. From manatees wallowing in clear springs, to Roseate Spoonbills nesting in mangroves, walkingstick insects atop pitcherplants in a seepage bog, and gopher tortoises burrowing in open pine forest, nature is Florida's heart and soul. With a little foresight and strategic planning, people can continue flocking to Florida to walk its beaches, snorkel its reefs, fish its waters, kayak its springs, and view its unique array of animals for many generations to come. It is my enduring hope that Florida will always have its wild.

White Ibis (*Eudocimus albus*)

Acknowledgments

It's hard to know where to begin giving credit for a complex project such as this. Many people directly and indirectly helped turn it from inspiration to reality. So let me start at the very beginning with my parents, Lois and Ronald Hines. Some of my earliest memories include sitting in a wildflower field to watch buzzing insects in Mount Rainier National Park, standing on a bridge to watch bright red salmon swim upstream beneath emerald moss drapery in the temperate rainforest of Olympic National Park, and hiding in a screen of bushes to watch a bull moose in Rocky Mountain National Park. My parents' sense of curiosity, wonder, and respect for the natural world set the stage for the many wildlife adventures I've embarked upon since. My brother, Adam Hines, shared in so many of my early adventures and inspires me with his passion for the natural world. The yard of my Aunt Laverna Ernst and my late Uncle Walter Ernst was always filled with dragonflies, fireflies, birds, and squirrels, providing me with an early model for coexistence.

In the dedication I thank John Iverson and Bill Buskirk specifically for introducing me to Florida and its animals, but all the field-oriented professors at Earlham College played a role in luring me to this field through their enthusiasm. It was John Iverson's guidance that led me into herpetology and the graduate program at Florida International University, and I'm grateful for his continued mentorship. I also want to thank George Gann of the Institute for Regional Conservation where I was a field biologist and Theodora Long of the Marjory Stoneman Douglas Biscayne Nature Center where I was an environmental educator for formative training opportunities, guidance, insights, and support through the years.

More directly related to this project, I'm grateful to the National Park Service and the Florida National Parks Association for supporting me as Artist-In-Residence at the Big Cypress National Preserve while I worked on this *Wild Florida* book in 2020. In particular I thank Everglades National Park Superintendent Pedro Ramos; and, at Big Cypress National Preserve, I thank Superintendent Thomas Forsyth, Kit Carrington, Rita Garcia, Laurie Humphrey, Deborah Jansen, Itziar López, Matthew McCollister, Cody Meridith, Mike Reupert, and William Snyder.

This project benefited from the support of many organizations, and I wish to thank the following: Hilary Swain, Betsie Rothermel, and Mandy West of the Archbold Biological Station; Julie Wraithmell, Shawn Clem, Adam DiNuovo, Chris Farrell, Paul Gray, and Jacqui Sulek of Audubon Florida; Darrell Thomas of Blue Spring State Park; Michelle Davis and volunteers of the Cape Florida Banding Station; Lance Arvidson of Common Ground Ecology; Jeffery Schmid of the Conservancy of Southwest Florida; John Fitzpatrick of the Cornell Lab of Ornithology; Hailey Möller of the Falcon Batchelor Raptor Rehabilitation Center; Dennis Giardina, Ashlee O'Connor, and Amy Siewe of the Florida Fish and Wildlife Conservation Commission; Lilly Anderson-Messec of the Florida Native Plant Society; Brenda Hoch of Florida Skunk Rescue; Jon Blair and Sandi Richmond of Gilchrist Springs State Park; Jaret Daniels of the McGuire Center for Lepidoptera and Biodiversity at the Florida Museum of Natural History; Greg Curry, Sarah Norris, and Jill Schmid of the Rookery Bay National Estuarine Research Reserve; Edwin McCook of the Suwannee River Water Management District; Peter Kleinhenz of the Tall Timbers Research Station and Conservancy; the Tallahassee Museum; Joe Barros, Alison Enchelmaier, Ana Lima, and Brian Rapoza of Tropical Audubon Society; Marc Branham, Natalie Bergeron, Sarah Steele Cabrera, Harlan Gough, and Holly Ober of the University of Florida; and Lyn Heller, Ron Magill, Tiffany Moore, Frank Ridgley, and Steven Whitfield of Zoo Miami.

I am grateful for the assistance of many individuals who provided advice, guidance, and support in different capacities for this book, including all the kind people who generously pointed out wildlife along various trails. I am especially thankful to Anne and Tim Ross for letting me invade their home for weeks on end in my quest to photograph bears. I also thank the following: Kevin Achee Lee-Yuk, Donnie Barber, Tammy Case, Lucy and Robert Duncan, Ellin Goetz, Cynthia Guerra, Rex Hamilton, Erica Henry, Paul and Cyndy Hetser, Steve Kandell, Gene Kirwan, Linda Lacovini, Dennis Olle, Dana O'Hara Smith, Gary Pappas, Craig Porter, Randy Quick, Randy Rogers, John Sheldon, James Watling, Cristina and Kevin Whelan, and the Santa Rosa County Sheriff's Office for towing my Jeep out of a spot no towing company would touch.

From biological insights to history tidbits, from helping me decide what type of scent cover to buy to making sure my tires were fieldworthy, and from any number of editing rounds to making final choices among images, Jim Kushlan has been an integral part of this project from the beginning. This book would not be what it is without his support, and for that, and so much more, I am forever grateful.

Key Deer (*Odocoileus virginianus clavium*)

Finally, I thank the University Press of Florida and its staff for taking my words and images and making them into a book. I particularly thank Meredith Morris-Babb and Linda Bathgate who inspired me to dream up this book idea with their invitation for me to submit a proposal to publish my photography. I thank Romi Gutierrez and Sian Hunter for carrying the baton forward to make sure the book became a reality, my anonymous reviewers for their helpful feedback, and Eleanor Deumens, Cindy Durand, and Larry Leshan for their editorial and design assistance in production.

Wood Stork (*Mycteria americana*)

Index

Page numbers in *italics* refer to photographs and captions.

Agama picticauda. *See* Peters's rock agama
Agkistrodon conanti. *See* Florida cottonmouth
Aix sponsa. *See* Wood Duck
Alligator mississippiensis. *See* American alligator
Alopochen aegyptiaca. *See* Egyptian Goose
American alligator (*Alligator mississippiensis*), *i*, 133–134, *133*, *134*, 168, *192*, 208, *293*; biogeography, xiv; blended, 146, *147*; conservation, xvi; Florida icon, 28
American beaver (*Castor canadensis*), 108, *109*, 112, 114, *115*, 146, 184. *See also* Beaver lodge
American Coot (*Fulica americana*), *191*
American crocodile (*Crocodylus acutus*), xiv, 58, *59*, *81*, 104, *105*, *221*, 224, *240*; biogeography, 3, 79; blended, 148; conservation, xvi
American Flamingo (*Phoenicopterus ruber*), 26–28, *26*, *27*, 146, *147*, 256
Ammodramus savannarum floridanus. *See* Florida Grasshopper Sparrow
Ammospiza maritima mirabilis. *See* Cape Sable Seaside Sparrow
Anaxyrus quercicus. *See* Oak toad
Anaxyrus terrestris. *See* Southern toad
Anhinga (*Anhinga anhinga*), *v*, 184, *185*
Anhinga anhinga. *See* Anhinga
Anolis carolinensis. *See* Green anole
Anolis sagrei. *See* Brown anole
Antigone canadensis. *See* Sandhill Crane
Apalachee (Indigenous people), xvi
Apalachicola River, 109, 124
Aphelocoma coerulescens. *See* Florida Scrub-Jay
Appalachian Mountains, 109, 124
Appalachian or Allegheny spotted skunk (*Spilogale putorius putorius*), 32, 109
Apple snail (*Pomacea* spp.), 44, 95–96, *96*
Aptenopedes sphenariodes. *See* Linearwinged grasshopper
Aramus guarauna. *See* Limpkin
Archbold Biological Station, 24, 37, 195
Archilochus colubris. *See* Ruby-throated Hummingbird
Ardea Herodias. *See* Great Blue Heron
Ardea occidentalis. *See* Great White Heron
Argentine giant tegu (*Salvator merianae*), xv, 49
Arvidson, Lance, *258*, 287–288
Aspidoscelis sexlineata sexlineata. *See* Eastern six-lined racerunner

Athene cunicularia floridana. *See* Burrowing Owl
Audubon Florida, 258, *259*
Audubon, John James, 28, 98, 106

Bahama Mockingbird (*Mimus gundlachii*), 6, 79
Bahaman swallowtail (*Heraclides andraemon pallas*), 281
Bahia Honda State Park, *256*, 266–268
Bald Eagle (*Haliaeetus leucocephalus*), 142, *143*, 146
Bananaquit (*Coereba flaveola*), 6
Barefoot Beach, *223*, 226
Barnacle Historic State Park, 188–189
Barred Owl (*Strix varia*), *218*, 219
Bat, 79, 224, 225–227, 252, 261, 263. *See also* Brazilian free-tailed bat; Evening bat; Florida bonneted bat; Hoary bat; Southeastern myotis
Bat Conservation International, 256, 278
Bat house, 226–227, 228, *229*, 277–278
Beach mice (*Peromyscus polionotus* ssp.), 224
Bear. *See* Florida black bear
Beaver lodge, 108, *113*, 114
Beetle, 35, 72, 79, 261. *See also* Geiger tortoise beetle; Miami tiger beetle; Scrub palmetto scarab beetle; Six-spotted tiger beetle
Big Cypress fox squirrel (*Sciurus niger avicennia*), 243–244, *243*, *244*
Big Cypress National Preserve, 15–16, 74–75, *74*, *76*, 133, 148, 186, 189, *189*, 203, 243, 257, *260*
Big Shoals State Park, 129
Biscayne Bay, 76, 80, 85, 92, 104, 188, 223, 225, 246
Biscayne National Park, 80, 188, 257, 279
Black Skimmer (*Rynchops niger*), 258, *259*, 274, *274*, 275
Black Vulture (*Coragyps atratus*), 10–11, *10*, *11*
Black-necked Stilt (*Himantopus mexicanus*), 291
Black-throated Green Warbler (*Setophaga virens*), 7
Blackwater River State Forest, *113*, 149, 184, 212
Blended, 146–149, 151–152, 164
Blue land crab (*Cardisoma guanhumi*), 3, 79, 88, *89*
Blue Spring State Park, 92, 148, 171
Blue-winged Teal (*Spatula discors*), 146
Bobcat (*Lynx rufus*), xiv, 75, 200–201, *200*, *201*, 223
Bos taurus. *See* Florida cracker cattle
Bottlenose dolphin (*Tursiops truncatus*), 188, 222, 225, 246–247, *246*, *247*
Brahminy blindsnake (*Indotyphlops braminus*), 47
Branham, Marc, 171
Brazilian free-tailed bat (*Tadarida brasiliensis*), 228, *229*
Broad-headed skink (*Plestiodon laticeps*), 122, *123*

299

Brotogeris versicolurus. See White-winged Parakeet
Brown anole (*Anolis sagrei*), 44, *45*, 47
Brown basilisk (*Basiliscus vittatus*), xv
Buff-bellied Hummingbird (*Amazilia yucatanensis*), 6
Burmese python (*Python molurus bivittatus*), xvi, 48, 49, 74–76, *75*, *76*, 258, *260*
Burrowing Owl (*Athene cunicularia floridana*), 2, 241–242, *241*, *242*
Bush katydid nymph (*Scudderia* sp.), *111*
Buteo lineatus. See Red-shouldered Hawk
Butterfly, 79, 146, 261. *See also* Bahaman swallowtail; Florida atala; Miami blue; Monarch; Palamedes swallowtail; Schaus swallowtail; zebra longwing; zebra swallowtail

Cabrera, Sarah, *257*, 266, 268
Calusa (Indigenous People), xvi
Cammarano, Brian, *254*
Camp Keais Strand, *193*
Canis latrans. See Coyote
Canis rufus. See Red wolf
Cape Florida Banding Station, *254*, 258
Cape Sable, 149, 198
Cape Sable Seaside Sparrow (*Ammospiza maritima mirabilis*), 198, *199*
Caracara plancus cheriway. See Crested Caracara
Carolina Wren (*Thryothorus ludovicianus*), 116, *117*, 282
Cardinalis cardinalis. See Northern Cardinal
Cardisoma guanhumi. See Blue land crab
Caretta caretta. See Loggerhead sea turtle
Caribbean monk seal (*Neomonachus tropicalis*), xvi
Castor canadensis. See American beaver
Cattle, 46, *222*; Great Florida Cattle Drive, 191; industry, 52, 64. *See also* Cowboy; Florida cracker cattle
Cattle Egret (*Bubulcus ibis*), 5, 7, 64, *65*, 221
Cave Swallow (*Petrochelidon fulva fulva*), 5, 224, *232*, 233
Central Florida Zoo & Botanical Gardens, 264
Chestnut-fronted Macaw (*Ara severus*), 49
Chipmunk, 108, 146
Chlorocebus pygerythrus. See Vervet monkey
Cicindelidia floridana. See Miami tiger beetle
Cicindela sexguttata. See Six-spotted tiger beetle
Climate change, 6, 181, 192, 224, 288
Coconut Grove, 60, 103, 189, 230, 261
Coe, Ernest, 186
Coexistence, 220–227, 249, 251, 288
Coluber constrictor. See North American racer
Common green darner dragonfly (*Anax junius*), 4
Common Ground Ecology, *257*, *258*, 287
Coontie (*Zamia integrifolia*), xvi, 101–3, *101*, *102*
Coragyps atratus. See Black Vulture
Coral Gables, 131
Cowboy, 52, 64

Coyote (*Canis latrans*), 5, 223, *248*, 249, 282, 284
Crested Caracara (*Caracara plancus cheriway*), 2, *20*, 21, 242
CREW Bird Rookery Swamp, 214
Crocodylus acutus. See American crocodile
Crotalus adamanteus. See Eastern diamond-backed rattlesnake
Crystal River National Wildlife Refuge, 92–93, 184, *186*
Cuban Pewee (*Contopus caribaeus*), 6, 79
Cuban treefrog (*Osteopilus septentrionalis*), 44, 68, *69*, 245
Cyclargus thomasi bethunebakeri. See Miami blue
Cypress: Big Cypress Swamp, 15, 76; dome (habitat), 74, 160; forest (habitat), 67; knee, 116, 214; swamp (habitat), 22; tree, 17, 42, 74, 100, 142, 148, 182. *See also* Big Cypress fox squirrel; Big Cypress National Preserve

Dagny Johnson Key Largo Hammock Botanical State Park, 188
Danaus plexippus. See Monarch
Daniels, Jaret, 281
Dasypus novemcinctus. See Nine-banded armadillo
De Leon Springs State Park, 126
Deer, 3, 70, 111–112, 168, 185, 223. *See also* Key deer; White-tailed deer
Dermochelys coriacea. See Leatherback sea turtle
DiNuovo, Adam, 259
Didelphis virginiana. See Virginia opossum
Dire wolf (*Canis (Aenocyon) dirus*), xvi
Dolphin. See Bottlenose dolphin
Domestic cat (*Felis catus*), 54–55, *55*
Double-crested Cormorant (*Nannopterum auritum*), 149
Douglas, Marjory Stoneman, 186
Dove Creek Hammock, 189, *190*
Dragonfly, 129, 261. *See also* Common green darner dragonfly; Eastern amberwing
Dry Tortugas, 77, 217
Drymarchon couperi. See Eastern indigo snake
Dryobates borealis. See Red-cockaded Woodpecker
Duck, 220. *See also* Muscovy Duck; Wood Duck
Dusky Seaside Sparrow (*Ammospiza maritima nigrescens*), xvi, 198

Eastern amberwing (*Perithemis tenera*), 155–156, *155*
Eastern copperhead (*Agkistrodon contortrix*), 108, 184
Eastern cottontail (*Sylvilagus floridanus*), 196, *197*
Eastern diamond-backed rattlesnake (*Crotalus adamanteus*), xi, *xi*, 216, 217, 240
Eastern fence lizard (*Sceloporus undulatus*), 33, *128*, 129
Eastern gray squirrel (*Sciurus carolinensis*), 182, *183*, 204, *205*, 221–222, 261

300 · Index

Eastern indigo snake (*Drymarchon couperi*), 189, 264, 265
Eastern lubber grasshopper (*Romalea microptera*), 144, *145*
Eastern newt (*Notophthalmus viridescens*), 12, *13*
Eastern six-lined racerunner (*Aspidoscelis sexlineata sexlineata*), 135, *135*
Eastern Screech-Owl (*Megascops asio*), 252, *253*, 262, *262*
Egret, 180, 184, *185*. See also Cattle Egret; Great Egret; Reddish Egret; Snowy Egret
Egretta rufescens. See Reddish Egret
Egyptian Goose (*Alopochen aegyptiaca*), xv, 58, *59*
Elanoides forficatus. See Swallow-tailed Kite
Equus caballus. See Florida cracker horse
Eudocimus albus. See White Ibis
Eumaeus atala florida. See Florida atala
Eumops floridanus. See Florida bonneted bat
Eurasian Collared-Dove (*Streptopelia decaocto*), 44
Eurycea guttolineata. See Three-lined salamander
Eurypepla calochroma floridensis. See Geiger tortoise beetle
Evening bat (*Nycticeius humeralis*), 227, 228, *229*
Everglades, xvi, 181, 186, 198, 217; animals, xvi, 75–76, 87, 104, 106, 118, 153–154, 180; plants, 148. See also Everglades mink; Everglades National Park
Everglades mink (*Neovison vison everglandensis*), 138, *139*
Everglades National Park, 14, 87, 154, 184, *185*, 186, 190, 198, 249, *260*

Falcon Batchelor Raptor Rehabilitation Center, 252, *262*
Fascell, Dante, 188
Felis catus. See Domestic cat
Fire management, 35, 37, 64, 198, 212, 288
Fireflies (*Photuris* spp.), *170*, 171, 263
Fisheating Creek, 100
Fishing, 1, 184, 188
Fitzpatrick, John, 37
Florida atala (*Eumaeus atala florida*), xvi, 3, 101–3, *101*, *102*, 261
Florida Bay, 28, 58, 76, 146, 180–181, 249
Florida black bear (*Ursus americanus floridanus*), 5, 38–41, *39*, *40*, 259; biogeography, xiv, 3, 111–112; conservation, xvi, 189, 192, 222–223
Florida bog frog (*Lithobates okaloosae*), 3
Florida bonneted bat (*Eumops floridanus*), 3, 256, *258*, *276*, 277–278
Florida box turtle (*Terrapene bauri*), 112, *166*, 167
Florida Caverns State Park, 108
Florida cottonmouth (*Agkistrodon conanti*), 112, 124, 160, *161*, 240
Florida cracker cattle (*Bos taurus*), 64, *65*
Florida cracker horse (*Equus caballus*), 52–53, *53*
Florida Cracker Horse Association, 52

Florida crowned snake (*Tantilla relicta*), 3
Florida Federation of Women's Clubs, 186
Florida Fish and Wildlife Conservation Commission, 249, 256, 258
Florida Grasshopper Sparrow (*Ammodramus savannarum floridanus*), 184, 257, 287–288, *287*
Florida Keys, 146–148; animals, 6, 28, 67, 72, 87, 91, 104, 106, 111–112, 119, 164, 167, 174–175, 195, 217, 264, 279; habitats, 2; plants, 98; reserves, 189, *190*
Florida manatee (*Trichechus manatus latirostris*), 92–94, *92*, *93*, 148, 184, *186*, 293; biogeography, 3, 79; conservation, 106, 224–225, *226*
Florida mouse (*Podomys floridanus*), 3
Florida Museum of Natural History, 281
Florida Panhandle, 108–112, 146, 222; animals, 32, 68, 76, 114, 118, 121, 124, 131, 167, 172, 184, 264, 282; habitats, 2, 136
Florida panther (*Puma concolor coryi*), 14–16, *14*, *15/16*, 70, 186, 223, 240, *292*; biogeography, 3, 111; conservation, 54, 189, 192–193; ambassador animal (Uno), 253–254
Florida Panther National Wildlife Refuge, 219
Florida red-bellied cooter (*Pseudemys nelsoni*), 208, *209*
Florida sand skink (*Plestiodon reynoldsi*), 3, 24, *25*
Florida scrub lizard (*Sceloporus woodi*), 3, 33–35, *33*, *34*, 129, 188
Florida Scrub-Jay (*Aphelocoma coerulescens*), 2, 3, 36, 37, 259
Florida spotted skunk (*Spilogale putorius ambarvalis*), 31–32, *31*, 112
Florida Skunk Rescue, 270
Florida watersnake (*Nerodia fasciata pictiventris*), 17, *17*
Florida Wildlife Corridor, 16, 192–193
Florida wolf (*Canis rufus floridanus*), xvi
Florida wormlizard (*Rhineura floridana*), 3
Forsyth, Thomas, 74, *260*
Fox, 75, 111, 259. See also Gray fox; Red fox
Fred C. Babcock/Cecil M. Webb Wildlife Management Area, 64, *65*
Fregata magnificens. See Magnificent Frigatebird
Frog, xiii, xix, 68, 99–100, *100*, 109, 245, 261. See also Florida bog frog; Cuban treefrog; Green frog; Green treefrog; Pine barrens treefrog; Southern leopard frog; Squirrel treefrog
Fulica americana. See American Coot

Gainesville, 108, 225, 226–227, 228, 257
Geiger, John, 98
Geiger tortoise beetle (*Eurypepla calochroma floridensis*), 3, 97–98, *97*
Giant sloth (*Megatherium* sp.), xvi
Gilchrist Blue Springs State Park, 116
Golden Gate Estates, 38–41, 222, 223
Golden silk orbweaver (*Trichonephila clavipes*), 82, *83*

Index · 301

Gopher tortoise (*Gopherus polyphemus*), 2, 149, *223*, 226, 250–251, *250*, *251*, 264, 293
Gopherus polyphemus. See Gopher tortoise
Grackle (*Quiscalus* spp.), 22, *23*, 221–222
Gray fox (*Urocyon cinereoargenteus*), 130–132, 224, 230–231, *230*, *231*
Gray Kingbird (*Tyrannus dominicensis*), 4
Great Blue Heron (*Ardea herodias*), 42, *43*, 106, 153
Great Crested Flycatcher (*Myiarchus crinitus*), 261
Great Egret (*Ardea alba*), 106, 153, 204
Great Florida Birding and Wildlife Trail, 192
Great White Heron (*Ardea occidentalis*), 106, *107*
Green anole (*Anolis carolinensis*), 29–30, *29*, *30*, 44
Green frog (*Lithobates clamitans*), 126, *127*
Green iguana (*Iguana iguana*), xiv, xv, 77, 146
Green lynx spider (*Peucetia viridans*), 149, *149*
Green sea turtle (*Chelonia mydas*), 1
Green treefrog (*Hyla cinerea*), xvii, 68, 245, *245*
Guana Tolomato Matanzas National Estuarine Research Reserve, 122

Habitat loss, xvi, 6–7, 94, 102, 152, 174, 181, 186–193, 198, 223–224, 264, 274, 290, 291–293
Haliaeetus leucocephalus. See Bald Eagle
Harlequin coralsnake (*Micrurus fulvius*), 234, 240
Helping, 94, 186–188, 192, 224–225, 251, 252–262, 263
Hemidactylus mabouia. See Wood slave
Heraclides aristodemus ponceanus. See Schaus swallowtail
Heron, 184. See also Great Blue Heron; Great White Heron; Yellow-crowned Night-Heron
Himantopus mexicanus. See Black-necked Stilt
Hispid cotton rat (*Sigmodon hispidus*), 157–158, *157*
Hoary bat (*Aeorestes cinereus*), 4
Hoch, Brenda, 270
Hummingbird, 261. See also Buff-bellied Hummingbird; Ruby-throated Hummingbird
Hunting: by animals, 21, 54, 85, 99, 106, 138, 149, 200, 212, 246–247, 253, 278, 282; by people, xvi, 28, 70, 76, 130–132, 174, 180; overhunting, 86, 108, 142, 185–186, 282
Hurricanes, 75, 78, 266–267, 279
Hyla cinerea. See Green treefrog

Iguana iguana. See Green iguana
Indian Peafowl (*Pavo cristatus*), 60, *61*
Indian River Lagoon, 1, 94
Indigenous people, xvi, 1, 64, 102, 141. See also Apalachee; Calusa; Timucua
Island glass lizard (*Ophisaurus compressus*), *202*, 203

Jansen, Deborah, 15
Jennings, May Mann, 186

Keys. See Florida Keys
Key Biscayne, 48–49, 58, 103, 104, 148, 188, *254*, 258, 266
Key deer (*Odocoileus virginianus clavium*), 3, 111–112, 164, 174–175, *174*, *175*, 221–222, 297
Key Deer National Wildlife Refuge, 174–175, 208
Key Largo, 54, 76, 188, 189, 281
Key Largo cotton mouse, 54
Key Largo woodrat (*Neotoma floridana smalli*), 54, 188
Key West, 1, 28, 64, 68, 79, 91, 106
Kinosternon baurii. See Striped mud turtle
Kleinhenz, Peter, 136
Knight anole (*Anolis equestris*), xv
Kroegel, Paul, 186

La Sagra's Flycatcher (*Myiarchus sagrae*), 79
Lake Okeechobee, 76, 78, 131, 181
Lake Talquin State Forest, 124
Lampropeltis elapsoides. See Scarlet kingsnake
Latrodectus bishopi. See Red widow spider
Lavender Waxbill (*Glaucestrilda caerulescens*), 48–49
Leafless beaked lady's-tresses orchid (*Saciola lanceolata*), 111
Least Tern (*Sternula antillarum*), 274, *275*
Leatherback sea turtle (*Dermochelys coriacea*), 271–273, *271*, *272*
Leiocephalus carinatus armouri. See Northern curly-tailed lizard
Liguus fasciatus. See Liguus tree snail
Liguus tree snail (*Liguus fasciatus*), 87, *87*
Limpkin (*Aramus guarauna*), 6, 148
Linearwinged grasshopper (*Aptenopedes sphenariodes*), *176*, 177
Lithobates clamitans. See Green frog
Lithobates sphenocephalus. See Southern leopard frog
Lizard, xv, 54, 57, 121, 261. See also Argentine giant tegu; Broad-headed skink; Brown anole; Brown basilisk; Eastern fence lizard; Eastern six-lined racerunner; Florida sand skink; Florida scrub lizard; Florida wormlizard; Green anole; Green iguana; Island glass lizard; Knight anole; Northern curly-tailed lizard; Peters's rock agama; Puerto Rican crested anole; Reef gecko; Southeastern five-lined skink; Tokay gecko; Wood slave
Loggerhead sea turtle (*Caretta caretta*), 1, 2, *255*, 257, 285–286, *285*, *286*
Loggerhead Shrike (*Lanius ludovicianus*), 144
Lontra canadensis. See Northern river otter
Lynx rufus. See Bobcat

Macaca mulatta. See Rhesus macaque
Magill, Ron, ix-x, 264
Magnificent Frigatebird (*Fregata magnificens*), xiv, 77, 78, 80

Malaclemys terrapin rhizophorarum. See Mangrove diamond-backed terrapin
Manatee. *See* Florida manatee
Manatee Lagoon Eco-Discovery Center, *226*
Manatee Springs State Park, 92
Mangrove, 26, 49, 50, 67, 77, 91, 142, 146, 174, 293
Mangrove diamond-backed terrapin (*Malaclemys terrapin rhizophorarum*), *140*, 141
Mangrove Cuckoo (*Coccyzus minor*), 148
Manomera sp. *See* Walkingstick
Marco Island, 250–251
Marsh rabbit (*Sylvilagus palustris*), 164, *165*
Masked Booby (*Sula dactylatra*), xiv, 77, *79*
Matheson, R. Hardy, 188
McCollister, Matthew, 74, *74*, *76*, *260*
McGuire Center for Lepidoptera and Biodiversity, 257, 281
Megascops asio. See Eastern Screech-Owl
Meleagris gallopavo. See Wild Turkey
Mephitis mephitis. See Striped skunk
Merritt Island, 181, 198
Miami, 28, 48, 49, 63, 88, 99, 148, 223, *225*, 230, 233, 247, 278, 279
Miami blue (*Cyclargus thomasi bethunebakeri*), 3, 256–257, *256*, *257*, 266–268, *266*, *267*
Miami tiger beetle (*Cicindelidia floridana*), 256, 289–290, *289*, *290*
Migration, 4, 78, 88, 94, 150–152, 159, 162, 259, 288
Miller, Lloyd, 188
Möller, Hailey, *262*
Monarch (*Danaus plexippus*), viii, 146, 150–152, *151*, *152*, 261
Mouse, 178. *See also* Beach mice; Florida mouse; Key Largo cotton mouse
Munroe, Mary Barr, 186
Muscovy Duck (*Cairina moschata*), 58
Myakka River State Park, 70, 168, *192*, 194
Mycteria americana. See Wood Stork
Myotis austroriparius. See Southeastern myotis

Naples Zoo at Caribbean Gardens, 253–254
Native species, xiv, xvi, 1–7; animal essays, 8–43, 82–107, 113–145, 150–183, 194–219, 228–251, 264–290; biogeography, 77–80, 108–112, 146–149; conservation, xvi, 184–193, 220–227, 252–263; plants, 98, 78, 101–3, 152, 223, 261
Neotropic Cormorant (*Nannopterum brasilianum*), 6, 149
Neovison vison evergladensis. See Everglades mink
Nerodia fasciata pictiventris. See Florida watersnake
New Guinea flatworm, 49
Nine-banded armadillo (*Dasypus novemcinctus*), 4–5, *18*, 19
Nonnative species, xv–xvi, 44–49; animals, 29, 77, 95–96, 130, 245; animal essays, 50–76; management, 24, 258, 261, 288; plants, 49, 152
Norris, Sarah, *255*, 285–286
North American racer (*Coluber constrictor*), 239–240, *239*, 261
Northern Cardinal (*Cardinalis cardinalis*), 220, 261
Northern curly-tailed lizard (*Leiocephalus carinatus armouri*), xix, *62*, 63
Northern raccoon (*Procyon lotor*), 75, 148, 194, *194*, 224, 236–238, *236*, *237*; biogeography, *xiv*, 111; as predator, 104, 286
Northern river otter (*Lontra canadensis*), xii, *193*, 214, *215*
Notophthalmus viridescens. See Eastern newt
Nycticeius humeralis. See Evening bat

Oak (plant): Live oak, 210, 236, 52, 204, 230, 252; Scrub oak, 8, 37; wildlife-friendly attributes, 259–261
Oak toad (*Anaxyrus quercicus*), 195, *195*
Ocala National Forest, 37, 38, 168, 189, 196, 210
Ochlockonee River State Park, 204
Odocoileus virginianus. See White-tailed deer
Odocoileus virginianus clavium. See Key deer
Onychoprion fuscatus. See Sooty Tern
Ophisaurus compressus. See Island glass lizard
Osteopilus septentrionalis. See Cuban treefrog
Ovenbird (*Seiurus aurocapilla*), 254
Overharvest, xvi, 1, 86, 87, 102, 141, 264

Palamedes swallowtail (*Pterourus palamedes palamedes*), 261
Paleoindians, xvi
Panhandle. *See* Florida Panhandle
Panther. *See* Florida panther; Texas cougar
Parks and reserves, 16, 184–193
Patagioenas leucocephala. See White-crowned Pigeon
Pavo cristatus. See Indian Peafowl
Paynes Prairie, 52, 225
Pelican Island Elementary School Eco Troop, 188
Pelican Island National Bird Reservation, 185–186
Peppermint stick insect (*Megacrania batesii*), 172
Perithemis tenera. See Eastern amberwing
Pet trade, 48, 57, 141, 264
Peters's rock agama (*Agama picticauda*), *56*, 57
Petrochelidon fulva fulva. See Cave Swallow
Peucetia viridans. See Green lynx spider
Phoenicopterus ruber. See American Flamingo
Photuris spp. *See* Fireflies
Pine, 35, 38, 142; Longleaf, 204, 212; forest/pineland, 22, 64, 101–2, 114, 185, 189, 222, 293; rockland, 78, 174, 190–91, 256, 290; scrub, 8, 35, 195, 234
Pine barrens treefrog (*Hyla andersonii*), 184
Pine Jog Environmental Education Center, *220*
Piping Plover (*Charadrius melodus*), 4

Index · 303

Pitcher plant, 149; bog (habitat), 172, 293. *See also* Whitetop pitcherplant; Yellow pitcherplant
Platalea ajaja. *See* Roseate Spoonbill
Plestiodon inexpectatus. *See* Southeastern five-lined skink
Plestiodon laticeps. *See* Broad-headed skink
Plestiodon reynoldsi. *See* Florida sand skink
Plume hunting, 86, 180, 185
Pomacea spp. *See* Apple snail
Ponce de Léon, Juan, 1
Ponce de Leon Springs State Park, 121
Prairie (habitat), 21, 22, 149, 174, 198, 222, 242, 287–288
Procyon lotor. *See* Northern raccoon
Pseudemys nelsoni. *See* Florida red-bellied cooter
Pseudotriton ruber vioscai. *See* Southern red salamander
Psittacara erythrogenys. *See* Red-masked Parakeet
Puerto Rican crested anole (*Anolis cristatellus*), xv
Puma concolor coryi. *See* Florida panther
Pyrocephalus rubinus. *See* Vermilion Flycatcher
Python molurus bivittatus. *See* Burmese python

Ramos, Pedro, 74, *259*
Ranches, 19, 21, 52, 64, 191, 222, *222*, 242, 287–288, *287*
Red fox (*Vulpes vulpes*), 7, 130–32, *131*
Red widow spider (*Latrodectus bishopi*), 2, 8, *9*, 188
Red wolf (*Canis rufus*), xvi, 255, 282–84, *283*
Red-cockaded Woodpecker (*Dryobates borealis*), 212, *213*
Red-eared slider (*Trachemys scripta*), xv, 46–47
Red-masked Parakeet (*Psittacara erythrogenys*), *46*
Red-shouldered Hawk (*Buteo lineatus*), ii, 228
Red-whiskered Bulbul (*Pycnonotus jocosus*), xv, 49
Red-winged Blackbird (*Agelaius phoeniceus*), xix, 222
Reddish Egret (*Egretta rufescens*), 84, 85–86, *85*
Reef gecko (*Sphaerodactylus notatus*), 79
Restoration, 154, 181, 198, 225, 288
Reupert, Mike, 74, *76*, *260*
Rhesus macaque (*Macaca mulatta*), 46, 47, 49, 66, 67
Rhinella marina. *See* South American cane toad
Ridgley, Frank, 277–78
Rim rock crowned snake (*Tantilla oolitica*), 3, 188, *190*
Romalea microptera. *See* Eastern lubber grasshopper
Rookery Bay National Estuarine Research Reserve, 255, 257, 285
Roosevelt, Theodore, 185–86
Roseate Spoonbill (*Platalea ajaja*), 3, *80*, 180–81, *180*, *181*, 184, 185, *187*, 293
Ross, Anne and Tim, 41
Rostrhamus sociabilis plumbeus. *See* Snail Kite
Ruby-throated Hummingbird (*Archilochus colubris*), 4, 162, *163*
Rynchops niger. *See* Black Skimmer

Saber-toothed cat (*Smilodon fatalis*), xvi
Saciola lanceolata. *See* Leafless beaked lady's-tresses orchid
Salamander, 108, 109, 124, 146. *See also* Three-lined salamander; Southern red salamander
Sandhill Crane (*Antigone canadensis*), 148, 159, *159*, 222, *222*, 224
Sarracenia flava. *See* Yellow pitcherplant
Scarlet kingsnake (*Lampropeltis elapsoides*), 234, *235*
Sceloporus undulatus. *See* Eastern fence lizard
Sceloporus woodi. *See* Florida scrub lizard
Schaus swallowtail (*Heraclides aristodemus ponceanus*), 3, 257, 279–81, *279*, *280*
Schmid, Jill, *255*, 285–86
Sciurus carolinensis. *See* Eastern gray squirrel
Sciurus niger avicennia. *See* Big Cypress fox squirrel
Scrub (habitat), 2, 8, 24, 33–35, 37, 129, 135, 188, 195, 224, 234
Scrub palmetto scarab beetle (*Trigonopelastes floridana*), 2, 8
Scudderia sp. *See* Bush katydid nymph
Sea turtle, 1–2, 77, 79, 149, 263. *See also* Green sea turtle; Leatherback sea turtle; Loggerhead sea turtle
Seabranch Preserve State Park, 8, 188
Seagrass, 92–94, 106
Seepage stream, 2, 124, 136
Seiurus aurocapilla. *See* Ovenbird
Seminole Indian, 52, 64
Setophaga virens. *See* Black-throated Green Warbler
Short-tailed kingsnake (*Lampropeltis extenuata*), 3
Sigmodon hispidus. *See* Hispid cotton rat
Silver River, 49, 67, 148
Silver Springs, 46, 67, 148
Six-spotted tiger beetle (*Cicindela sexguttata*), *120*, 121
Skunk, 258. *See also* Appalachian or Allegheny spotted skunk; Florida spotted skunk; Striped skunk
Snail, 3, 49, 79, 148. *See also* Apple snail; Liguus tree snail
Snail Kite (*Rostrhamus sociabilis plumbeus*), xiv, 95–96, *95*
Snake, 37, 68, 109, 135, 138, 178, 212. *See also* Brahminy blindsnake; Burmese python; Eastern copperhead; Eastern diamond-backed rattlesnake; Eastern indigo snake; Florida crowned snake; Florida watersnake; Harlequin coralsnake; North American racer; Rim rock crowned snake; Scarlet kingsnake; Short-tailed kingsnake
Snowy Egret (*Egretta thula*), 153
Sooty Tern (*Onychoprion fuscatus*), xiii, xiv
South American cane toad (*Rhinella marina*), 46, 72, *73*, 245
Southeastern five-lined skink (*Plestiodon inexpectatus*), *112*

Southeastern myotis (*Myotis austroriparius*), 228, *229*
Southern fox squirrel (*Sciurus niger niger*), 244
Southern leopard frog (*Lithobates sphenocephalus*), 210, *211*
Southern red salamander (*Pseudotriton ruber vioscai*), 136, *137*
Southern toad (*Anaxyrus terrestris*), 4
Spanish (Colonial era), 46, 52, 64, 70
Spilogale putorius ambarvalis. See Florida spotted skunk
Squirrel, 70, 111, 222, 259. See also Big Cypress fox squirrel; Eastern gray squirrel; Southern fox squirrel
Squirrel treefrog (*Hyla squirella*), 68
St. Augustine Alligator Farm Zoological Park, 184, *187*
St. Marks National Wildlife Refuge, 146, 150, 189, 200, 207
St. Vincent National Wildlife Refuge, 255, 282
Striped mud turtle (*Kinosternon baurii*), 118–19, *118*, *119*
Striped skunk (*Mephitis mephitis*), 269–70, *269*
Strix varia. See Barred Owl
Sula dactylatra. See Masked Booby
Sus scrofa. See Wild hog
Suwannee River, 10, 129, 192
Swallow-tailed Kite (*Elanoides forficatus*), 4, 99–100, *99*, *100*
Sylvilagus palustris. See Marsh rabbit
Sylvilagus floridanus. See Eastern cottontail

Tadarida brasiliensis. See Brazilian free-tailed bat
Tallahassee, 108, 114
Tallahassee Museum, 255, 282
Tantilla oolitica. See Rim rock crowned snake
Tampa Bay, 181
Temperate species (biogeography), 3, 108–12
Terrapene bauri. See Florida box turtle
Texas cougar (*Puma concolor*), 15
Three-lined salamander (*Eurycea guttolineata*), 124, *125*
Thryothorus ludovicianus. See Carolina Wren
Timucua (Indigenous People), xvi
Toad, 3, 72. See also Oak toad; South American cane toad; Southern toad
Tokay gecko (*Gekko gecko*), xv
Tree island, 87, 198
Trichechus manatus latirostris. See Florida manatee
Trichonephila clavipes. See Golden silk orbweaver
Tringa semipalmata. See Willet
Tropical hammock (habitat), 87, 98, 102, 148, 174, 189, 217, 279–81
Tropical house gecko. See Wood slave
Tropical species (biogeography), 3, 77–80
Turtle, 47, 68, 109. See also Florida box turtle; Florida red-bellied cooter; Mangrove diamond-backed terrapin; Red-eared slider; Striped mud turtle

Tursiops truncatus. See Bottlenose dolphin
Twostriped Walkingstick (*Anisomorpha buprestoides*), 172

University of Florida, 256, *257*, 266; Bat houses, 226, 228, *229*
Urocyon cinereoargenteus. See Gray fox
Ursus americanus floridanus. See Florida black bear

Vermilion Flycatcher (*Pyrocephalus rubinus*), 206, *207*
Vervet monkey (*Chlorocebus pygerythrus*), 47, 49, 50, *51*
Virginia opossum (*Didelphis virginiana*), 75, 178, *179*, 224, 253
Vulpes vulpes. See Red fox

Wakodahatchee Wetlands, 42, 225, *227*
Walkingstick (*Manomera* sp.), 172, *173*
Water management, 154, 181, 198, 225
Wetland treatment system facilities, 225, *227*
White Ibis (*Eudocimus albus*), 153, 180, 294
White-crowned Pigeon (*Patagioenas leucocephala*), xiv, *90*, 91, 98
White-tailed deer (*Odocoileus virginianus*), xiv, 22, *23*, **110**, 111–12, *189*
White-winged Parakeet (*Brotogeris versicolurus*), xv
Whitetop pitcherplant (*Sarracenia leucophylla*), 172, *173*
Wild hog (*Sus scrofa*), 44–46, 70, *71*
Wild Turkey (*Meleagris gallopavo*), 38, 70, 168, *169*, 223, 259
Wildlife corridor, 16, 192–93, 259, 264. See also Florida Wildlife Corridor
Wildlife rehabilitation, 94, 252, 254, 262, *262*
Wildlife-friendly, 41, 239, 244, 261, 263
Willet (*Tringa semipalmata*), vi
Wood Duck (*Aix sponsa*), 148, *148*
Wood slave (*Hemidactylus mabouia*), 44, *45*
Wood Stork (*Mycteria americana*), xxi, 153–54, *153*, *154*, 225, *227*, 298

Yellow pitcherplant (*Sarracenia flava*), 149
Yellow-crowned Night-Heron (*Nyctanassa violacea*), 272–73

Zebra longwing (*Heliconius charitonius*), 149, 261
Zebra swallowtail (*Eurytides marcellus*), 149
Zoo Miami, *15/16*, 16, 256, 264, 277–78, 290
Zoos, xvi, 50, 63, 221–22, 254–56, 282–83. See also Central Florida Zoo & Botanical Gardens; Naples Zoo at Caribbean Gardens; St. Augustine Alligator Farm Zoological Park; Tallahassee Museum; Zoo Miami

Kirsten Hines is a Coconut Grove–based author, wildlife photographer, and conservationist with a master's degree in biology and background as an environmental educator. Her writing and photography have appeared in various publications, including several of her own books on Florida's nature and history, such as the award-winning wildlife gardening reference *Attracting Birds to South Florida Gardens* and the pictorial history *Everglades National Park*. Kirsten's images have also been featured in numerous photography showcases, public art programs, and exhibitions. She aims to inspire conservation action through her storytelling, wildlife-oriented presentations, guiding and workshops, and through not-for-profit work such as cofounding Phoebes Birding to connect women through nature, and serving on such boards as Audubon Florida and Tropical Audubon Society. Learn more about Kirsten and her work at www.KirstenHines.com.